"I could not tell wh(
or the one being dre
considerable inner t(
I realized that it didn t actually matter.

Baron Klaus von Lügner

This book is dedicated to

PAT MALLEA

*with whom I once shared a lot of wine in a Spanish restaurant
in the north of England*

Dedalus Original Fiction in Paperback

A BOX OF DREAMS

David Madsen is the pseudonym of a theologian and philosopher. He is the author of *Memoirs of a Gnostic Dwarf*, *Confessions of a Flesh-Eater* and *Orlando Crispe's Flesh-Eater's Cookbook*. His work has been so far translated into eleven languages and has received worldwide acclaim.

The film rights of *Confessions of a Flesh-Eater* have been sold and filming will begin in 2004.

David Madsen

A Box of Dreams

Dedalus

Published in the UK by Dedalus Ltd, Langford Lodge, St Judith's Lane, Sawtry, Cambs, PE28 5XE
email: DedalusLimited@compuserve.com www. dedalusbooks.com

ISBN 1 903517 22 2

Dedalus is distributed in the United States by SCB Distributors,
15608 South New Century Drive, Gardena, California 90248
email: info@scbdistributors.com web site: www.scbdistributors.com

Dedalus is distributed in Australia & New Zealand by Peribo Pty Ltd,
58 Beaumont Road, Mount Kuring-gai N.S.W. 2080
email: peribo@bigpond.com

Dedalus is distributed in Canada by Marginal Distribution,
695 Westney Road South, Suite 14, Ajax, Ontario, L15 6M9.
email: marginal@marginalbook.com web site: www.marginal.com

First published in 2003

A Box of Dreams © *David Madsen 2003*

The right of David Madsen to be identified as the author of this work has been asserted by him in accordance with the Copyright, Designs and Patents Act, 1988.

Printed in Finland by WS Bookwell
Typeset by RefineCatch, Bungay, Suffolk

A C.I.P. listing for this book is available on request.

. . . when, suddenly, just as I was lifting a forkful of *filet de bœuf poêlé villette* to my mouth, the lights went out and I was unexpectedly plunged into a pitch-black nothingness. The train had jolted and shuddered to a halt. There was little point in trying to peer from the window, since the darkness outside was as impenetrable as that within. I was wrapped in a profound inky silence, as hermetically sealed in its depths as the train was by the frozen, snowbound wilderness all around it. I was startled – almost shocked – when I heard a voice speak close to my ear, because as far as I was able to recall, I had been the sole occupant of the dining-car.

"Do not worry," the voice said. "We shall be on our way eventually. Are you bound for B—, may I ask?"

"No," I said.

"Then for R—, perhaps?"

I was even more startled, quite definitely shocked now, when I realized that I couldn't actually remember precisely *where* I was going. It was absurd. Was there not a ticket in the pocket of my jacket? But then, in such blackness, it would be quite impossible to read.

"No, not there, either," I managed to say.

"Ah. In that case, perhaps you will permit me to inquire –"

"No, please don't ask me any further questions. They unsettle me."

"Why?" the voice said, immediately ignoring my request.

"Because I do not seem to be able to answer them. The fact is, until you asked me, I thought I knew very well where I was going. Now, however . . ."

"You are unsure?"

"Worse. I simply can't remember. Where does this train terminate?"

"Well, to be perfectly truthful –"

"No! I can't bear it, I don't want to know!"

"– but we shall surely be delayed for some time if the line ahead needs to be cleared of snow."

"I thought it had stopped snowing several hours ago," I said.

"It never stops snowing in this part of the world. Not at this time of year."

"What part of the world are we in, then? Where exactly are we?"

"You appear to have accepted your topographical amnesia with remarkable equanimity," the voice observed.

"I once spent twelve months in a Zen monastery," I replied. "Learning to accept things as they actually are."

"The teachings had some success, then?"

"Even if they had been a total failure I should not have been aware of it since, being trained to accept things as they actually are, I would have been as indifferent to failure as to success."

"Surely not," the voice said. "For if you had achieved the ability to accept either success or failure as they way things actually are – or *tathata* as one should properly say – the teachings must undoubtedly have succeeded. Indifference would necessarily preclude failure, but it would not obliterate your capacity to distinguish between failure and success."

"I don't follow your reasoning."

"Doesn't Zen insist that this is precisely what you should *not* do, follow the conventions of reason?"

"You seem to know an awful lot about it," said I, feeling a little irritated by this unwelcome display of superior learning.

"So I should. For three years I was the amanuensis of Master Hui Po."

I gasped, despite myself.

"Isn't this rather a coincidence?" I managed to say. "A Zen neophyte and an intimate of the great Master Hui Po, both trapped in total darkness in a dining-car snowbound in the middle of – where did you say we were?"

"We are presently at a complete standstill, my friend. It is *tathata*. The way things actually are."

I sat enfolded in the silence for several moments, then I said:

"Perhaps . . . perhaps you could tell me something? Something I've always wanted to know . . ."

"If I can, I most certainly will."

"What exactly *is* the sound of one hand clapping?"

At that moment I was struck with considerable force on the top of the head by something that felt like a rolled-up newspaper or possibly a cardboard tube – the kind one uses to send certificates or large photographs through the post. I cried out and covered my head with the palm of one hand.

"That hurt! How could you? Whatever possessed you?"

"I was merely answering your question, my friend. It is precisely the way Hui Po brought me, instantaneously, to enlightenment."

I was furious.

"Once," the voice went on calmly, "he poured a pot of boiling tea over the exposed testicles of one of his handsome young disciples, asking this question as he did so: 'What do you do when you are scalded?' The disciple screamed in agony. 'Exactly so,' remarked Hui Po, kicking the youth full in his bare, burning scrotum. And the disciple achieved *satori*."

"You should be ashamed of yourself," I said, "striking a complete stranger like that. How on earth did you manage such an accurate aim in this dreadful blackness?"

"Hui Po once entrusted me with the task of translating *Zen and the Art of Controlled Urination* into Danish. I should imagine that something of the profundity of the work rubbed off."

"What, in any case, was the disciple doing with his testicles exposed?"

"I would rather not say."

"Is that how you treat everyone who happens to ask you a simple question?" I said, far from mollified to learn that I had received a considerably milder response from Hui Po's amanuensis than I obviously would have done from the Master himself.

"The question you asked was not simple at all, as you must know, even after only a year in your monastery. But not always, no. Please allow me to apologize."

Then, to my astonishment, I felt someone kiss me full on the mouth. It was a man, I was sure of that, for there was something lasciviously urgent in the intent of that kiss, a suggestion of controlled predatory hunger which one does not expect to find in a woman, and certainly not in a lady. Besides, I also detected the rough impress of unshaven stubble.

"How dare you!" I cried, pulling myself away and lashing out with a fist in the darkness.

"*Tathata.*"

Now a hand was inside my shirt and delicate fingertips began to caress my left nipple, flickering, tweaking, pinching.

"What the devil do you think you're doing?"

Then there were two hands, the fingers moving like the legs of purposeful spiders.

"Stay where you are!" I shouted. Oblivious to my protests, the swine threw himself upon me, dragging me down onto my back across the seat. I thrashed and struggled but my assailant was obviously strong, and I was easily overpowered. I felt the weight of him crushing the breath out of me.

"Get off, get off, before I call the guard!"

He smothered my words with passionate kisses. His hands ripped open my shirt and his naked chest, which was very muscular and quite hairy, pressed hard against mine. I could feel the swift thump-thump of his heart.

"Help me!" I screamed, but the blackness swallowed up my cry.

He forced my legs apart.

"Oh no, please don't do that —"

"But why?" a low, lewd voice whispered in my ear.

"Because I don't like it . . ."

And at once, much to my surprise, the vile assault upon my person ceased.

"You should have said so before," the voice said. "I assumed you would be used to this kind of thing."

"*What?*"

I pulled myself upright in my seat and began fastening my shirt buttons, straightening my collar.

"After all, an exceptionally good-looking fellow like your-self must constantly attract sexual advances, welcome or otherwise."

"How dare you say such a thing!"

"That you are exceptionally good-looking?"

"No, I didn't mean that. Besides, how do you know *what* I look like? Do you mean to tell me that you can see me, even in this wretched darkness?"

"Oh yes," the voice answered. "Quite clearly."

At that moment the train shuddered, creaked, shuddered again and began to move. Then the lights came on. I rubbed my face briskly.

"Ah, so you are awake! You seemed to have dozed off over your *filet de bœuf poêlé villette*, but you could have been meditating for all I know. I was concerned that you might accidentally stab yourself in the eye with your fork. I had been thinking of trying to arouse you, but one doesn't like to impose."

I looked up at the person sitting opposite me. He was a small, extremely elderly man with an abundant white beard. Perched on his rather prominent nose was an old-fashioned pair of pince-nez. In fact, he seemed rather old-fashioned – other-worldly, even – altogether.

"You're an absolute villain!" I cried, hardly managing to control my anger. "An animal! What do you mean by attacking me in that way?"

The old gentleman appeared to be genuinely confused. He blinked several times and shook his head.

"In what way?" he asked.

"You know perfectly well in what way."

"My dear sir, I assure you –"

"In that – that *sexual* way."

"Ach, nein!"

"You sexually assaulted me, you know you did. Do you intend to sit there, bold as brass, and deny it?"

"I am eighty-four years old," he replied. "Does it seem likely, even supposing I had the inclination, which I certainly do not, that I would succeed in carrying out a sexual assault on a man young enough to be my grandson?"

My mouth, fishlike, opened and shut. I was unable to think clearly. I was confused. Of course, I realized immediately that what the old gentleman had said must certainly be true – but then – damn it all! – *someone* had attacked me, that much was certain, and we were the only two occupants of the dining-car. Who else could it have been? On the other hand, I was quite sure that my assailant had been young and strong, poss-essing a muscular body, whereas the man opposite me was anciently wizened.

"Do you think it could have been the guard?" I asked, feeling that the question was absurd but unable for the moment to think of a suitable alternative.

"Surely I would have *seen* an attack such as you describe? Were you sodomized?"

"What?"

"Was full anal penetration achieved, or was it simply a mat-ter of *frottage* and a little mutual masturbation? Did ejaculation take place?"

I was startled by the clinical frankness of his questions and he sensed it.

"There was nothing mutual about it, I assure you!"

"Please do not be alarmed, my young friend. It is perfectly in order for me to ask. I am a psychiatrist. Allow me to intro-duce myself: I am Dr Sigmund Freud of Vienna."

I barely restrained a snigger.

"I don't wish to appear rude," I said, "but aren't you being ridiculous? Sigmund Freud died a good many years ago."

Dr Freud, or whoever he was, tut-tutted impatiently and scratched his white beard.

"I am not *that* Sigmund Freud," he replied. "And to be frank with you I am heartily sick and tired of having to explain this fact to innumerable individuals who are appar-ently incapable of conceiving the probability – indeed, when one considers the vast number of inhabitants past and present of this rather insignificant planet, the *certainty* – that two human beings will share the same name."

"I apologize," I murmured. "I didn't mean to offend you. Please remember that I have recently been the victim of a

savage and unprovoked erotic assault. I'm still not thinking very clearly. And in answer to your question – no, there was no anal penetration."

"What, then?"

"Well – this is acutely embarrassing, as I'm sure you will appreciate – he jumped on top of me, kissed me with great ardour and tried to grab me, down there –"

"Where?"

"Down where he had no business to be."

"But no sodomy?" Dr Freud asked with, I thought, a slightly rueful tone.

"What happened was bad enough."

"If it happened at all, that is."

"Of course it happened, I should know! In any case, how could you possibly have seen anything in that darkness?"

"What darkness?"

"What darkness?" I cried. "Why, the darkness into which we were so unexpectedly plunged when the lights went out! When the train stopped –"

"My dear young man, I assure you that the lights did *not* go out, not even for a second. Neither has the train stopped, or even slowed down for that matter, at any point since we left V—."

"But this is nonsense. It's absurd!"

"You accuse me, a psychiatrist, of talking absurd nonsense?" Dr Freud said, his wrinkled old face reddening in outrage.

"Well no, not exactly that – I mean – but the lights *did* go out, I tell you."

"And I tell you that they did not."

"Then, if this is the case, what's happening to me? Am I going mad?"

"It is fortunate, is it not, that you are seated opposite some-one whose profession by a strange quirk of fate renders him absolutely qualified to answer precisely that question? Imagine! I could have been a butcher or a bookbinder. Then where would you be?"

"Almost as strange a quirk of fate," I remarked, "as two men, both psychiatrists, both called Sigmund Freud. You were

never the amanuensis of the Zen Master Hui Po, by any chance?"

"It's really rather amazing that you should ask me that," Dr Freud replied.

"You mean to tell me that you *were* Hui Po's amanuensis?"

"No. I mean that you have mentioned the one subject in all the world – I refer to Zen Buddhism – in which I have no interest whatsoever. Even my poor friend Dr T.D. Suzuki could not persuade me to examine its fundamental tenets. However, we often took tea together."

"It is certainly odd," I said, "but it does not bring me any nearer to discovering the identity of my assailant."

"Your *sexual* assailant," said Dr Freud. "Don't forget that."

"Is it important?"

"Sex is always important, my dear young friend. Particularly if, as I am about to suggest, it takes place within the context of a dream."

"A dream? You think it was nothing but a dream?"

"Where dreams are concerned, it is never a case of 'nothing but' ," said Dr Freud with a trace of severity in his querulous old voice. "Quite the contrary, I assure you. And yes, that is precisely what I think."

I leaned back in my seat, pushed the plate of cold *filet de bœuf poêlé villette* to one side and whistled slowly, softly.

"A dream, eh? Well, that might explain a great many things," I said. "And if it really was a dream, then I wouldn't be going mad after all, would I?"

"I am afraid that is neither a valid nor even a logical deduction as far as psychiatry is concerned. But do not be dismayed. Let us concentrate on the assumption that you *dreamt* the train stopped, the lights went out, and someone subjected you to a thrilling sexual assault."

"I never said it was thrilling!"

"Your unconscious clearly thought so, otherwise you would never have dreamt it. Naturally, your conscious mind rejects the notion. Let us attempt to unravel the imagery of the dream. We have some time before we reach N—."

"N—? Is that where this train is going?"

"Dear me, no. It is only where I get off. It goes some considerable distance beyond there."

"Where exactly *is* it going, then?"

"Do you know, I haven't the faintest idea. Is N— your destination also?"

I took a deep breath.

"That's part of the dream too," I whispered. "I can't remember my destination."

"But if you can't remember – why! – you must *still* be dreaming. Surely if you were awake, you would know where you are going?"

"You mean," I cried, "you mean that *you* are a part of the dream too? That I'm dreaming this entire conversation?"

A look of consternation crossed Dr Freud's face.

"I sincerely hope not," he said. "That would have implications of a somewhat disturbing nature for me."

"Yes, of course. It would imply that you actually don't exist."

"And yet I feel myself to be real enough. I have a home, a family, a profession in which I can claim to have achieved some modest success. How can I not exist?"

"You exist only for as long as I continue to dream," I said, feeling rather important. "And I want to wake up. In fact, I think I will."

Dr Freud suddenly screamed.

"No, no! I beg you, don't!"

"But it's a very unpleasant experience not to know where one is going."

"If you wake up you will destroy me! Everything I am, all that I possess: my research, my books, my lovely home with the Bechstein piano and the small Vuillard watercolour of a naked woman eating pilchards –"

"Unless . . ."

"Unless what?" Dr Freud demanded in an agitated manner.

"Unless," I said, "it is *you* who are dreaming!"

"What?"

"Well, it's perfectly possible, isn't it? You could have fallen asleep soon after leaving V—. You could be dreaming that I

fell asleep and dreamt about being sexually assaulted and, in fact, that I am dreaming still."

"You suggest that I am dreaming that you had a dream?"

"That is exactly what I am suggesting Dr Freud."

He pushed his small frame further back into his seat and hunched up his frail shoulders. He was wearing a black overcoat with a fur collar that seemed much too big for him.

"Young man," he said at last, "you have posed a sinister and complex conundrum. Whichever way you look at it, one of us is certain to cease existing the moment the other wakes up.

"The question to be asked, surely, is this: which of us is having the dream? Who is the dreamer and who the dream? As a psychiatrist you must be a connoisseur of dreams. Can't you tell?"

"At this precise moment I regret to say that I cannot. The interpretation of a dream requires many hours of intense discussion, particularly about intimate sexual matters, with the dreamer. Indeed, it is the result of such discussion."

"Couldn't we discuss it now? It might help."

Dr Freud shook his head.

"I do not imagine that you would be able to afford my fees," he murmured regretfully. "Besides, in my book *The Interpretation of Dreams* –"

"Didn't Sigmund Freud write that?"

"I *am* Sigmund Freud!"

"But not *that* Sigmund Freud –"

"And my book is not *that* book."

"This is all terribly confusing," I said.

"Not for me it isn't."

"Please continue."

"As I was saying, in my book *The Interpretation of Dreams* I make it quite clear that even though the events of a dream are, compared to the waking state, absurd and impossible – such as flying through the air, the transmutation of form, a confusingly perverse chronology, and so on – within its absurdity the dream is characterized by a consistency of logic on its own terms, and within its impossibility it is unmistakably real. We must always remember that the events of a dream

constitute a code, they mask the unacceptable and therefore their language is euphemistic. A euphemism is not unreal, it merely points to a reality other than itself. The *bête noir* of my younger days, Carl Jung, would not agree with me, of course."

"I assume you do not refer to the *original* C.G. Jung of Küsnacht?"

"Why do you assume that?"

"Well —"

"As a matter of fact I *do* refer to that Carl Jung. Would it not be foolish to deduce, as you have clearly done, that because there are two psychiatrists called Sigmund Freud, there must also be two Carl Jungs, since he was a psychiatrist also?"

"I'm afraid you're confusing me," I said.

"Jung himself thought it hilarious that there were two Sigmund Freuds. He once remarked to me over a plate of *bouillabaisse provençale* at Bollingen that it proved God has a sense of humour."

Dr Freud clearly noticed my downcast look and added in an almost affectionately concerned manner:

"Forgive an old man his reminiscences. I have not forgotten our problem. It should not prove too difficult a task, I think, to find out which one of us is dreaming the other."

Surrendering to the pessimism of my present mood I was about to contradict Dr Freud when the door of the dining-car suddenly opened and a guard came in. He was an immensely fat man with surly, swarthy features whose crumpled, stained uniform did not adequately accommodate his bulk. He looked as if he had just woken up from a prolonged, alcohol-induced slumber.

"Tickets gentlemen, if you please," he said.

"Can you tell me where this train terminates?" I asked.

"Never mind about where it terminates. It's my job to find out whether or not you've got a right to be on it in the first place, before I start answering stupid questions."

"It isn't a stupid question," I said angrily. "It's a perfectly reasonable question."

"I ask you," the guard replied, giving me a distinctly

unpleasant smile, "is it reasonable for a man to be travelling on a train without knowing where it's going?"

"Well, put like that, no."

"What other way is there to put it? In any case, I haven't got time to be standing here arguing with the likes of you. What are you, an anarchist?" Then, more darkly, he added: "Or a left-wing homosexual, maybe. Where's your ticket?"

Then, to my amazement, he turned to my elderly companion, bowed low with a great show of subservience, and murmured:

"Good evening, Dr Freud. Nice to have you aboard again, sir. I trust Madame Freud is well?"

"Thank you for your concern, Malkowitz. I am afraid Madame Freud is not particularly well these days. Her bowels are a constant trial. She is presently obsessed by the idea that there is a large serpent lodged in a length of her lower intestine."

"Good heavens, sir! I take it you're attempting to rid her of such a fanciful notion?"

"No indeed I am not, Malkowitz. It was I who induced it in the first place. By way of an experiment, you understand."

"Of course, Dr Freud, naturally."

"However, I seem to have overestimated the ability of Madame Freud's mind to distinguish between reality and delusion. I shall reverse the effects of the experiment in due course, but not just yet. Not until my observations have been properly concluded. At the moment she is consuming vast quantities of laxatives in a frantic attempt to flush out the creature —"

"Which doesn't actually exist in the first place, eh?" wheezed Malkowitz. "Well, well, sir! There's always a humorous side to every situation, that's what I say."

"You callous swine!" I cried, unable to restrain myself, moved by the plight of this poor woman, a hapless victim of Dr Freud's cruel psychological experimentation. "How could you do such a thing to your own wife?"

Dr Freud's sunken, wizened face visibly paled.

"My wife?" he murmured, his voice suddenly full of shock

and pain. "Who said anything about my wife? My wife has been dead these fifteen years!"

"What?"

"Struck down by a rare tropical virus that ate her to death from within, by ghastly, inexorable degrees, rotting her organs and burrowing into her brain. Ah, it is utterly heartless of you to remind me of that terrible agony! Heartless!"

"Then who thinks she's got a snake in her intestine?"

"My daughter, young man. Malkowitz was enquiring after the health of my daughter."

"But I distinctly heard him say *Madame* Freud. Surely your daughter did not marry a man with the same surname as herself?"

"That is precisely what she did – a second cousin, as it happens. She was granted a costly dispensation by the pope."

"You're not Catholic, are you?"

"Of course not. We are, all of us, Jewish. However, it is always best to be on the safe side. In my professional opinion religion is simply the sublimation of the libido for the sake of social convention and, therefore, psychologically speaking, harmful in the extreme. Nevertheless, if one must live according to the dictates of an illusion, it is better to choose the illusion with the most convincing pedigree. Furthermore, as it happens, a distant relative of mine has been working for some time in the secret archives of the Vatican library. He is particularly interested in the *Codex Bartensis* and variations of Valentinian soteriology and often has occasion in the labyrinthine corridors of that august institution, to come across His Holiness browsing in the phenomenology section."

"Look," said the guard called Malkowitz, interrupting Dr Freud, "I don't know what your game is, but I'm not leaving until you've shown me your ticket. Where is it, eh? Failure to produce a valid ticket whilst travelling on the State railway carries a very heavy penalty, I'll have you know."

"A minimum of seven years imprisonment with hard labour," Dr Freud said, nodding his head slowly.

This struck me as somewhat excessive.

"But I *must* have a ticket!" I cried. "Wait a moment – here – it's really got to be here somewhere –"

I thrust my hand inside my jacket and scrabbled around in the pocket. I admit that by now my stomach was churning violently, for not only was I in danger of being exposed as nothing more than a figment of someone's imagination, I was also being threatened with seven years behind bars. My prospects looked bleak in either case, since if indeed I was but a figment I would cease to exist the moment the dreamer woke up, and if I wasn't, the possibility of incarceration seemed ever more likely because . . .

"Can't you find it?" asked Dr Freud.

. . . digging deep into my inside pocket, I was shocked to discover . . .

"Isn't it there?"

. . . precisely that. *It wasn't there.*

"No," I said. "It isn't. I can't think what might have happened to it. I know that I bought a ticket before boarding the train."

"And where exactly *did* you board the train, may I ask?"

"I . . . I can't remember exactly."

"Can you remember approximately, then?" asked Dr Freud.

I was beginning to wish the old man would mind his own business. Everything he said just seemed to make things worse.

"Approximately isn't good enough I'm afraid," Malkowitz said in a stern tone of voice. "You can't board a train *approximately*. I've never heard of such a thing."

"Remember Malkowitz, you are not trained in psychology, as I am."

"Look Dr Freud, I appreciate your desire to help this young man to find a way out of his predicament. Typical, if I may be allowed to say so, of a man as kindly by nature as yourself – but I have my job to do. If he hasn't got a ticket, I'll just have to arrest him. I have no choice."

"That's ridiculous!" I protested. "You're an employee of the State railway, not a policeman. You can't go around arresting people, you haven't got the authority."

Dr Freud said:

"I'm very much afraid you are wrong there. You see, Malkowitz has been granted special emergency powers by the Department of Internal Security."

"I'd prefer it if you didn't mention that, Dr Freud."

"Come, come, my dear fellow! No need for false modesty."

"Well, have you got a ticket or not?" the guard with special emergency powers demanded.

"No," I said. "I haven't. I simply can't understand it."

"Perhaps," Dr Freud suggested, "it was stolen by your assailant?"

"What's this?" said Malkowitz.

"Our friend here seems to think that he was sexually assaulted when the lights went out."

"But the lights didn't go out. I would have noticed if they had."

"Exactly what I told him, but he wouldn't have it. He insists that the lights went out, the train stopped, and in the resulting darkness he was the victim of a violent sexual attack. He assures me that no anal penetration occurred, but the charge remains serious nonetheless."

"No anal penetration, eh?" Malkowitz said slowly, rubbing his stubbled chin.

"It seems to be that someone capable of such an assault would also be quite capable of petty theft."

"You've got a point there, Dr Freud."

"Our young friend at first accused me of perpetrating the deed –"

"What?"

"Oh yes, I assure you."

To my surprise and intense irritation, Malkowitz suddenly leaned forward and struck me lightly across the face with the back of his hand. It did not cause pain, but it was insulting in the extreme.

"There," he said, like a crotchety nanny rebuking a fractious charge. "That's for your sauce."

Dr Freud continued:

"Then he seemed to think that it might have been you, Malkowitz."

"I said no such thing!" I cried.

"Oh but you did, I distinctly remember it. When you had accepted that a respectable elderly gentleman like myself could not possibly have done what you accused him of, you then suggested that the guard might be the guilty party."

"By God!" fumed Malkowitz, "I've a good mind to thrash him within an inch of his life for saying such a thing! What does he think I am, an animal? A deviant? I'll have you know, you young ruffian, I'm a happily married man. I'd be a father, too, if it wasn't for my wife's defective tubes. Is that what you're taunting me with? My poor wife's tubes? I'm man enough to beat you senseless, you callous little bastard!"

Malkowitz raised his fists into the air in what he assumed was a threatening manner, but I could tell that it was all bravado. I wasn't intimidated. He couldn't thrash a fly, and we both knew it. Like all bullies, he was weak and soft and pitiful inside.

"Calm yourself Malkowitz," Dr Freud said soothingly. "This gentleman is merely trying to state his side of the case."

"Will you please stop acting like a defence counsel!" I shouted at Dr Freud. "I am not on trial. I was the one who was assaulted, remember?"

"And you're claiming it was me who did it, eh?" Malkowitz muttered.

"I am certainly not saying any such thing –"

Dr Freud interrupted:

"Of course, there *is* a way to prove Malkowitz's innocence."

"What might that be, Dr Freud?"

"Why, to re-enact the crime, naturally."

"Re-enact it?" I said, beginning to feel slightly sick.

"Yes. It would be the perfect solution, don't you see? Our friend here will surely be able to tell whether or not it was you who assaulted him, Malkowitz, once he is able to compare what it feels like with *you* on top of him, to what it felt like at the time of the alleged attack."

"Don't I have a say in this?" I protested.

"I must admit," Malkowitz mused, "it does sound a sensible idea. He's a good-looking fellow right enough. A bit of man-to-man horseplay is certainly a tempting proposition. Life can be lonely on the long distance runs, I don't mind admitting. When Hubert Dankers was on the night express to P— with me, we found ways to amuse ourselves during the long, dark hours. Now poor old Hubert's got his haemorrhoids, of course –"

"You swine!" I yelled at him. "I shan't permit it!"

"That's settled then," Dr Freud said. "But remember Malkowitz: the original attack stopped short of anal penetration."

"More's the pity, eh, Doctor?"

"Off you go!" Dr Freud cried with enthusiasm and, as he did so, the lights went out again and the meaty arms of the guard with special emergency powers granted by the Department of Internal Security pinned me down across the seat. His disgustingly wet, blubbery lips planted kisses on my mouth and all over my neck, then his tongue wormed its way into my ear, leaving sticky deposits there as it traced a revolting curlicue around and down across my throat.

"Rip the shirt open!" I heard the shrill, quavering voice of Dr Freud shriek. Malkowitz did as he was ordered. His meaty fingers tweaked and squeezed my nipples and I screamed with the pain. The immense weight of the monster was crushing me, pressing the breath out of my lungs and the blood from my veins as oil is pressed out of ripe olives. I thought my eyes would surely pop out of their sockets. I could feel his hot, sour breath on my face.

"No penetration, mind . . ."

I felt the sweat pour down between his great, fatty breasts and run in rivulets across my chest. It smelt like rancid butter. His hairy belly heaved spasmodically on mine. His erection was pressing urgently against my groin.

"Enough!" I cried, as Malkowitz pushed my thighs open and reached for my private parts. "For God's sake, enough!"

Then, exactly as before, the precipitate assault on my person ceased and the lights came on again. I dragged myself upright in my seat, dishevelled and shaken and outraged.

"Well?" Dr Freud demanded. "Can you now positively identify Malkowitz as your assailant?"

I was struggling for breath.

"No," I managed to gasp. "I can't."

"How can you be certain?"

"The man who sexually assaulted me in the first instance was much younger, much leaner –"

"Are you suggesting I'm fat?" demanded Malkowitz belligerently, buttoning up his trousers.

"Well, to be perfectly honest – oh God, give me time to catch my breath! – the fool very nearly suffocated me –"

"Continue, my friend, please."

"Well, he was also rather more attractive. On the other hand, Malkowitz merely repulses me."

Malkowitz began to cry.

"Do not distress yourself," Dr Freud said in a kindly manner. "Far better to be physically repulsive and innocent of a vile criminal act, than attractive and guilty."

"I dare say you're right," Malkowitz said, blowing his nose into a large, stained handkerchief. "And all this means we're back to square one, doesn't it?"

"Which is where, exactly?"

"I'll tell you where! We're back to the fact that this person who called me fat and repulsive doesn't have a valid ticket for his journey. What's your name?"

"I – that's another thing – I don't remember," I said, quietly desperate by now.

"Well I'm going to arrest you anyway."

Dr Freud said softly:

"Despite your special emergency powers, I'm afraid you can't actually do that, Malkowitz."

"Why on earth not, doctor?"

"Because before your arrival on the scene, we had already ascertained that if neither you nor I perpetrated the sexual assault, it must have been a dream."

"A dream?"

"Precisely. The problem is, we do not know which one of us is dreaming and which one is being dreamed. You see, if it proves to be our nameless young friend here, then I am doomed to extinction the moment he awakes – so are you, for that matter – and I don't much care for this possibility. On the other hand, if *I* am the dreamer, then he is the one who will cease to exist, and I don't suppose that would suit him any more than it suits me. You, Malkowitz, are in the unfortunate position of being condemned to non-existence whichever of us turns out to be the dreamer."

"Oh . . . I'm not, am I?"

"I'm very much afraid so. And if you do not in fact exist, you can't very well arrest anyone, can you?"

Malkowitz protested:

"But you *know* me, Dr Freud – why, you know me well! – which surely means that you're the one doing the dreaming, that I must have some independent existence outside of the dream, right? You'd hardly be dreaming of someone you've never met, would you?"

"On the contrary," Dr Freud replied, "only last week I had the most delightful dream about Madame Fanny d'Artignani the opera diva, and yet I've never met her. Neither in any sense can I be said to know her."

"Not even in the biblical sense, doctor?"

"No."

"Oh God, what a fine pickle we're in, and no mistake!"

"Be calm Malkowitz. I think there may be a solution."

"What might that be?" I asked, anxious not to be left out of the conversation, in case I ceased to speak altogether and became the dream-figment I dreaded becoming.

Dr Freud settled himself back in his seat and stroked his white beard thoughtfully.

"Well," he began, "I had intended to alight at N—, where I am due to address an important conference of homeopaths on the subject of dysmorphic disorders –"

"Perverts," Malkowitz muttered in disgust, spitting.

"Not homosexuals Malkowitz, *homeopaths*."

"Give 'em whatever fancy name you like, doctor, they're all a bunch of deviants."

"However," Dr Freud continued, "if all three of us were to get out at the next scheduled stop, we would be able to search the nearest public records office for evidence of our existence. A name, an address – why – every inhabitant in the entire region will be there! It would take a very short time indeed to find what we are looking for. I'm certain of it."

"You can't be certain of anything in this life," I said rather sulkily.

Malkowitz glared at me and muttered:

"Are you certain of that?"

Then he continued in a disgustingly servile tone of voice:

"We bow to your superior knowledge doctor, but I don't think I ought to abandon my post, do you?"

"Oh, it wouldn't be for long. Besides, I can always square things with your immediate superior. His daughter is a patient of mine, did you know?"

Malkowitz nodded gravely and said in an awed whisper:

"Psychotic irregularities of the sexual –"

"Yes, but I have hopes of a complete recovery. Several of the more serious self-inflicted wounds are now almost healed."

"You never did tell us where this train terminates," I said with an accusing stare.

He shifted the weight of his enormous bulk from one foot to the other, standing almost on tip-toe like a ballerina.

"That's because I don't know," he replied in a mixture of sullen resentment and embarrassed apology.

"What?" I cried sarcastically, "A guard invested with special emergency powers by the Department of Internal Security, who doesn't even know the final destination of his own train?"

"It isn't my train, it belongs to the State."

"The question of ownership is irrelevant," Dr Freud put in.

"Begging your pardon doctor, but not to the State it isn't."

"And why, pray, can you not tell us the train's final destination?"

"Because the schedule was changed after we left V—. Central Bureau telephoned to say they would call back with details of the revised schedule within the hour, but –"

"But *what*, Malkowitz?"

"But five minutes after the call, the wires came down in the blizzard. We're completely cut off from Central Bureau – something that's never happened before, and I don't care for it one little bit, I can tell you. Well, since I don't have details of the revised schedule, I don't actually know where the train is going."

"What about the driver?"

Malkowitz shrugged, as if to suggest that the driver was of no importance.

"Probably Ernst," he said. "But Ernst hasn't spoken to me for weeks on account of that business with his wife's underwear. Besides, I don't suppose he's got any idea either. He'll just keep going until we get the signal to stop."

"And the other passengers? Have they been informed of our common predicament?" Dr Freud demanded.

"To tell you the truth," Malkowitz said, "I couldn't find any."

"None at all?"

"Oh, there *are* other passengers on this train, I don't doubt that for a moment. It's just that I couldn't find any."

"What on earth do you mean, Malkowitz?"

"Well, you know how people are, doctor. God knows, you've treated enough maniacs and perverts in your time! Some are like our smart young friend here and take a special pride in travelling without a valid ticket, thus defrauding the State railway. They hide in toilets and under the seats when they see an important official like myself coming along. Little better than common thieves, that lot. Then you get the love-birds who don't want to be disturbed, so they pull down the blinds and keep the compartment door shut. It quite turns a man's stomach to see some of the *devices* they leave behind."

"What devices?" I asked.

"Horrible, vile things for the most part. Things to heighten pleasure, to prolong the divine moment, things to

prevent conception, to inflict mild pain – contraptions to ease insertion – to abnormally increase length and thicken girth –"

"Oh!" Dr Freud cried. "I would very much like to see them."

Malkowitz's face had turned a peculiar shade of red.

"There's a special room set aside at Central Bureau to house these mislaid or abandoned devices. They're exhibited in glass cases, just as they were found by the night-shift cleaning staff, some still actually stained and smeared with abominable substances. Naturally, women employees are never allowed in that room, and men under the age of twenty-one can only view the exhibits accompanied by a qualified doctor. It affects them, you see, with their impressionable young minds."

"Would it be possible for you to arrange a private viewing for me?" Dr Freud asked Malkowitz.

"For heaven's sake!" I cried. "We have far more important matters to consider!"

The old man glanced at me and nodded. Then he said:

"Indeed we have. Perhaps you will you kindly begin by telling us your *full* name, so that it can be the first thing we look up in the public record office."

"I told you," I muttered uneasily, "I can't remember. I've forgotten. I don't know who I am. Isn't it ghastly?"

"Indeed it is, for all three of us."

Then Malkowitz said:

"Why don't you hypnotize him, doctor?"

"Do you know Malkowitz, I think that is an excellent suggestion!" Dr Freud said, and Malkowitz preened himself absurdly, like a bloated egotistical rooster.

"Do you have any objections, young man?"

"Yes, quite a few," I replied. "However, I assume I have no alternative."

"You assume correctly," Malkowitz snapped.

Dr Freud reached inside his voluminous coat.

"So then, let us begin."

He pulled out a gold pocket-watch on a short gold chain

and held it up in front of my face. He began to swing it slowly from left to right then back again.

"Relax and listen to my voice," he said, that voice suddenly unctuous and low. This was quite obviously his professional tone, adopted for nervous patients or those of a volatile disposition.

"It will not take very long," he continued. "You will soon be feeling sleepy . . ."

"Is it possible to be hypnotized in a dream?" I asked.

"Certainly, provided that the hypnotist is dreaming too. No more questions, now. Hush . . . hush. Simply listen to my voice. Listen . . only . . . to my . . . voice . . . *vooiccsssss* . . ."

The last thing of which I was conscious was Malkowitz looking across at me darkly.

"Don't imagine that I've forgotten," he muttered.

"Forgotten what?" I managed to say, thinking momentarily of seven years in a State penitentiary.

"That you called me fat."

I tried to deny this, but the dark embrace of slumber lifted me in its infinite arms and carried me far away.

* * *

The next thing I remember was hearing voices – tentative, whispered voices – clearly belonging to Dr Freud and Malkowitz but in some peculiar way distorted by an uncharacteristic inflection:

Dr Freud: He would never know. How could he? He's in a trance. You can do anything to a man in a trance.

Malkowitz: Surely there'd be marks, Dr Freud? Or a stain, maybe?

Dr Freud: Not in my experience, which is extensive . . . vicariously, of course.

Malkowitz: I'm a well-built man, doctor.

Dr Freud: So much the better, Malkowitz. I am convinced that the effects of the original trauma which caused his total amnesia can be relieved to a certain degree by a secondary trauma. It would be treating like with like – a sound principle.

Malkowitz: By God, doctor, they all say you're a genius, and they're right!

At that moment, by a massive effort of will, I managed to pull myself up from the deep hypnotic slumber into which I had been put and, like someone emerging blinking into the light from a dank, dark pit, I gradually began to be aware of the surrounding night of stars and snowfall. But what were we doing out of the train? Indeed, where *was* the train?

"Ah!" cried Dr Freud querulously, "so our young friend has awoken!"

I shook my head. I shivered. I was suddenly very cold. Then I realized that I was standing ankle-deep in the crisp, powdery snow, supported by Malkowitz. His maloderous breath was hot and moist on the nape of my neck.

"Don't worry," he said in a disturbingly concerned manner. "You won't fall, I've got hold of you."

"I've no intention of falling," I said. "Get off me."

"That's the trouble with the younger generation," Malkowitz said to Dr Freud. "No sense of gratitude."

He touched my backside with one hand and I distinctly heard him snigger. There was something odd about the feel of it. Then, to my utter horror, I noticed that although both he and the doctor were well wrapped up against the cold of the night, I was wearing only a dark jacket – was it mine? – and below the waist nothing but a pair of tight little briefs.

"I'm naked!" I cried.

"Do not exaggerate," Dr Freud commented. "You are not naked, you are simply semi-exposed from the waist down."

"But why? What's become of my trousers?"

Then I turned to Malkowitz and said more slowly, with a definite note of accusation in my voice:

"What have you done with them?"

I was sure that if anyone had done anything sinister with my trousers, it would be Malkowitz.

"Nothing has become of them my friend," Dr Freud said. "You were never wearing any."

"What?"

"Not as far as I could see."

"I don't believe you!"

"I assure you that it is so."

"You can't call Dr Freud a liar," Malkowitz said threateningly. "And don't be looking at me in that suspicious manner, you young pervert."

"I'm not a pervert –"

"Oh? What else would you call a man who travels on public transport with no trousers?"

"Malkowitz has made a valid point there," said Dr Freud.

"Look," I protested, agonized by the cold, "I'm freezing to death!"

Malkowitz looked me up and down in a curious way, then he said:

"Leather boots and skimpy panties, indeed. You must be a funny sort, in my opinion."

He was right: I *was* wearing leather boots, but they didn't

appear to be mine. Were they? What sort of boots did I usually wear?

Malkowitz added:

"I managed to get you this. It crossed my mind that once you were off the train the cold might get the better of you."

"What is it?"

He flourished something in the air before draping it across my arm. It was a woman's skirt: a long, red crushed velveteen skirt studded randomly with paste rhinestones. It was the sort of thing an artiste in a transvestite cabaret might wear.

"I can't put that on!"

"There's gratitude for you," Malkowitz muttered. "I couldn't find anything else. You're lucky to have this. Go on, put it on before you freeze."

I knew at that moment that I hated Malkowitz. As I struggled into the ridiculous skirt, I heard Dr Freud say:

"He really ought to have a pair of stockings. Bare legs have always struck me as particularly vulgar."

"Or tights?" Malkowitz suggested.

"Ugh! I cannot abide the things! Tights have more often been murder weapons than accessories of decent *couture*."

"Do you mind?" I said.

Dr Freud seemed suddenly to become aware again of my presence.

"The attempt at hypnosis was unsuccessful, I'm afraid. We still don't know who you are."

"Why are we standing here shivering to death?" I asked, becoming rather irritated with the two of them by now. "Well *I'm* shivering to death, anyway. Where's the train?"

Malkowitz looked uneasy.

"I'll be getting a bollocking from Central Bureau for that, I dare say."

"For what?"

"You see, we stopped for about fifteen minutes somewhere down the track a bit. Well, naturally, I had to get off to see what was going on. Dr Freud came with me for a breath of fresh air, and since you were in a hypnotic trance we couldn't very well leave you on your own in the carriage, could we?

Especially with no trousers on. You wouldn't have thanked us for that, I'm sure."

"I'm not thanking you for *this*, either."

"The train simply went on without us I'm afraid," Dr Freud said. "Before Malkowitz had a chance to speak to the driver, that is. Who *was* the driver, Malkowitz?"

"I couldn't really say, doctor. I didn't see the roster before we left V—. I'd assumed it was Ernst, but it might have been Hubert Dankers or Jerzi Fallovitch. Then again it might not. Hubert has been suffering with his haemorrhoids lately and can't take too much sitting down for any length of time, so they've been putting him on the midday run to B—. Mind you, when he gets out of the driver's cab at Central Station, they still have to wash the blood off the seat . . ."

"Look," I interrupted, sick of Malkowitz's rather nauseating drivel and shaking uncontrollably with the cold, "this isn't getting us anywhere. What the hell are we going to do?

I began stamping my feet, like an impatient horse, sending up little cloudbursts of fine, silvery snow.

"We must walk to the nearest town," Dr Freud said confidently.

"Where *is* the nearest town?"

Malkowitz shot me a pitying look.

"The nearest town," he said, "will be the first one we come to, won't it?"

"In which direction? Do either of you actually have any idea where we are?"

"I have many ideas as to where we are *not*," Dr Freud said, "but that doesn't really help us. I suggest we simply follow the track: trains stop at stations and where there is a station there is also a town. Do you think that's reasonable?"

"Anything is more reasonable than standing around here," I hissed, my teeth beginning to rattle now.

So we started to trudge through the snow, the three of us: the psychiatrist, the guard and the man in the crushed velveteen skirt who didn't have a clue who he was. We kept close to the railway line, watching for any sign of life – lights, cottages, barns, anything – anything at all that might indicate even the

periphery of civilization. Then, much to my irritation, Malkowitz had a bright idea.

"We ought to have a sing-song," he announced with an annoying chirpiness. "Just to take our minds off the horrors of our situation, I mean."

"What horrors?"

"Oh well, you know ... sub-zero temperatures, deep snowdrifts, wolves, maniacs with knives. That kind of thing."

"Maniacs with knives? You're the only maniac around here," I said.

"Do you know *The Linden Grows Where I Kissed Ulrica*?"

"No."

"What about *Twelve-Fingered Jenny*?"

"Equally unfamiliar."

"*Equally Unfamiliar*? Never heard of it."

"That isn't a song, you idiot —"

"Then why the hell did you suggest it?"

"Look, I'm too cold and too angry to sing."

"Perhaps," Dr Freud said slowly, "it might help if I told you something about myself? After all, we may have a long walk, and it can certainly do neither you nor I any harm to get to know each other a little better. What do you say?"

"It won't be possible to get to know me better," I answered. "Until I first find out who I am."

"Don't try to impress us with your fancy homosexual logic," Malkowitz grumbled, puffing and panting as he sank halfway up to his knees in snow with every laboured step.

"Well, there's nothing stopping you getting to know *me* better, is there?" Dr Freud said.

"I suppose not."

"There we are, then. It may perhaps help to pass the time and take our minds off the cold."

I shrugged.

"I don't care," I replied. "My ears are already frozen solid, I can't feel my face, my testicles will soon be dropping off and my feet are a distant memory. What does it matter if I have to listen to you? One more misery can't make that much difference."

As the three of us tramped on into the night, he began to talk.

"I was born in Vienna," (Dr Freud said), "in 19——, the fourth of twelve children, six males and six females, five of whom unfortunately died in infancy. My mother herself, her poor body worn out by unceasing labour of both the gynae-cological and the domestic variety, expired giving birth to her twelfth child, named Marcus-Elisha after my paternal grand-father and now an eminent taxidermist residing somewhere in Switzerland, still practising his craft at the age of seventy-one. You may have read – for the story was printed in several specialist European journals – of the recent commission he received from the Sultan of Bashwar, which involved stuffing and mounting on a pedestal of solid gold His Serene Highness' favourite concubine. My brother had devised a par-ticularly effective method (involving certain rare and costly compounds of an experimental and therefore unpredictable nature) for preserving the natural bloom of fresh young skin; learning of this unique invention, the Sultan was most anxious that Marcus-Elisha should apply its advantages to the corpse of the concubine, who had died at the tender age of nineteen as a result, so it was whispered among the eunuchs, of an excess of passion on the part of his Serene Highness. Alas, the task was abandoned when it became obvious that neither my brother nor any of his most trusted assistants could actually manage to stuff the concubine without succumbing to sexual arousal; naturally, the implication of necrophilia was too dis-tressing to permit work to continue. I mention Marcus-Elisha in particular because only he and I, out of all the Freud sib-lings to survive infancy, have 'made something' of ourselves, as popular parlance would have it.

"Among the younger generations of our race there is, and always has been, an inherent urge toward competition and achievement; I cannot explain why this should be so, except to suggest that perhaps it is an instinctive response to our long history of persecution coupled with the fact that we are prob-ably the most gifted people on earth. Scientists, artists, writers, polymaths, poets, merchants and – inevitably, one might say! –

physicians of the human mind, are all to be found in profligate abundance among us. Every one of our children inherits a sense of the vital importance of success, which is nurtured in the bosom of the family and developed within the nexus of a self-protective tribalism. 'If we are born to oppression and persecution,' our fathers tell their sons (less is expected of daughters, naturally), 'we must also be competitors and achievers.' Well, my brother Marcus-Elisha and I have most certainly followed that particular counsel.

"It is true that my sister Hannah was a moderately gifted musician and eventually ended up in the string section of the Stuttgart Philharmonic, but in later years she joined an esoteric kabbalistic sect that encouraged its members to indulge in dangerous ascetic practices: in particular, frequent periods of fasting and severe self-inflicted penances. It was whilst undertaking such a penance – the precise nature of which I do not consider it proper to describe here – that poor Hannah damaged her womb and was thereafter unable to position her instrument correctly without excruciating agony. She once passed out during a performance of Merkenberger's *Parenthesis in F Minor* – through pain, not boredom – and, eventually, was obliged to resign from the Philharmonic. She never played the violoncello again and took her own life two years later. My father did not fully recover from the shock of her death and took to spending more and more time alone in his study, eating nothing but aubergine pancakes and muttering imprecations against a God he no longer believed in.

"The only other member of the family still living is Samuel, our eldest brother, and as far as Marcus-Elisha and I are concerned, he has utterly wasted his life. For some peculiar reason known only to himself Samuel decided to become a painter and my father indulged this fancy by paying for him to attend the Academy of Fine Art in Munich; as far as I can tell Samuel spent most of his time there seducing the female students – or at any rate, the good-looking ones – and getting riotously drunk for days on end. Unsurprisingly, he left without a diploma and, for the next decade or so, managed to support himself by churning out mediocre portraits of insufferably

middle-class individuals whose financial resources more than matched their social ambition, but whose pedigree did not: minor prelates dreaming of the bishopric to which they would never be elevated, sanitary-ware manufacturers, popular romantic novelists aspiring to write literature, all those kind of people. This lamentable state of affairs might well have continued indefinitely had Samuel not been asked to paint a likeness of Princess Amafalda Schweigbrünner-Donati; the portrait was a commission from her husband Prince Hans-Heinrich, who wished to present it to his wife on the occasion of her fortieth birthday. Naturally, since it was to be a surprise, the likeness could not be drawn from life, so the Prince gave my brother a small photograph that had been taken on a family holiday at Schloss Brüggensdorf; on the back of the photograph the Prince wrote: *'seduta su cavallo'* but Samuel, whose grasp of Italian was limited, understood this to mean that His Highness wished his wife to be portrayed seated on a cabbage. The painting – an excellent likeness of Princess Amafalda squatting on her haunches with a small cabbage between her thighs and a somewhat surprised look on her face – was duly completed and, inevitably, rejected as an outrage; however, a certain dealer from Paris of unusually shrewd disposition – Bottard by name – bought the portrait and exhibited it in one of his galleries in Geneva, where it immediately caused a sensation. Samuel was credited with the invention of a new kind of surrealism – a *mélange* of the metaphysical lyricism of Chagall and the pseudo-Orphism of Delaunay – and suddenly he was flooded with commissions from all kinds of people who wished to have themselves painted in *le style nouveau légumesque* as it came to be called, and were willing to pay handsomely. In fact, these commissions have been keeping Samuel in some considerable comfort for the past thirty-three years, for after finishing a life-size portrait of the Duke of Roughlandshire painted entirely in shades of blue and depicting His Grace in the nude, embracing a gigantic ultramarine cucumber, my brother never picked up a paintbrush again. He continues to live in his villa in the Grand Canaries, still attempting to seduce pretty

women at the age of ninety-eight, still drinking himself into a stupor every Saturday night. Contact between us is, I am glad to say, minimal.

"I decided to become a psychiatrist in order to spite my father, but you may already have guessed this. You see, by the time I came to be born, the *other* Sigmund Freud was already a figure of public opprobrium and private esteem: he was hated by the man-in-the-street who was inevitably outraged and horrified by his theories of incest and patricide, but adored by his disciples, many of whom regarded him as the new – one might almost say the *genuine* – Jesus Christ. For whereas Jesus based his preaching on the primacy of the human soul, Freud offered freedom by unmasking the very notion of 'soul' as a dangerous illusion, exposing the real psychological impera-tives and impulses that lurk in the darkness surrounding our frail consciousness. In this sense, Freud was akin to the ancient Gnostic masters, whose fundamental dictum was: *gnothi seau-ton* – 'know thyself'. In place of sin Freud substituted ignor-ance and for salvation, self-knowledge . . . as indeed all sound psychology does.

"My father was firmly on the side of the man-in-the-street and gave me the name Sigmund solely in order to ensure that there would be a second Sigmund Freud in the world who was not as irredeemably corrupt as the original; it was for him a matter of balancing the scales and, to a lesser extent, restor-ing the honour of our race. For me, as I have said, it was purely and simply a matter of spite. My father had wanted me to take up the study of music and, indeed, as you may have ascer-tained from the resumé of my poor sister's tragic life, music was an enduring passion in our family. My father himself had in his youth written a monograph on Johannes Brahms' *Four Songs Opus 17* and was a talented amateur composer, winning several minor prizes for his settings of the poems of Rävenskreuz. *Der Fluß* was sung by Anna-Maria Heisenbaum to great acclaim at the third International Festival of Con-temporary Lieder at Salzburg. I am inclined to believe that my father, despite the stern paternalism with which he fulfilled his obligations as the head of our family, was at heart a

sentimentalist; indeed, the former may have been an attempt to disguise the latter. I am sure that, artistically speaking, he would have described himself as a romantic, but to my mind his music provides ample evidence for my own belief. Sentimentalism you see, is a fatal disease in all art, for it weakens, undermines and trivializes; yet in those days popular taste was incapable of distinguishing between romanticism and sentimentality. This was the great weakness of the late nineteenth-century as you must know, and is precisely why there is so much deplorable art of that period. True romanticism appeals primarily to the imagination and is a reaction to the self-imposed restraints of classicism; as such it aspires to originality and freedom. Sentimentality on the other hand is the conscious stimulation of feeling, the end result of which is invariably an excess that debases originality and turns freedom into dissipation; everything about sentimentality is second-rate, cheap and mawkish. Just as my father's musical compositions were, I'm afraid to say, which is no doubt why they won prizes.

"On the wall in his study, hanging just behind his desk, my father had a small landscape by Caspar David Friedrich; it was painted in 1799, shortly after the artist had left the Copenhagen Academy and moved to Dresden. Now, no one in his right mind would deny either that Friedrich was one of the greatest German romantic painters or that he was a landscape artist of supreme skill; yet that painting on my father's wall represented, to my mind at least, the furthest extreme of romanticism, its weakest boundary so to speak, where it becomes infected and undermined by the emotional excess of sentimentality. It may be that this infection was caused by the fact that Friedrich was still unsure of himself as an artist and had not yet begun to acquire the determination and self-assurance that characterizes his mature works, I do not know. All I know is that I loathed it. It was called *Prayer by Moonlight* and depicted a craggy, snowbound landscape bathed in silvery winter moonlight; there was a half-ruined abbey in the foreground, its crumbling walls twined about with creeping growths, and there in the snow in front of the arched doorway

39

a nun knelt rapt in contemplative prayer, her pale faced turned up toward the moon, her hands spread in a gesture of pious supplication. *Ach!* Five minutes of looking at that picture and I felt sick, as if I had eaten too much *sächertorte*. When I compare it now to some of Friedrich's later works, such as the *Stages of Life* series, I admit that I can see the faint germ of his genius there, but I see no reason to revise my opinion that it is a bad painting, or at the very least, the product of technical inexperience, and I stand by my childhood detestation of it. *Prayer by Moonlight* summed up my father as an artist, and indeed as a man, for I have already told you that I believe his aloof and authoritarian manner as a paterfamilias was an attempt to conceal what he knew to be his true character. I think he was a thoroughgoing sentimentalist, but one who was ashamed to have himself seen as such. Why else should he have hung such a picture in his study, where the rest of us could not enter without his express and infrequently-given permission? And for what reason did he take such delight in it, other than he knew it reflected the nature of his own soul? Concealment and joy – yes! – these two elements make me think my diagnosis is correct.

"At any rate, I rebuffed his plans for me to make a career for myself in the world of music. He was deeply shocked. 'You have been taking piano lessons twice a week for the past six years,' he said. 'At my expense. Are you now telling me that I have been wasting my money? And that Herr Artur has been wasting his time?' I replied: 'Not at all,' outraging him by my casual attitude. 'Explain yourself, sir!' he thundered. 'I am grateful to you for the lessons,' I said, 'since I am now a rather accomplished pianist for my age, and my ability will provide me with a great deal of pleasure for the rest of my life. I shall always love music, but I do not wish to earn my living that way. As for Herr Artur, I am sure that he too is grateful for these lessons, since not only have they helped him to pay his rent, they have also provided him with an opportunity to slip his hand into my underdrawers and thus obtain a sexual satisfaction which, twice a week for the past six years, has clearly mitigated the dreariness of an otherwise most unsatisfactory

existence.' '*What!*' my father cried, almost exploding. 'Oh, don't be too hard on Herr Artur,' I said. 'He hasn't done me any damage, I assure you.' My father said: 'What in the name of God are you saying? Do you even *know* what you're saying, boy?' 'Oh yes,' I answered. 'Herr Artur suffers from arrested sexual development.' My father's eyes nearly popped out of his head. 'I won't have such filthy talk in my house!' 'It isn't filthy, it's scientific. I read it.' 'Where did you read it?' my father demanded. 'In a book about psychology. Martin Feberberg lent it to me.' 'By heaven!' my father cried in a trembling voice, 'I shall make sure that *his* father thrashes him within an inch of his life!' I replied coolly: 'He lent it to me with his father's permission. Martin wants to be a psychiatrist, and so do I.' My father did not speak. At that moment I think he was probably incapable of speech. What he did instead was to strike me across the cheek, very hard, with the back of his hand. Then he staggered against the wall, breathless and stunned. Holding back the tears I said as calmly as I could: 'I am sorry that my decision has angered you father, but it is unalterable.' 'Sigmund, how can you say such a thing? How can anything be unalterable when you are only fourteen years old?' I repeated: 'I want to be a psychiatrist.' 'It's completely disgusting! Pornography masquerading as science, voyeurism of the most hypocritical kind, probing the intimate erotic fantasies of young women and relishing the vile desires of dirty old men. Reducing everything to –' 'To what, father?' 'Reducing the beauty and nobility of the human soul to the dimensions of a dribbling penis!' my father shouted aloud, raising a clenched fist in the air and shaking it furiously. 'Psychiatrists? They're all utterly insane!' He stumbled toward the door. 'Maybe it's *your* fault,' I said in a quiet voice. 'What's that you say?' 'If you call your child a drunkard from the moment of its birth you shouldn't be in the least surprised if that's what he turns out to be. It is elemental Neoplatonism, father: a man comes to resemble that which he continually contemplates, or in my case, is obliged to contemplate. I've been called Sigmund Freud from the moment of my birth; I have seen that name on countless official documents and

certificates and heard it on innumerable lips. Is it therefore any wonder that I want to be a psychiatrist?' 'I refuse to listen to such rubbish!' my father screamed and he left the room, slamming the door behind him.

"It was not long afterwards, alas, that I discovered for myself that in spite of his apparent detestation of Freudian 'pornography', my father was secretly tormented by its seductive glamour and was addicted to the kind of obsessive neurotic practices that would have kept Freud in cigars for months. Indeed, to paraphrase Voltaire, if my father had not existed, Freud would have been obliged to invent him. Hindsight suggests that it was precisely because of his addiction that my father hated the modern psychoanalytical theories so vehemently; after all, what man would not desire to smash the mirror which reflects his own ugliness? At any rate, one afternoon I was passing his bedroom, which was on the second floor of the house, and I noticed that the door was ajar; this was unusual to say the least, for my father always kept that door locked whenever he was out on business, and I had naturally assumed that there were secrets behind it which he wished to protect from the curiosity of his children. After all, every paterfamilias is entitled to a reasonable degree of privacy where his personal affairs are concerned; why, I myself have a small safe with a combination lock to which no one else has access, and in which certain specialized books and letters of a delicate nature are kept. As wives and mothers, women too are entitled to their secrets, theoretically, anyway; practically speaking however they have no secrets, for they cannot resist confiding them to one another.

"As I stood there, silent and astonished, I suddenly heard a low, throaty moaning coming from within the room. Interspersed between the moans were strange little melancholy sobs. I thought I could also make out words of some kind, but what they might be I did not know. My first reaction was to think that my father was ill and in pain, but the longer I listened, the more I became convinced that these peculiar noises were not expressive of suffering but – rather – something quite different. Suddenly there were butterflies in my

stomach. My lower back began to tingle. Gentlemen, I am sure you have already guessed what I did next! Yes, I crept nearer to that open door and gently pushed it open a little wider, so that I could see inside the room. What other child would not have done the same? The temptation was irresistible! I saw my father stretched out on the bed, on his back, and he was in the nude; nude to all intents and purposes that is, for he was wearing nothing more than a pair of corsets designed for the female figure, the laces pulled tight and fastened with elaborate little bows. It must have been one of my deceased mother's garments, most of which were still folded away in the chest-of-drawers in her room, a kind of shrine to her memory. Above the corset his flabby breasts, thick with grey hair, were squashed into a grotesque parody of womanly attributes, and rolling folds of puckered fat oozed over the frilly edges. Down between his legs there was much hair, darker there like a great ragged bush, and standing upright on the bulging pouch of his testicles his penis quivered and shook.

"It was, so it seemed to me, very long and immensely thick and I could not begin to imagine how he had managed to hide such a monster beneath his clothes all these years. How had he kept it a secret? How on earth was he able to conduct his daily business whilst bearing such a gigantic burden? For I could only assume that it must surely be enormous even when unaroused, to achieve such dimensions when fully erect. I was deeply, deeply shocked, gentlemen! Despite Herr Artur's frantic gropings and the tentative masturbatory experiments I occasionally conducted with my friend Martin Feberberg, I was by no means sexually informed, and I was therefore totally unprepared for such a sight. My own erections, and those of Feberberg, were ludicrously unimpressive compared with this gigantic thing. Suddenly, my precocious knowledge of Freud was revealed for what it really was: a bragging child's shallow conceit. There was still so *much* that I had to learn! When my father grasped his penis in one hand and began to rub it briskly, murmuring *'Mama, oh mama, I'm a good little girl!'* as he did so, I lost my nerve. I pulled the door shut as

quietly as I could and fled down the hallway. Later, I discussed the size of my father's manhood with Martin Feberberg and we came to the conclusion that some kind of comparative evidence was needed before we would be in a position to judge whether or not any abnormality was involved. 'You could try and get a glimpse of *your* father's penis,' I suggested. 'In an erect state, of course.' Martin looked at me wide-eyed. He said: 'I think that might be rather difficult, Sigmund.' Too difficult to be at all practical in fact, and the idea was soon forgotten. For my part however, I was more than ever determined to study the infant science of psychiatry – or, to be more precise, psychoanalysis – not now merely to pique my father, but also to gain some understanding of the deep, dark urges that drove him to lie on his bed in a woman's corset and abuse himself.

"Alas, a further fifteen years were to elapse before I was able to begin my studies, partially because my father's opposition was unyielding. Once, in a rare moment of filial supplication, I begged him: 'Father, will you not relent?' And in reply he said: 'There is a novel by Henry James called *Washington Square*. Do you know it? No, too busy reading the sick fantasies of perverted elderly men, I suppose. Well, in that perspicacious novel a father not too dissimilar to myself is asked the selfsame question by his willful and ungrateful child: *Will you not relent?* Do you know what his answer is?' 'I haven't read it,' I murmured. My father went on: 'This strict but just and upright man replies: *Shall a geometrical proposition relent?* And there you have it, Sigmund: my own response to your entreaty. I might add that, at the end of the novel, the father's wisdom and foresight in matters concerning his child is amply vindicated. Goodnight to you, Sigmund.' As soon as I could, I purchased a second-hand copy of *Washington Square* from old Isaac Liebermann the bookseller, and I discovered to my delight but not greatly to my surprise that my father had not only completely misunderstood the relationship between parent and child, but had also failed to discern the sympathies of the author, for whom 'wisdom and foresight' in this particular case were nothing more than an excuse to inflict emotional

and mental suffering. The contention of Thomas Aquinas, *summa ius summa inuria* – that the perfection of justice is the height of injustice – would have been incomprehensible to a man like my father.

"It was my sister's suicide that finally broke his self-contained and unyielding spirit; I also suspect that he blamed himself for not putting an end to her eccentric penances: indeed, it may be that in some twisted way he actually approved of them, for it was certain that he believed pain to be of benefit to the soul. Yet if any of us could be called his favourite child, it was Hannah. Typically, he expressed his affection for her more by what he *didn't* say or do, than what he did: for her he tempered his paternalistic remonstrances, holding back the sarcastic jibe, refraining from raising his hand in anger; such tokens sound unremarkable enough, but for the rest of us they were clear signals of his special regard. I have always believed that Hannah herself was quite blind to them. Hannah's method of suicide fell within the classical tradition: she cut her wrists. She attired herself in her best white nightgown, covered the dressing-table with all her certificates of musical proficiency, set out the photographs taken during rehearsals with the Stuttgart Philharmonic – one of them actually with von Bräuchsnitz conducting – then she lay down on her bed and opened her veins with the jagged edge of a broken wineglass. By the time we found her, the nightdress had been stained almost completely crimson with her spent blood. My father's first anguished words were: 'Look what she has done to me!' Then he shut himself in his study and left it with increasing infrequency, venturing out only when absolutely necessary. He even began to sleep in there, and we eventually noticed a powerful and pervasive smell of urine emanating from the room. Each morning one of us was obliged to empty his chamber-pot. He called every so often for aubergine pancakes, which greatly irritated Inge, our skilled but slightly retarded cook. 'It is an insult!' she would grumble. 'Nothing but aubergine pancakes. This wouldn't be happening if your mother was alive, God rest her soul. Have you heard him, praying in that peculiar voice? Aubergine

45

pancakes have addled his brain, that's what I say. What your father needs is a good helping of *lebewurst* and fried potatoes.' Indeed we *had* heard him pray, and a most peculiar sound it was too – a kind of subdued crooning – not entirely dissimilar to the noise he had made the day he had abused himself wearing corsets. What he was actually saying to the Lord none of us could tell, but I doubt very much that he believed his prayers would be either heard or answered; perhaps they were simply complaints and protests as most of the psalms are, for the Book of Psalms had always been his favourite reading. Once, I remember, he came out into the hallway and shouted in a loud voice: 'God is *not* dead!' and I wondered who had been foolhardy enough to suggest to his face that the case was otherwise. Then, to my astonishment: 'He is not dead because he has never existed!' But behind the closed door of his study, the mumbled prayers went on.

"I began my studies in Vienna two years to the day before Adolf Hitler was appointed Chancellor of Germany and was fortunate enough to have completed them before 'Heil Hitler!' replaced the traditional Austrian *Grüss Gott* –"

At that moment, Malkowitz shouted in a loud, excited voice:

"Look, oh look!"

He was waving a hand toward what appeared to be the yellowish lights of a village, glowing dully on the horizon; I thought at first they must be cottages or a cluster of farm-steads, but the longer I looked the more numerous they seemed to become, and it was soon obvious that we were approaching a sizable town. As we trudged on with renewed energy and enthusiasm, more shapes emerged out of the vel-vety darkness: a church spire . . . then some sort of dome . . . the sloping roof of a municipal building . . . oh yes, it must certainly be a town!

Dr Freud said:

"Perhaps I may be allowed to continue with the story of my life at a more convenient moment –"

"Certainly doctor," Malkowitz replied on behalf of us both, irritating me at once. "It's a fascinating tale, even though

I've heard it many times before. I don't know, every time you tell it, somehow there's always something new."

"We're saved!" I cried, pointing ahead with a frozen forefinger that was, strangely, still capable of trembling.

"Saved, young man?" Dr Freud queried. "I was not under the impression that we were in danger of being damned. Or do you claim the expertise of a theologian, now?"

"You know what I mean," I said. "This means food and warmth and a bed for the night!"

"For Dr Freud and myself, undoubtedly," Malkowitz responded. "But I'm not so sure about you."

"What?"

"Do you really think any hotel with a half-decent reputation is going to accommodate a man wearing a woman's skirt who doesn't know his own name? They'll think you're drunk, or a sex maniac, or possibly both."

I couldn't think of anything to say to this and was therefore grateful when Dr Freud murmured:

"These things can be easily explained, Malkowitz."

"Can they? How?"

"Well, we could tell them that our friend here is a female impersonator –"

"You certainly could *not!*" I protested.

"A bohemian, then. An artist, a free spirit."

"What about the name?"

"We shall give him one."

"What?"

"But of course, nothing could be easier. Now, what would you like to be called?"

"I want my *own* name," I said somewhat petulantly.

"But you don't remember what your own name is."

"No."

"*Ergo*, you must be given one."

"What about Ulrich?" Malkowitz suggested.

I shook my head vigorously.

"Definitely not."

"Fortinbras?"

"Don't be absurd –"

47

"Hans?"

"No, that's far too common."

"Do you mind?" Malkowitz muttered. "Hans was my brother's name. I don't think it's common at all. How about Erich?"

"No."

"Niklaus?"

"No, no . . ."

"Martin, Friedrich, Gustav, Alan, Patric, Johannes, Paul?"

"Hendryk!" I cried, suddenly inspired. There was something about the name that rang a bell, but I couldn't quite think what, exactly. It certainly had a comfortable, familiar feel about it. "Yes, I shall be Hendryk. I'm quite happy with that."

"What's this? Is it a wagon of some kind?" Malkowitz said. "Look! It *is* a wagon! Don't they have motorized vehicles around here?"

"It would appear not," Dr Freud murmured.

It wasn't a wagon, it was an old-fashioned horse-drawn carriage, plunging at a stately pace through the snow towards us. I could see the driver, completely covered in a great cloak and wearing a stovepipe hat, flicking his lash gently across the backs of the coal-black horses. For a brief moment it looked rather magical and romantic, then I remembered what Dr Freud had said about romanticism and sentimentality. Perhaps, frozen stiff, hungry and unable to remember who I was, I was merely taking refuge from the harsh reality of my situation in the slush of sentimentality? After all, the carriage approaching us could be full of robbers or even murderers; or it could pass us by completely, uncaring of our plight; or it could be the authorities come to arrest us for trespassing, spying, or – remembering my skirt – lewd public behaviour. And yet, coming across the snow like that in the still, inky silence of the winter night, the lights of the town winking on the horizon, the moon faint but clear – well – it could almost be one of those paintings by Caspar David Friedrich that Dr Freud spoke of. Indeed, I was rather sorry that it wasn't.

"It's going to stop!" Malkowitz shouted. "They've seen us!"

"Actually," Dr Freud said in a thoughtful voice, "it rather seems to me that they are *expecting* us."

I looked at him uneasily.

"Hi there! You there!"

"He means us!" hissed Malkowitz.

The coach drew nearer and nearer, and we heard the thud-*de*-thud-*de*-thud of the horses' hooves, deadened by the thick snow. Then they began to slow down as the coachman pulled on the reigns. They bared their yellow teeth. Steam drifted off their magnificent flanks. It was a fine coach indeed, adorned with an impressive gold coat-of-arms on each door. The horses shook their great heads, whinnied, released plumes of silver-grey breath into the cold night air. Finally, they were still.

The coachman looked down at us. He was a thin, sunken-cheeked fellow with a ragged moustache.

"I was on my way to the station," he said in a voice that was as melancholy as his features. "I thought that's where you'd be. Didn't you take the train?"

I shot an accusing glance at Malkowitz.

"You'd better ask *him* that," I said.

"Then I saw you walking though the snow, so I thought I ought to pick you up. You don't actually *want* to walk, do you?"

"No, not at all!" cried Dr Freud.

"Well then, you'd best get aboard."

"But where are we going?"

"To the count's place, of course. He's been waiting for hours. Well, are you coming or not?"

We clambered gratefully into the leather-and-polish-fragrant warmth of the coach. Wedged between the frail, wizened Dr Freud and the vast, malodorous Malkowitz, I drew my skirt demurely down over my legs, like a prim and proper librarian or a wary spinster. Then we were off.

★ ★ ★

The "count's place" – whoever the count might turn out to be – was a large, imposing urban villa set back from a wide, tree-lined avenue illuminated by quaint and rather ornate gas-lamps. As we pulled up, half-a-dozen servants, some of them clearly housemaids, came scurrying out of the massive double front doors and down the steps, ready to take our baggage. Needless to say, we didn't have any. Surprised and confused by this, they stood around waving their arms and bowing, smiling and gesturing, uncertain of what their duty should be in the event of having nothing to carry into the house.

"Welcome to Schloss Flüchstein, sirs," a tall, uniformed man with less of a helpless look about him than the others, said respectfully. I assumed that this was the major-domo or butler or some such personage. I also thought it was ridiculously pretentious to call an urban villa – however impressively proportioned – *Schloss* Flüchstein. Or *Schloss* anything, come to that.

"Count Wilhelm will be with you shortly. You are well in time for dinner, which will be served at eight, as usual."

Well, at least now we knew the count's name.

"Dinner? Did you say dinner?" Malkowitz cried excitedly. I could hardly blame him, for by this time I myself was feeling faint with hunger.

"Yes, sir. The late countess is not expected tonight."

"The *late* countess?" Dr Freud repeated. "The countess is deceased?"

"Not at all sir, bless you! She is exactly what I said: late. She is always late for every appointment, important or trivial. That is why she is called the *late* countess. It is, you might say, a private family joke. It simply slipped out, sir. I had forgotten that you are strangers. Well, not *entirely* strangers, of course . . ."

"What do you mean?"

Then the count himself came out: a rotund, florid, bald individual dressed in a dinner suit, wearing a vast assortment of decorations on his lapel, smoking a fat, expensive-looking cigar. His face was flabby: plump folds of skin hung from his jowls and gathered beneath several chins; his eyes, like raisins in a cheesecake, were a dark, nondescript colour, possibly brown of some variety, although it was difficult to tell without coming up close. His lips glistened: the red, ample lips characteristic of the hedonist, the glutton, the secret pervert. I am not saying that the count actually *was* any of these things, simply that he looked as though he might be. He patted his cheeks with an ornately embroidered handkerchief. He seemed to be hot and flushed, despite the cold. Perhaps it was hot inside?

"Ah!" he shouted, stuffing the handkerchief back into his pocket and rubbing his hands together briskly. I noticed several heavy rings glittering on his sausage-like fingers. "So here you are at last! I was getting worried. Are you safe, are you well? Thank heavens you were preserved from the danger of wolves and maniacs with knives!"

Malkowitz glanced at me and smirked complacently.

"We are perfectly well," Dr Freud said, just as if there was nothing amiss. However, it surely could not be denied that there were a number of things very much amiss: I did not know who I was, I could not remember where I was meant to be going, Malkowitz had lost his train, Dr Freud's journey had been unexpectedly interrupted by a series of peculiar circumstances which meant that he could now no longer deliver his important address on dysmorphic disorders – damn it all! – wasn't that enough to be going on with?

Count Wilhelm extended an exquisitely manicured hand.

"Dr Sigmund Freud," said Dr Freud, taking it in his own skeletal, liver-spotted version. "And this is Malkowitz."

"Capital! I do believe I have read your *Interpretation of Dreams*, doctor. Only in translation of course, but the salacious flavour is properly retained I'm glad to say. Not the *other* version by the *other* Freud, of course! Ha ha!"

Then, turning to me, the count beamed and said:

"Then you certainly don't have to tell me who *you* are, my dear young man!"

"I don't?"

"Indeed not!"

"Hendryk," I said with a degree of caution.

"Yes, yes, absolutely. But what am I doing chatting away like this and keeping you in the cold? Please, my most honoured guests, you are welcome to my house!"

The count did not appear to be concerned by the fact that we were carrying no luggage, although I saw him glance curiously at my skirt once or twice. He ushered us through the doors into the entrance hall, followed by the whispering gaggle of servants. The floor was inlaid with black and white marble lozenges and a huge staircase swept down from the upper levels; half-a-dozen doors of polished oak with brass and crystal handles obviously led off to other rooms; including the library, perhaps? Such a place would certainly have a library. Or a smoking-room, dining-room, a drawing-room elegantly furnished with discreetly expensive antiques?

I glanced around as unobtrusively as I could, and much to my surprise, I noticed that the walls of the hexagonal entrance hall were hung not with the mounted heads of stags or wild bears or even foxes, but cows. *Cows?*

"I see you are admiring my trophies," the count observed.

"Well . . . yes. I imagine they do not make for a difficult hunt."

"You're wrong there. As a matter of fact, some of those cows can be pretty ferocious beasts, especially when they know they're being stalked. The mooing is ghastly, like the cry of lost souls. Always sends a cold shiver through me, I can tell you."

"Really?"

"We lost several of our best young men last season to raving, blood-maddened cows. One of them had his head almost half-torn off, then poor Gustav had a sizable chunk of his wedding tackle ripped away, but he survived."

"He survived?"

"Yes. That's why I say *poor* Gustav. What normal man

would want to live like that, eh? Permanently at half-cock, so to speak. Ha, ha!"

The count – clearly not of any lustrous lineage, I had decided by now – shook his head. Then in a brighter voice he said:

"But please! Come into the study. Dimkins has started a fire, I believe."

"Good heavens!" Dr Freud said in an alarmed whisper. "Is he an arsonist?"

"No, not at all. I meant that he's lit the fire in the study for us, so that we can be warm as we talk."

"Ah. I knew a man once, a particularly interesting example of the compulsive-obsessive personality disorder, who could not resist the urge to set tobacconists alight."

"The shops or the proprietors?"

"Both, usually. To him you see, it made sense, it was perfectly logical. When I suggested that according to this way of thinking we should stuff Post Office workers into collection boxes or roast butchers and eat grocers and bakers, he looked at me with a radiantly astonished smile and said: 'Why, *thank* you, doctor!' "

"What happened?"

"The following week he took an axe to an eighteen-year-old female assistant in the fresh meat department of a well-known food emporium and began to gnaw on her severed arm. He managed to consume a couple of ounces of raw human flesh before they got him under control."

"I can assure you," the count said with an uneasy and rather forced laugh, "that no such thing will happen at Schloss Flüchstein. Dimkins will see to that. I beg you, come this way gentlemen."

"Dimkins is surely an English name, excellency," Dr Freud commented as we entered the count's study.

"Yes, it is. But he's actually a Baltic Slav. However, since it is a well-known fact that English butlers are the best in the world, I allowed him to adopt the name. It was all Grabowski's own idea –"

"Grabowski?"

"Dimkins."

"Ah."

"Yes, the fellow kept on and on, wearing me down, really. 'I want to be an *English* butler, sir! Oh sir, please permit it, please!' He practically went on his bended knees to persuade me, he offered all kinds of strange little inducements. Why, once he even tried to – he swore I'd like the feel of it! – well yes, anyway, he'd read the name Dimkins in a book and decided that was what he wanted to be called. And he has been ever since."

The study was even more odd than the hexagonal entrance hall. The walls were ordinary enough, wood-panelled, but entirely devoid of any picture, painting, shelf, display cabinet, whatever. There weren't even any mounted cows' heads. Most of the furniture seemed to have been crammed into one corner, far away from the window, which was covered by thick velvet drapes; in the middle of the room however, surrounding a tiny coffee-table, were four cane chairs that would have looked less incongruous in the garden, in my opinion. It looked like a room in a house whose inhabitant was preparing to move away. Perhaps this was indeed the case. A feeble, half-hearted fire, giving out no warmth whatsoever, flickered in the hearth. I shivered involuntarily.

"What a lovely skirt you're wearing," the count murmured. "So elegant, so well-chosen."

"It was *me* who chose it," Malkowitz said with absurd pride in his voice. I wanted to smack his fat face.

Count Wilhelm raised one eyebrow and regarded me quizzically.

"Naturally," I put in quickly, "Malkowitz does not usually choose my clothes. It's just that, well, on this occasion –"

"Say no more, my dear Hendryk! Believe me, I know what the artistic temperament is all about! Genius and eccentricity always go together. Why shouldn't you wear women's clothes if that is your desire? What does the mundane world with its hypocritical notions of convention understand of the wild, the untamable, the creatively independent soul? I applaud you, young Hendryk, I salute you!"

Then, to my utter astonishment, he turned to Dr Freud

and, smiling broadly, I distinctly heard him say through clenched teeth:

"The dirty little pervert thinks the rest of us are morons. He wears a skirt and we're shit. I know his type."

Dr Freud nodded sagely and blinked his snake-like old eyes. Then the count turned back to me, laid an avuncular hand on my shoulder and said:

"My daughter is exactly the same as yourself."

"In what way?" I asked.

He leaned forward and whispered gently, almost tenderly, in my ear:

"She also likes wearing skirts."

"Short skirts?" asked Malkowitz, who had apparently overheard this confidence.

The count looked across at him and shrugged.

"You know how young girls are."

"Is she a virgin?" Dr Freud asked.

Count Wilhelm reddened and puffed out his cheeks, making himself look rather like an irate toad.

"My dear doctor!" he spluttered. "Adelma is thirteen years old!"

"Yes, yes, a thousand apologies excellency, but as a psychiatrist –"

"Of course she isn't a virgin! What, do you imagine she's coarse-featured or short-limbed? Deformed in some way perhaps, so that men turn from her in disgust?"

"I assure you, excellency –"

"She's a lithe, lovely, seductive little creature, as you will see for yourself tonight."

Count Wilhelm's anger dissipated as swiftly as it had erupted. He turned to me and smiled.

"Never mind Adelma," he said in a soothing, conciliatory tone of voice. "We've no time now to discuss my daughter's sexual history, fascinating though it is. What about your talk tomorrow tonight, Hendryk?"

"My talk?"

"Of course! I assume my driver told you about the arrangements? Oh, yes, I understand that there will be

secondary matters to attend to: sightseeing, for example, Sunday worship and so on. Not forgetting the bouts of love-making, naturally!"

He winked conspiratorially and leaned forward to poke me in the thigh with a fat but remarkably powerful forefinger. Then he went on:

"But there'll be plenty of time for all that, you have my word. No, I'm referring to tomorrow evening. Playing cool, is that it? Well, I don't blame you, Hendryk! You don't want to give too much away, I understand that. We're all absolutely thrilled about it, I can tell you."

"About my talk?"

"Yes."

Count Wilhelm burst into gruff barks of slightly manic laughter. He waved a hand towards Dr Freud and Malkowitz.

"Quite the dark horse, our Hendryk, eh?"

"Perhaps more so than you think," Dr Freud said.

"Of course, it's been advertised throughout the city for weeks and I dare say it will be standing-room only when you walk onto the platform. I'm having the ballroom converted into a temporary auditorium, you see."

I was by now beginning to feel exceedingly uncomfortable. Not only could I not remember my own name – for I had no reason to believe that it might actually be Hendryk – it also appeared that I was scheduled to give a talk to a huge audience, the subject of which was completely unknown to me. I would have to find a way of discovering it without arousing the count's suspicion.

"Do you have any experience of it yourself, excellency?" I asked, unable to control a slight quivering in my voice. I saw Dr Freud glance at me then at Malkowitz.

"No, not at all," Count Wilhelm replied. "It's never interested me, I'm afraid. You see, this is all for Adelma."

"Adelma?"

"Precisely. It's something she's wanted to learn for years but hasn't ever had the opportunity . . ."

I realized, with considerable relief, that it was obviously nothing to do with sex.

". . . and that's a great shame gentlemen, I freely admit it. Adelma has always been what you might call a *restless* girl, constantly yearning and pining for something she can't quite identify, never at ease, always seeking, searching, never satisfied. That's why she's so promiscuous, I suppose. Would that be classified as a mental illness, Dr Freud?"

Now it was Dr Freud's turn to feel discomfort. He shifted a little in his great baroque chair like a slow, sly, reptilian thing, blinking his rheumy eyes behind the glittering pince-nez. He opened his mouth to speak, but to the surprise of us both, Malkowitz, whom I had suspected of having dozed off, spoke first.

"I wouldn't call it an illness count," he said. "More like a *gift* in my opinion, if I may be so bold as to express such an opinion."

"Indeed you may, my dear fellow!" cried Count Wilhelm in delight. "And in what way exactly, would you consider Adelma's restless questing after God knows what, to be a gift?"

Malkowitz cleared his throat.

"Well," he said, "if you're satisfied with what you've got . . ."

"Yes?"

". . . then there's no reason to want anything you *haven't* got, is there?"

"And?"

"And if you don't want anything you haven't got, you might as well have nothing at all, right?"

Dr Freud croaked. Or choked. I couldn't be sure which.

"Who wants nothing?" Malkowitz went on with a triumphalistic flourish of one hand in the air and in the manner of an exceptionally gifted logician who has just concluded a complicated and esoteric syllogism. "Nobody! Nobody wants nothing because everybody wants *something*! That's little Adelma's gift, you see: she *knows* she wants something . . . she just doesn't know what it is."

Count Wilhelm's mouth had fallen open and there was a little dribble of saliva glistening on the first of his several chins.

He slapped one meaty hand on an even meatier thigh.

"By God, Malkowitz, I think you have it!" he cried.

I was surprised, to say the least, that the count had taken Malkowitz's homespun drivel as profundity.

"Yes, indeed, you've identified the problem with the utmost clarity! Tell me, are you a philosopher?"

Malkowitz shrugged modestly, his face reddening.

"Well, I've been called that in my time," he murmured. "I haven't had any formal training, of course."

"You simply must meet our Professor Bangs, old fellow – indeed, you almost certainly will do during the course of your stay here."

"Malkowitz," Dr Freud chipped in, "has been granted special emergency powers by the Department of Internal Security."

"Ah," Count Wilhelm said with a sigh, "that probably explains it." Then, turning to me, he continued: "This is why tomorrow night will be so important to Adelma. In an undoubtedly clumsy but affectionately paternal attempt to relieve her existential restlessness, I suggested that *this* might well be the thing she's been looking for, the perfect answer to the problem of her endless searching. *This*, I explained to her, might be the one experience to bring her complete and total satisfaction."

"What, exactly?" Malkowitz asked, making me exceedingly glad that I had not been obliged to do so.

"Why," said the count, sounding slightly befuddled, "yodelling, of course."

Yodelling?

"Long before yodelling it was tapestry, then the pogo-stick. She got quite good at that I must say, until she accidentally pogoed onto Suzette and went right through the poor little thing's stomach –"

"Suzette?"

"Her kitten. And, well, a couple of months ago nothing in the world mattered as much to her as calligraphy. That's why I suggested the yodelling because once I heard that you were coming, it seemed the obvious choice. I hope you don't

mind? You don't think my arranging the talk is an imposition?"

"No, of course not, but I hadn't really –"

"When she hears your talk tomorrow she'll want to begin lessons at once, I know that, Hendryk. Would you be prepared to accommodate her?"

Then with a sly wink he added:

"In the yodelling sense, I mean."

"Well –"

"I realize that as one of the world's leading authorities on yodelling you are inevitably a man whose time is precious, but you would be handsomely recompensed, I can assure you of that."

At that moment Malkowitz, doubtlessly aggrieved at the swiftly fading patina of his moment of glory, said rather belligerently:

"I didn't know *he* was one of the world's leading authorities on yodelling."

Dr Freud remarked hurriedly:

"Even someone granted special emergency powers by the Department of Internal Security cannot know everything, Malkowitz. Besides, Hendryk is a modest fellow. He never talks about his prestige as one of the world's leading authorities on yodelling."

"You'll be giving a practical demonstration, I hope?" the count added.

My stomach turned over several times and sank, with a kind of attenuated rumble of despair, into the slushy depths of my churning lower bowels.

"Gentlemen, allow me to apologize,' Count Wilhelm said, getting to his feet with the breathy effort imposed by obesity. "I am quite sure you must be hungry. Well, there is just time enough to attend to your toilet before dinner is served at eight o'clock. Dimkins will show you to your rooms."

Then he rubbed his hands together briskly and cried:

"Oh, Adelma will be *so* happy! At least for a while, anyway."

Then he bustled out of the room.

Upstairs in the chilly stone-flagged corridor, hung with more mounted cows' heads, I berated Dr Freud for his flagrant deceit.

"How dare you tell him that?" I hissed, keeping my voice low for fear of being overheard by a servant. "You *know* that I'm not one of the world's leading authorities on yodelling! The idea is grotesque."

"How do I know? Even you yourself don't know. You can't remember who you are. Perhaps it's true."

"That I'm an authority on yodelling? Don't be absurd!"

"But what else could I say? If I had denied it, we would undoubtedly have been thrown out to fend for ourselves in the freezing night."

"And possibly thrashed within an inch of our lives too," Malkowitz added.

"Is that what you want? For us to be beaten to a pulp and dumped in the snow?"

"Well, put like that –"

"I think you're being selfish," Malkowitz said.

"What?"

"We've done everything for you, everything! We've given you a name, a job, status, the lot. It's about time you considered Dr Freud and me, you self-centred bastard. We don't want to freeze to death out there."

"Neither do I, I assure you!"

"So all you have to do is pretend to be a world authority on yodelling for a few hours, that's all. Is it too much to ask?"

"Frankly, yes. Besides, that *isn't* all: I have to give an address on the subject, in case you've forgotten *and* provide a practical demonstration."

"You'd better start polishing your skills then, hadn't you?" Malkowitz said with malice in his piggy eyes.

"Too late for that," Dr Freud observed with a trace of regret in his voice. "I do believe I heard the dinner-gong."

He glanced at his wristwatch.

"No, I am not mistaken. It is precisely eight o'clock, gentlemen."

Suddenly, I wanted to cry.

The dining-room was vast, almost a baronial hall, but at least there were no cows' heads. It was also – like the rest of the villa apparently – extremely chilly. I was obviously not the only one to notice this, for at one end of the table a tiny old woman sat swathed in an overcoat, that was far too big for her, gloves and fur ear-muffs. The count gestured vaguely in her direction.

"Princess Elizabeth van Hüssdorfer," he said indifferently.

The old woman did not look up. A few places away was a tall, florid man of middle age dressed in an elegant dinner suit and white bow-tie.

"Arthur Lax," murmured the count.

"Arthur Lax the violinist?" Dr Freud inquired with interest.

"No, Arthur Lax the gynaecologist. He fiddles with quite a different sort of instrument, eh, doctor?"

I thought this remark was rather tasteless, but said nothing. I took a seat between Dr Freud and Malkowitz. The count sat at the head of the table, naturally, and beside him was a lugubrious-looking fellow with a straggling moustache, who introduced himself as Martin Martinson, but did not indicate the nature of his work. Perhaps he had none. Although the great table was laid for at least twenty people, there were no other guests.

"Professor Bangs," the Count said, "is unable to join us as usual. You know how absorbed he is in his magnum opus. Will it ever be finished, I wonder? You're a philosopher Malkowitz, you must understand how it is."

Malkowitz nodded with spurious sympathy.

"Ah!" cried Count Wilhelm, "the first course! What shall it be? A hearty soup, perhaps . . . or grilled sardines with a little lemon and black pepper? Or savoury vegetable parcels: how Mrs Kudl loves to make her vegetable parcels! Or maybe oak-cured ham, sliced wafer-thin with fresh melon and figs?"

My stomach began to rumble. Certainly, this was sure to be a fine feast, for there were three sets of knives and forks – including fish knives – and two dessert spoons. There were

also sparkling crystal wineglasses and tiny, delicate little schooners for liqueurs. However, when the servant entered the hall he was carrying absolutely nothing: no silver salver, no tureen, no tray of plates. He sidled discreetly up to the count and whispered in his ear. I saw the count's face drop.

Malkowitz nudged me in the ribs.

"I'm starving," he hissed. "Are you?"

"Absolutely," I whispered back.

The count raised one hand to attract our attention.

"It seems there has been a small explosion in the kitchen," he announced. "Fortunately only a scullery maid was seriously injured, but until the meat arrives, I'm afraid we shall just have to fill up on bread."

Malkowitz turned to Count Wilhelm, and to my great embarrassment he said:

"That's a pity. Hendryk here has just told me that he's absolutely starving."

"Is this true?" the count asked me.

"Well yes, but –"

"I'll have you know that my bread is exceedingly *good* bread, young man! We have the finest bread in the city, as a matter of fact. There are sourdough twists, courgette brioche, poppyseed rolls, wheat batch, rye batch, *pecorino* and rosemary plaits. Isn't that enough for you?"

"I'm sorry," I began. "I really didn't mean –"

"Then eat, my boy! Tuck in with abandon!"

We fell upon the bread like ravenous animals, tearing off chunks with our fingers and stuffing them into our mouths without consideration either for etiquette or each other. Malkowitz piled at least six or seven poppyseed rolls onto his plate before reaching for the sourdough twists. Only Princess Elizabeth van Hüssdorfer seemed oblivious to our swinish behaviour. She sat wrapped up like an ancient infanta, picking fastidiously at a tiny piece of brioche.

We also consumed a great deal of wine, mainly a gloriously deep *Saint Emilion 59*, and it was not too long, the bread heavy as a brick in my stomach, before I realized that I needed to use the lavatory.

"The meat, the meat!" Count Wilhelm cried as the same servant entered and once again whispered something in his ear.

"What?" I heard him hiss. Then more whispering.

"It would seem," he said, "that the lamb absolutely refuses to sit comfortably in the baking tray –"

"Good heavens!" Dr Freud interrupted. "Is it still alive?"

The count looked at him in bemusement.

"Of course not," he said. "It was purely a figure of speech. The tray is too small for the joint."

"Ah."

"But we still have those excellent *rosette* and capsicum flat-breads, the tortilla wraps and the salt-crusted *focaccia* –"

As it transpired, the entire meal was to consist of nothing but bread. I ate now not with the fervour of a starving beggar but the slow, plodding distraction of a glutted gourmand who simply shovels food into his mouth because it is still there on his plate. Furthermore, my bladder was on the point of bursting and I stood up, muttering half-hearted apologies. Much to my relief the count seemed to understand my need.

He coughed discreetly and said:

"Third door on the left, young Hendryk."

Perhaps it was because I was a little drunk, but I had great difficulty finding the third door on the left. The long, narrow corridor outside the dining-room was dark, and I groped my way along it by placing my hands on the walls. At one point I brushed against something and I heard it fall on the flagstones with a shrill tinkling – glass. Probably a picture . . . I could only hope it wasn't too valuable. The first door I tried opened onto a room that seemed even darker than the corridor. Nothing. I moved on and cautiously turned the cold metallic handle of another. I blinked several times in the rich, mellow light that only oil-lamps can provide. On a small bed hung with damask and silk, a young woman of quite astonishing beauty was reading a book. She was wearing nothing but a pair of tight pink briefs. The book rested on her magnificently taut breasts, indenting the creamy flesh.

She placed the book on her stomach and stared at me. Her eyes were dark: dark like a starless night, deep with unspoken promises and implications of intimacy. Her mouth was soft and red and pouted in an unutterably delicious manner. I felt a *frisson* of desire caress my spine.

"Do you mind?" she said. "I'm trying to read."

"What are you reading?" I managed to say in a hoarse whisper.

"*An Annotated History of the Cyrillic Alphabet* if you must know. Now will you please close the door?"

I did close it, but my heart was throbbing with an even greater violence than my bladder. Who was she, this flawless angel with the eyes of a practised seductress? Who could she be? Sooner or later, I determined that I would find out. Meanwhile, I succeeded in locating the third door on the left and pushed it open.

I was taken aback to discover that the count's toilet was exactly like a public lavatory: a cavernous place with a tiled floor and walls, a long urinal divided into sections, four wash-basins and mirrors, a row of cubicles with doors that would reveal the shoes and lowered trousers of the person sitting within. It was all very strange. However, I was even more surprised to see Martin Martinson standing at the urinal. How on earth had he got here before me? Perhaps there was a short cut. He was obviously having some sort of problem: he groaned and shook himself, groaned again and raised himself on the balls of his feet

"It's getting more and more difficult," he remarked, as I stepped up to the section beside him and unbuttoned my fly.

"What is?"

"What do you think?" he snapped, "driving a tram? I mean *peeing* of course!"

"Ah. I'm sorry."

"Don't be, it isn't your fault – oh yes, here it comes – oh! No, no, just a dribble – ah, it's like pissing hot glass! That damned bitch must have picked up something from one of the hundreds of men she's accommodated for cash. Now she's passed it on to me . . ."

I could not help reflecting that men who go with prostitutes have no one to blame but themselves if they catch some vile disease.

"Ships that pass in the night I suppose," I said with a somewhat moralizing inflection in my voice.

"What are you talking about?" Martinson said, screwing up his face in agony.

"I take it you don't even know her name . . ."

"Of course I know her damned name, you idiot! Is there any reason why I shouldn't know my own wife's name?"

"Your wife?" I echoed, swiftly buttoning myself up and heading as quickly as I could for the door.

"Yes, my wife!" Martinson screamed, doubling up in agony.

When I took my seat again at the table, I saw that all the bread baskets were empty. Malkowitz was sprawled out in his chair, a dribble of saliva on his chin, his uniform as an official of the State railway and holder of special emergency powers invested by the Department of Internal Security, heavily splattered with a variety of crumbs. Dr Freud appeared to have dozed off, and there was no sign of Princess Elizabeth van Hüssdorfer.

"Ah, Hendryk my boy!" the count cried effusively. "Too late for dessert, I'm afraid. We've scoffed the lot."

Momentarily galled that something other than bread might have been served in my brief absence, I blurted out:

"Dessert? Why, what was it?"

"The most delicious multi-grain, soft-crust organic cob . . ."

"Such a pity," I managed to mutter. "Perhaps next time."

"Of course, of course! I'll have a batch baked especially for you. And now, if someone will wake Dr Freud, I think it is high time for us to make our way, satiated and somnolent with rich fare are as we are, to our several beds. A place will be saved for the countess. Perhaps Mrs Kudl will have managed to cook the lamb before her return."

What remained of the company – that is to say, Count Wilhelm, Malkowitz, Arthur Lax and myself – rose, leaving Dr Freud to doze on, and left the dining-room. I reflected

with some amusement that Arthur's bowels would be any-thing but *lax* in the morning, after consuming such a quantity of tortilla wraps and *pecorino* plaits.

I entered my room, a gloomy, sparsely-furnished, cell-like chamber, with a heavy heart. I took off my skirt and climbed into the chill bed without any great hope that the following day would bring an improvement in my fortunes.

* * *

−4−

As soon as I awoke, I glanced at my wristwatch: half-past eight. My head was aching from too much wine and my mouth felt dry and dusty. For a moment I could not remember where I was: you know how it is when you wake up in a strange bed. I was obliged to struggle for a few minutes with that dreadful sense of disorientation which seems to suggest that wherever one is, one has no right to be there.

There was a tap on the door and Dimkins entered. He was a thin, depressed-looking individual in his early sixties with sparse, slicked-down hair and large ears.

"Good morning, Herr Hendryk," he murmured. "I trust you slept well, sir?"

"Actually −"

"Breakfast is set out in the morning room, although the rest of the household has already eaten. In fact, they have eaten everything: the muesli, the fruit, the quail's eggs, Parma ham, kedgeree, grilled *blutwurst*, an assortment of matured cheeses −"

"Is there *anything* left?"

"Plenty of crusty breakfast rolls, sir."

He extracted a small brush from his jacket pocket and began to remove fluff and crumbs from my skirt, which was hanging over the back of a chair.

"I've been meaning to mention, sir," he said, "the count wondered whether you might care for a change of clothes. Something a little more appropriate for your talk tonight."

"Ah yes, my talk. Actually Dimkins . . ."

"You see sir, many of the older people here are what you might call *conservative*, set in their ways, so to speak. Your sexual preferences are no concern of mine, of course. Indeed, I have a great deal of sympathy for the invert: shame, secrecy, furtive fumblings in the dead of night, a brief release between the thighs of a total stranger . . ."

"I am *not* an invert, Dimkins!" I cried.

"No sir, of course you aren't. At any rate, Count Wilhelm

thought that perhaps a charcoal pinstripe with a nice patterned tie, if he can find one for you. How would that do?"

"Perfectly," I answered in a sullen tone of voice.

"I shall have them set out for you before this evening, sir."

As he put the little clothes brush back into his jacket pocket and began to move around the room, I sensed that he was waiting for me to get out of bed. Since I was naked I had no intention of doing so in his presence. Instead, I asked:

"How long have you been with the count, Dimkins?"

"Twelve years, sir. I don't live in, of course. That would lower the tone, as the count himself put it. I have a little house on the edge of town. I mean my wife and I have a little – yes, my wife and I –"

To my utter astonishment, he suddenly threw himself toward the end of the bed and sank to his knees. Then he began to weep.

"What on earth's the matter?" I asked.

"Oh sir," he blubbed, "you must forgive my display of weak and womanish emotion! Can you possibly help me? I'm desperate sir, really desperate. I thought, begging your pardon for the liberty, I thought that someone famous and worldly-wise such as yourself, well, that you would be able to tell me what I should do."

"What on earth do you mean, Dimkins? Are you in some kind of trouble?"

He lifted his melancholy, tear-stained face to mine and smiled weakly.

"Not me exactly, sir. My wife."

He pulled himself up a little and rested his torso on the end of the bed, his hands reaching out in a gesture approaching pious supplication.

"You must never tell His Excellency that I've made a fool of myself like this!" he said. "I would be dismissed at once."

"I won't breathe a word, I promise."

"I knew I could trust you, sir. As soon a set eyes on you – despite the skirt – I realized at once that you were a decent man."

"Thank you."

"Oh, I've seen all sorts here, sir! Yes, believe me. But you, you'll listen to me, won't you? You'll tell me what to do."

"I can't guarantee anything," I said. "But I can certainly listen, yes. What seems to be the problem with your wife?"

Dimkins lowered his head.

"She isn't eating, you see. Well, just a crumb or two of toast in the morning and a tumbler of water during the day. Then in the evening, maybe a slice of cold meat, but that's all. Now, sir – oh, you should see the state of her! – now –"

He began to cry again.

"– all skin and bone, her eyes practically popping out of her head, so weak with it too, it just breaks my heart to look at her."

"But why won't she eat?"

He looked up at me in desperation.

"Because I won't let her," he said.

"What?"

"You have to understand sir, Mathilde, that's my dear wife, was always a big woman. All her life. Even when I met her she was what you might call *robust*. By the time we were married she was like a carthorse. Oh, believe me, I had no objections! No sir, quite the opposite in fact. I actually liked her big. I adored her huge, balloon-like breasts, I worshipped her massive thighs, her luscious expanse of arse, if you'll pardon my manner of speaking, sir, and I wouldn't have wanted her any other way. She was always fond of her food, of course, constantly scoffing sweet pastries and delicate little pies, sometimes half-a-dozen at a time, you understand, so she just kept getting bigger and bigger. She was especially fond of those plum-and-almond flans that Schülster's on the Boulevard do so well. They serve them with whipped cream and plum confit, but Mathilde used to buy a box of them to take home and eat in the evenings in front of the fire. We were so happy, sir! You'd be hard pressed to find a happier couple than me and Mathilde, I'd say."

"What happened to change that?"

"Well, one day – a week before her birthday that is, as I have

good cause to remember, sir – I decided to treat her. I told her that we'd take a little trip into the centre of town, to a new dress shop that had only just opened, all the latest fashions, and I'd pay for any gown that took her fancy, whatever the price. Of course, poor Mathilde was over the moon! She hugged and kissed me and jumped up and down and – well, you know the way of things, sir – she started to over-excite herself, if you see what I mean. Couldn't control it. She wanted me to do the manly deed there and then, on the kitchen linoleum."

"Did you?"

"Oh yes, repeatedly. Then we took ourselves off into the bedroom and started it all over again. It was past three o'clock by the time we left the house for the dress shop. I don't mind telling you sir, we were both high as kites, happy as larks, like young sweethearts in love for the first time!"

"And?"

"Well, it all began when she found a frock she really liked, but they didn't have it in her size. In fact, they didn't have *anything* in her size. We were there almost until closing time, going through rack after rack of stuff, Mathilde trying to squeeze into one dress after another, but all to no good. In the end the snooty assistant – you must know what that sort are like sir, preferring women's clothes as you do."

"Look, Dimkins –"

"Well she practically threw us out of the shop. I was disappointed for Mathilde's sake, but I kept my mouth shut because I didn't want to upset her more than she already was. Then, just as we were almost home, she turned to me and said: 'Would you say that I was fat, Boris?' This took me back a bit, sir. I mean, it was obvious to anyone that she *was* fat, but I'd never looked at things in that light. I *loved* her, you see. God knows, I still do! When you love someone, it doesn't really matter whether they're fat, thin, short or tall, does it? She'd always been a goddess to me, perfect in every way. So I made up my mind not to answer, because I knew that if I did, I'd have to tell the truth and say yes, she was fat, and to me this would be like betraying our love. Do you understand what I'm saying, sir?"

"I think so."

"I suppose I could have told her she wasn't fat to *me*, but that wouldn't have made sense to her. How can you be fat to one person and not to another? And if I'd said that she *was* fat but it just didn't matter, I'd have been judging her by everyone else's standards. And nobody loved her like I did, sir. Well, it went on for days. Endless, nagging, persistent, always the same: 'Am I fat? Would you say I was fat? When does wellbuilt end and fat begin? Why didn't any of those dresses fit me? Was it because I'm fat? Am I fat?' Even in bed, sir. She forgot all about her clever, lewd little tricks and just kept asking the same question over and over. She didn't want to please me as a man anymore, she only wanted me to give her an answer, but like I said, I'd already made up my mind that I wouldn't betray our love by doing that. Oh, I never *stopped* loving her, sir! Not for a single moment, not even when I was obliged to strike her in an effort to make her stop, which she didn't, of course. It was driving me crazy. I couldn't think properly, I couldn't sleep, I couldn't even eat . . . and then, when I realized I wasn't eating properly and had started to lose weight . . . that's when the idea came to me."

"What idea?" I asked, fascinated and appalled by his story.

"Of not allowing *her* to eat. You see, I thought that if I managed to keep her away from food for a while, she'd lose weight just like I was losing weight with her never-ending questions, then I'd truthfully be able to turn to her and say: 'No Mathilde, you are *not* fat!' So one afternoon – I'd asked the count for permission to leave early that day – I went back home and tied her up with good, strong rope. I found her sitting at the kitchen table eating a plate of honey-and-ginger vermicelli with vanilla shortbread. I'll never forget her face as she looked up at me – there were crumbs of shortbread on her chin – and her eyes were wide with surprise to see me back early and her lips just started to form themselves into the shape of that vile, tormenting question: '*Am I fat?*' But before she had time to ask it for the millionth time, I smashed her in the face with my fist and she fell to the floor unconscious – so quickly, so easily, sir! – and suddenly there was blood, not

crumbs, on her chin, dribbling down from between her broken teeth. Oh God, I swear I thought I'd killed her! My poor, lovely Mathilde!"

He wept into the eiderdown, his head pushed between my feet. I managed to reach forward and pat one shoulder.

"Don't upset yourself Dimkins," I said with a sense of hopelessness. "I'm sure things will sort themselves out in the end."

"But how can they, sir?" he cried, lifting his imploring face to me. "I mean, how can things sort themselves out, as you so casually put it, when I won't let the suffering, wretched creature eat?"

"But you must, Dimkins! At once!"

Suddenly I began to feel rather queasy. There was a sinking feeling in the lower part of my stomach, a vague but growing apprehension.

"How long," I asked, "has Mathilde —"

"Been tied up, sir? Nearly a year now, I should think."

"Oh, my God . . ."

"I keep her down in the cellar, mostly. Oh, I've done my best to make it cosy for her, honestly I have! She's got a nice little electric fire, the glass lamp with the pink bead fringe that her mother bought her, a fresh jug of water every day, a vase of dried flowers I bought specially, and the mattress has only recently been re-sprung, so it's all what you might call home from home for her. On Tuesday and Saturday evenings I untie her legs so that I can satisfy my natural urges, but I can't take the gag out of her mouth in case she . . . well you never know, do you, sir? I only take the gag out in the morning to poke her regular bit of bread in, and the slice of cold meat of a night. The poor thing is so weak she can hardly chew, so usually I have to chew it myself first and kind of push it down with a finger. Oh, sir, you should see the way those huge dark eyes stare at me, pitiful and pleading, too dry and tight even for tears! Like I said, it breaks my heart, rips it in two, but what else can I do? It's true she isn't fat anymore – more like a stick insect, if the truth be told, a nightmare of skin and bone – but if I untie her and let her go she'll start to eat again, then she'll get fat and won't be able to find anything to fit her and those

hideous questions will start all over. It would drive me to suicide sir, suicide! I love my Mathilde so much I can't bear to see her suffering like this . . . but I can't let it all happen again sir, can I? What am I to do? Can you advise me? Please say you'll help! Oh *please* –"

He slithered to the floor sobbing, then lay still.

I was too shocked for a moment or two even to move. Finally, I managed to say in as firm a manner as I could:

"Dimkins, you must go home *at once* and untie your wife. You must give her some food – preferably liquid and hot for the present – then you must call the doctor. Do you hear what I'm saying, man?"

I could not actually see Dimkins, who was still on the floor beyond the end of the bed, but I detected a subtle and indeed somewhat sinister inflection in his voice when he at last answered me.

"Oh, I couldn't possibly do that, sir."

"But Mathilde will die, if you don't!"

"Actually, no. I looked it up in a book. I know exactly how little the body can survive on, and that's what I give her, regular as clockwork, every day. She won't die."

"Dimkins," I said, "I do believe you're insane."

The voice came again, slightly more sinister now. And sly, too.

"Thank you sir, for your kind advice. I knew I could rely on you. But you just don't understand about Mathilde and me. How could you, being the sort that you are?"

"What?"

"You've said what you think is for the best, sir, I can see that and I appreciate it. Besides, it's done me good to get it off my chest."

I heard the sound of a nose being vigorously blown.

"You must release your wife and see that she gets proper medical attention," I said.

Dimkins' voice was hard now:

"No, that will never happen, not now." Then, almost unc-tuously: "But thank you for listening, sir. I feel ever so much better."

73

"Dimkins, this is grotesque. Are you going to get up so that I can at least see you?"

To my surprise, the voice said:

"Actually sir, if it's all the same to you, I think I'll just lie here for a bit and have a nap. I've worn myself out."

Naked as I was, I got quickly out of bed, stepped over the motionless Dimkins and reached for my skirt.

I was becoming quite accustomed to that skirt: somehow the freedom of movement it made possible gave me a sense of lightness, and after knowing only the constricting grip of underpants, it was very pleasant to feel my testicles slapping against my thighs as I walked. Later, I thought I might find a suitable top to go with it: perhaps something in crushed silver velvet with beading at the neck. I discovered precisely how much I was becoming accustomed to it when I caught myself staring at a tray of nail varnishes in a shop window and wondering which shade would compliment it best. Truth to tell, the count's loan of a suit and tie would come not a moment too soon.

Dimkins' ghastly story had unsettled me, and in an attempt to rid my mind of the image of an emaciated, tormented Mathilde tied up in the cellar, I decided to take a stroll in the town. There was no snow here, I saw. After walking through the narrow, cobbled streets for about ten minutes I came into a spacious, sunlit piazza lined with cafés and restaurants, and thought that I would get myself a coffee and something to eat. Having evacuated all the previous night's bread in the normal manner, I was beginning to feel distinctly hungry again. I walked across the piazza and entered the *Café Exquise*, which was small but had a rather pretty yellow awning.

"You can't come in here," said the sour-faced woman behind the bar in a belligerent manner.

"Why not?"

"Because, if it's any of your business, which it isn't, it's reserved for a private function, that's why."

Confused and irritated, I glanced around the room.

"But the place is completely empty!"

"I said it was reserved for a private function . . . I didn't say *when*. As a matter of fact there's a big crowd due in twenty minutes. Why don't you try next door? They cater for –" and here she looked me up and down in a contemptuous way "– *your sort*."

I imagined that she was referring to my skirt, but I didn't greatly care. I told her that to go next door was exactly what I would do, and made a dignified exit. As I turned I quite clearly heard her blow a ripe, wet raspberry at me.

There were several tables outside the *Bar Fancy* and I decided to sit at one and enjoy the sunshine with my coffee. Perhaps also I would have an omelette, or a grilled chop.

A tall, rather handsome young waiter was in attendance immediately, a none-too-clean towel folded over one arm. He smiled unctuously.

"A coffee, please," I said.

"We have a delicious selection of sandwiches."

"No, no thank you," I said, thinking of the poppyseed rolls, the *focaccia* and the brioche with a faint feeling of nausea.

"Our bread is all home-made, madam. Fresh from the oven. What about a nice sandwich made with our nice oven-fresh bread?"

"No," I said. "I can't face the thought of bread at the moment. And I'm not *madam*. I just happen to be wearing a skirt, that's all. What I really want is meat. Any meat – a sausage, a chop, a hamburger, a spiced meatball – or even fish. Baked trout would do very nicely. Just don't bring me any bread, that's all I ask."

The waiter looked me up and down.

"A flesh-eater, eh?" he murmured. "Oh yes, I've got a nice big wedge of fresh meat you'd like."

He winked at me in a distinctly impertinent manner. Then, seeing my disapproving frown, he added quickly:

"How about if I fixed you up with a pan-glazed medallion of veal in honey-mustard sauce? Would that suit?"

"Perfectly," I said.

"Of course, it's a little more expensive than the other items on the menu . . ."

"That is of no consequence," I said airily, waving one hand in the air. Then, as the waiter disappeared inside, it suddenly struck me with an exquisite thrill of horror that it was of very grave consequence indeed, because I didn't have any money. However, before I had time to work out how to cancel my order without losing face with the cheeky young waiter, I heard a voice from across the square calling out:

"Is it you? It is, isn't it? It must be! Oh God, yes, it *is* you!"

I looked up to see a buxom woman loaded down with shopping, staggering toward me. She was smiling the kind of open, generously proportioned smile that revealed too many teeth: more than could possibly be needed for any practical purpose. She was not exactly unattractive but her features were a little too obvious, her copper-red hair suggesting more than a hint of artifice; she was wearing far too much make-up in my opinion and the garish floral print dress was very tight on her. The front of her bosom with its startling cleavage heaved as she made her way awkwardly, somewhat out of breath, toward my table. Quite obviously she knew me . . . but who the devil was she?

"Oh, I simply can't believe it!" she cried, dropping all her bags and squeezing me in an overpowering embrace that had a heady bouquet of talcum powder, Edoretti's *L'Amour* and, curiously, bolognese sauce. I felt quite faint.

"Well," she said, plonking herself into the chair opposite me, "this is absolutely wonderful! It's made my morning, it really has. They told me you were in town of course, and naturally I know all about your talk tonight. It goes without saying that I'll be there myself, but actually meeting you like this, looking so ordinary, so *accessible*, oh, it's really overwhelming for me! It almost makes me want to cry!"

"Please don't do that," I said. "Not on my account."

Her blue eyes widened. She leaned forward and kissed me on the mouth. I felt her hot, wet tongue – how huge it seemed! – attempting to push its way in, but I kept my lips shut tight. When she finally broke away, she was gasping, with admiration rather than exertion it appeared, because she then said:

"So *considerate*, too! So thoughtful, so solicitous. I never believed any of those people who said you were stand-offish and patronizing."

"Who said that?"

"Which is why I kissed you. It was a tribute, you understand, a way of expressing my gratitude for the dear, sweet, *wonderful* human being that you are."

At that moment the waiter came out carrying a tray. He put a small plastic plate in front of me. On the plate was a sandwich.

The buxom woman looked up at the waiter and said quite distinctly:

"He wanted me to put my tongue in his mouth."

Then she turned back to me and smiled sweetly.

"What's this?" I cried, outraged. "I specifically asked you not to bring me any bread!"

"What's wrong with it?"

"There's nothing's wrong with it, but it's not what I asked for. Where's my pan-glazed medallion of veal with honey-mustard sauce?"

The woman said to me:

"That's right, you make as much fuss as you like! They get away with murder these days, the idle swine."

"Look," the waiter explained, "I'm really sorry about this, but we're completely out."

"Of veal?"

"No, pans."

"What?"

"I just don't know where they've all gone to. But it was a heavy day yesterday, there was a lot on, and Axel is working the late shift this morning. Can't you make do with the sandwich?"

"If he doesn't want it, I'll have it," the woman said, snatching it from the plate and cramming half into her mouth. She began to chew and chomp with great vigour and enthusiasm, her eyes glittering with greedy pleasure. Then she swiftly consumed the other half, swallowing hard and following the swallow with a little belch. Staring at her, I was both fascinated and

appalled, for that which is appalling is inevitably fascinating. It was like a giant star falling into a black hole and simply disappearing. If this was how she always ate, small wonder she was a heavyweight.

"Here's the bill," the waiter said sullenly. He went back inside.

"This is on me," the woman trilled. "My husband will be thrilled when I tell him I actually shared a sandwich with the great man himself!"

Shared?

"Who is your husband, exactly?" I said, thinking that this might be an opportunity to find out who *she* was. Or even who *I* was, come to that.

She giggled coquettishly.

"Such a tease," she murmured, "such a joker! Honestly, it's a delight to know that someone as august as yourself actually has a sense of humour."

Then, lowering her voice a little, she leaned toward me and said:

"Could I ask you to do something for me?"

I was immediately on my guard.

"What, exactly?"

"Oh, I know it's a terrible imposition but it would mean so much to both of us: my husband and me, that is. He'll be there at your talk, naturally, but it's bound to be crowded and there might not be a suitable opportunity –"

"What favour?"

"Your autograph."

I was, I confess, considerably relieved. It was true that I could not remember who I was, but I could always sign myself "Hendryk" on the pretext of being friendly.

"Certainly you may have my autograph."

She uttered a tiny scream of pleasure, almost sexual in tone, it seemed to me.

"Here," she cried, rummaging in one of her bags. "I have a pen – yes, yes – oh, the absolute *honour* of it!"

"But what shall I write on?"

She thought about this for a moment, then to my horror

she pulled her left breast out and squeezed it in one hand, thrusting it toward me as far as it would go.

"Do it on this!" she said breathlessly. "And I shall never take another shower as long as I live!"

If this was a promise, it would certainly be unfortunate for her husband, I thought.

I signed the breast, bringing the tail of the "y" up to curl around the fat brown nipple. She quivered and shook and laughed and, after much pushing and prodding, managed to get it back into the extremely tight dress.

"We shall meet again tomorrow night!" she cried, standing up and gathering her bags together.

"I can't wait," I muttered, watching her stagger off across the square.

Back at Schloss Flüchstein I managed to find the library, which was located on the second floor, and I began wandering from shelf to shelf in a half-hearted attempt to find something – anything! – on yodelling. The thought of the address that I, as one of the world's leading authorities on the subject, was expected to give, had been with me all the morning, like a particularly ugly backdrop to an even uglier play penned by a mentally disturbed author with anarchist leanings. How large, I wondered, would the audience be? Was it possible that there would be other experts on yodelling – albeit of a less exalted status than mine – present? What on earth was I to say? The fact that my address was to be illustrated with a practical demonstration served to make matters infinitely worse, for whilst I could just about imagine concocting some kind of impromptu blah-blahing *vaguely* related to yodelling, there was no way I could see myself actually doing it. I would be exposed as a fraud or even, I realized with a *frisson* of dread, as an imposter, which was a far more ghastly prospect. Furthermore, whatever I might manage to say was not only for the delectation of a specially invited audience, but was also supposed to be for the particular benefit of Adelma, the count's daughter, afflicted so it seemed with a kind of psycho-sexual *wanderlust*. Had the lovely young girl with the taut

breasts reading a history of the Cyrillic alphabet been Adelma? Under other circumstances I could have hoped that it had been. However, since Adelma was apparently only thirteen years old, despite the "fascinating sexual history" to which her father referred, it hardly seemed likely.

The library was large and well-stocked, yet I began to notice that all the tops of the books were covered with a thin layer of dust, so I assumed that it was not overly frequented. Not by Count Wilhelm at any rate, whom I had definitely decided was a philistine as well as a boor. Pale afternoon sunlight shafted nebulously through the tall, mullioned windows of leaded glass at one end of the room and dust-motes floated and sparkled above the surface of the big mahogany reading table that stood on a centrally-placed red and brown carpet. There was a small green desk-lamp.

The count's collection was eclectic, to say the least, although he had probably bought his books by the yard, as men of money with pretension but scant literary inclination do. As I moved from shelf to shelf, gradually ridding my mind of Mathilde Dimkins' ghastly living death, the thought of my address on the subject of yodelling scheduled for that evening and – perhaps most awful of all – the fact that I could not remember a single piece of vital information about myself or my personal history, I gave myself up to the pacifying effects of watery sunlight and self-contained silence. I simply concentrated, but perhaps that is too strong and definite a word, on the books.

There was music, history, fine art, languages, literature and poetry: musical scores in the Eulenburg editions of Mainz, Riccordi of Milan and Schirmer, including most of the operas of Verdi and Wagner and the song cycles of Mahler; documented histories of Europe and America, lavishly illustrated encyclopedias of art, J.F. Kreuzmann's *Great Paintings of the Renaissance*, Maria Beck's collected monographs on El Greco and Velazquez; the complete works of Shakespeare, Goethe, Victor Hugo, Zola and Thomas Mann. All the major branches of science were represented, with a slight bias towards mathematics. There was also psychology – practically everything

that Freud ever wrote but very little Jung, I noticed – philosophy, theology, comparative religion, the esoteric and the frankly occult: I saw Max Hilber's *Theorie and Pracktise of Anciaunt Alchymical Magicke*, several volumes by the infamous Vicenzo Labellio-Schmidt, and Flossman's *Hermetic Corpus*. Then I came across biography, autobiography, cookery, sport – with a very definite emphasis on hunting and shooting – and, incongruously I thought, a selection of Do-It-Yourself manuals: I smiled when my fingers, trailing filmy tendrils of dust, alighted upon *The Junior Woodworker's Companion* by someone called Toby Snubble.

However, I did not smile in the knowledge that although many of these authors and their subject were at once familiar, I had no memory of ever reading them. Why? Obviously I had been in the habit of reading, otherwise every volume on every shelf would be unknown to me. Did I not have a little collection of my own books somewhere? How was it that I knew the names of Wagner, Shakespeare and Velazquez with an easy intimacy and yet not myself? And I had still found nothing about yodelling. However, before I could continue my desultory quest, the library door opened and Count Wilhelm entered. His face looked rather flushed. I immediately thought that he had been drinking.

"Ah, Hendryk!" he said with a patently false heartiness. Something unpleasant was coming, surely –

"You've missed lunch, I'm afraid."

– and it wasn't that. It must be something more.

"Mrs Kudl surpassed herself. Well, I suppose she wanted to make up for last night, eh? What a pity you weren't there. She gave us *Bisque de Langoustines, Bar Normande, Boeuf Provençale* and *Bavarois*. Absolutely excellent."

"Everything beginning with B," I said.

"Yes, well, she often gets little ideas like that in her head. Sometimes she goes for letters, sometimes shapes, or even colours. Once it was an all-green menu – beans and peas mainly – and I spent the night farting myself into a coma."

"I wasn't in for lunch. I was –"

"Oh, I know where *you* were, my dear fellow."

"Actually, Dimkins told me a rather disturbing story."

"Dimkins? Don't take any notice of him! The man is a reliable servant but I'm afraid he's completely round the bend. He once told me he's been keeping his wife in the cellar and slowly starving her to death."

"But that's what he told me!" I cried. "Is it true?"

"I've really no idea."

Count Wilhelm looked at me in a curious kind of way for a few moments then drew a cigar from his jacket pocket and lit up, puffing noisily.

"Look," he said, managing to sidle one heavy buttock onto the edge of the reading table, his left foot dangling, not quite reaching the floor, "I know you arty chaps are used to living free and easy lives, but don't you think it was a bit much?"

"What was?"

"I've already apologized to the archbishop on your behalf."

"I'm afraid I have no idea what you're talking about," I said as politely as I could, but Count Wilhelm's distinctly schoolmasterish tone was beginning to irritate me.

"I only hope to God it isn't going to develop into a full-blown affair," he muttered, jabbing his cigar in my direction.

"An affair? With whom?"

"The archbishop's wife, of course!"

I was taken aback, to say the least.

"But I've never met the archbishop," I protested. "I don't know him. How can you possibly think I'm having an affair with his wife? I don't know her either, come to that."

The count slid off the table. He walked around it to the chair and sat down heavily. His dark eyes glittered at me with something approaching contempt.

"Do you intend to deny, to my face, that less than three hours ago you exposed and fondled her breasts in full public view?"

I felt my stomach turn over.

"Her?" I managed to murmur. "That blowsy, tarty woman the café?"

wouldn't add insult to injury if I were you," Count m said. "If the archbishop finds out that in addition to

stripping his wife half-naked in a crowded piazza, you're going about calling her a tart, he won't be best pleased."

"The piazza most certainly was not crowded. In fact, as far as I recall, it was almost deserted."

"What does it matter, in any case?" the count answered airily. "You practically raped her, so I understand."

"From whom do you understand that?"

"The archbishop's wife herself, of course."

"Then she's a liar as well as a tart. I dare say she would have *liked* me to rape her. She was all over me."

"My dear Hendryk! Now look here —"

"No, *you* look here —"

"Did you, or did you not, do some kind of pornographic drawing on her breasts?"

I was beginning to get angry now.

"No!" I cried. "I did not! She asked me for my autograph and when I agreed, she pulled out her left breast and demanded that I sign that. She really didn't leave me any choice. I was very much embarrassed, I can assure you. Far more than she was."

For the first time in our conversation, the count appeared to believe me. He sighed and visibly relaxed, sinking back a little into his chair. He exhaled slowly, sending a silver-grey cloud of richly aromatic smoke in my direction.

"Well," he said, "if you can assure me that you have no designs on her virtue . . ."

"I can and I *do* assure you."

"Then perhaps it would be best to forget the whole sordid episode."

"I already have."

"Besides, the archbishop is a broad-minded and tolerant man . . . I dare say when you meet him after your talk tonight, he'll treat you just as if it never happened."

I had almost but not quite forgotten about the ghastly talk.

"He's a much-loved figure is our archbishop," Count Wilhelm went on, almost speaking to himself now. "That's because he's got a great deal of common sense and knows how to use it. He doesn't go overboard on this religion thing,

for a start. Some archbishops would, of course. The trouble is, give God an inch and he immediately grabs a mile, and before you know where you are, he's demanding to be in on almost every human affair you can think of: issuing commandments, devising impossible and impractical rules, telling you when you can eat meat and when you can't, all the rest of it. No, leave God out if you possibly can, and life will be much simpler all round. The archbishop knows this, sensible fellow that he is. Ritual is what the Church is good at, and ritual is what the Church should stick to. Archbishop Styler is himself a consummate ritualist, my boy. You could learn a thing or two from him, believe me. Our greatest and most popular celebration in the liturgical calendar – local usage, naturally – is the Feast of the Holy Napkin, and that came about solely because Archbishop Styler needed to blow his nose. Can you imagine that?"

"No, not really."

"He'd forgotten his handkerchief, you see. Slap bang in the middle of a High Mass and his nose started dripping all over the altar cloths, so he had to do something quick. Do you know what he did? Well, I take my hat off to him, I assure you! He sent a goodly clutch of acolytes out to the sacristy to fetch a handkerchief from his cassock pocket, and in they came again, in procession this time: thurifer, clavifer, incense-bearer, candle- bearers, the choir rendering *Oh Knowledge Know Thyself* in a particularly poignant combination of soprano and counter-tenor, and a golden-haired boy carrying the said handkerchief – now liturgically a napkin, you understand – on a crimson velvet cushion. Well, the congregation went wild! The women wept and the men cheered. Archbishop Styler improvised a series of grand liturgical gestures including an incensation of the handkerchief – napkin, I should properly say – and under cover of offering it up to the icon of ʰe thrice-hallowed Keys-in-Triplicate above the episcopal ʰedra, managed to blow his nose. There were many tears of ʰinely pious emotion shed that day, my boy. I don't mind ʰing to having had a little weep myself! Now, the Feast of ʰy Napkin is a civil and religious holiday. Why, our

schoolchildren write poems about it. These days we have a stock of napkins, all of silk, most embroidered in gold and silver thread; there's even an Order of Holy Virgins entirely dedicated to making them. The ritual itself has been greatly elaborated on over the years and not so very long ago the archbishop published an academic treatise on the style, symbolism and meaning of the rite. Not that it actually *does* mean anything of course – not a bit of it! – but that hardly matters, does it? People *need* ritual, you see, and it's the Church's job to give it to them. It satisfies, pacifies, contents and heals. The more complicated and the less meaningful it is, so much the better. Do you take my point?"

"Actually –"

"But what on earth are you doing shut up in this old place?"

Count Wilhelm's fat, flushed face suddenly assumed a sly look. He winked at me in an unpleasant manner.

"Fiddling with yourself, eh?"

"What?"

"Oh, I understand perfectly. Needed a little privacy to indulge in solitary pleasure, right? Well, I'm pleased you had the courtesy not to do it in front of the servants. I'm of the opinion that every man is entitled to take himself in hand. Look here, perhaps we could compare techniques one afternoon? I'm quite a skilled practitioner myself, but I'm always willing –"

"No, I assure you!" I cried. "I was merely looking at the books. I wanted – ah, well – I wanted –"

"Pornography?"

"No, not that . . ."

I hesitated. I could hardly tell him that I had been searching for something on yodelling, since he believed me to be a leading authority on the subject, and I had hitherto not disabused him of this absurd notion: indeed, I failed to see how I could, now.

"Well whatever it was you wanted my boy, you won't find it here. This place isn't used anymore. I'm surprised the door was left unlocked; Dimkins is usually so careful about these things."

He stood up and came close to me, putting one hand on my shoulder. With the other hand he made an elaborately dismissive gesture.

"All this stuff, all these books," he murmured. "They aren't our sort of thing, you know. They're all about *the other place*."

"What other place?"

He pointed his cigar up at the mullioned window.

"Out there, beyond."

"Beyond what?" I asked, becoming increasingly confused.

The count looked at me for a moment as though I were quite mad.

"Beyond here, of course," he answered. "Beyond *us*."

"But –"

"None of it is *real*, my boy. They're just millions and millions of words, that's all."

"I don't understand what you mean. Why do you have them here if you don't think they're real?"

Count Wilhem laughed almost incredulously at what he clearly perceived as my naiveté.

"Books, my boy, books! This is a library. Where else should I keep them? In one of Mrs Kudl's pantries? Ha!"

"But I still don't see –"

"Well, well, there we are. I won't take up any more of your time. I dare say you're busy polishing your address. We're all in a positive fever of anticipation about it, I can tell you! Try not to miss dinner. I believe Mrs Kudl has something extra special in mind. We don't want you to starve to death like poor old Frau Dimkins, do we? Ha ha!"

He walked briskly toward the door. Then he turned and looked back at me.

"Dimkins will leave the suit and tie in your room. Then you can get out of that damn skirt."

He left behind him a free-floating silver nimbus of aromatic smoke.

In desperation I went in search of Dr Freud and found him in his room. To my surprise, the young girl with the taut breasts I had seen reading *An Annotated History of the Cyrillic*

Alphabet was with him. They were sitting in armchairs near the window and had obviously been deep in conversation; indeed, the girl appeared to be slightly irritated by the interruption.

"What do *you* want?" she said.

Her voice was as husky and seductive as I remembered it. She sat with her legs crossed, the dark emerald skirt pulled up rather high over her thighs. Above the rise of the bosom, at her pale and slender throat, was a single pearl on a fine silver chain. Her face was so beautiful it almost made me dizzy: a smooth, clear brow, dark eyes that smouldered from within like embers that might at any moment burst into rekindled flame, a *retroussé* nose and a flawless, perfectly shaped, luscious scarlet mouth that could never have been created for anything other than pleasure which was illicit. She stared at me with the kind of insolence that inevitably arouses rather than offends.

"I'm sorry, I hope I haven't disturbed you . . ."

"As a matter of fact you have," the angel-temptress said with a contemptuous indifference that stiffened both my penis (the immediate effect of which was fortunately concealed by my skirt) and my resolve to stay.

Dr Freud explained:

"Adelma and I were discussing the effects of Längerhorn's syndrome on the development of tertiary syphilis."

"Adelma?" I cried. "The count's daughter? But that's impossible!"

"Why is it impossible?" she demanded.

"Your father told us. I mean. I understood you were thirteen years old?"

"I am."

I stared at her. I could not prevent my mouth from falling slowly open and staying that way.

"You look like a fish," Adelma said.

"And you look like – like –"

"Well? What do I look like?"

"A goddess!" I finally managed to blurt out.

She seemed momentarily mollified and smiled. Then the brief moment of effulgence faded and she became indifferent again almost at once.

"Of course, I've been thirteen for as long as I can remember."

"What?" Dr Freud cried in his cracked, trembling voice.

"Didn't papa tell you? Oh, yes. Everyone reckons, well, Professor Bangs reckons anyway, and he's the greatest brain we've got, that my last birthday occurred on the thirty-first day of the month."

"What month?" I asked.

"That isn't the point," she snapped at me, her delicate, almond-shaped little nostrils flaring in a particularly adorable way.

"Then what *is* the point, if I may ask?" Dr Freud murmured.

"The point is, it's been the *first* of the month ever since. So I've never had another birthday, ever again."

"Then you aren't thirteen at all," I said almost breathlessly. "I knew it. It would have been impossible."

"If I was thirteen on the last birthday I had, and I haven't had one since, I must be thirteen now, mustn't I?"

"Adelma's logic is impeccable, Hendryk," Dr Freud observed.

"Only in a world where it's always the first of the month, Dr Freud. And I know of no such world, do you?"

Dr Freud looked at me in a severe manner.

"I think that a world where young men with no trousers travel on trains without knowing who they are or where they're going, would be equally impossible. Don't you agree?"

Adelma glanced at Dr Freud with a curious look on her lovely face.

"Young men with no trousers?" she murmured.

"Precisely, my dear young lady."

"What Dr Freud means," I began hastily, anxious to steer the conversation away from my own peculiar circumstances, "is that –"

"I *know* what Dr Freud meant, thank you," said Adelma, getting up from the armchair: an action which momentarily afforded me a tantalising glimpse of the tight pink knickers

she was wearing when I first saw her . . . and was wearing still. By now they would surely be musky with her intimate fragrance. My heart began to flap and flutter in my chest like a hysterical bird.

"What *did* you want, anyway?" she said to me, tossing her head coquettishly.

"I need to speak to him – that is – about my – my talk tonight."

"Papa has arranged it especially for me, did you know that?"

"Yes."

"It had better be good then, hadn't it?"

As she passed close by me toward the door, I caught a whiff of some exotic, woody scent, something like sandalwood or sweet cedarwood. It was powerful and irresistibly heady.

Ignoring me, she turned back and waved to Dr Freud.

"Goodbye my dear," the old man said softly. I saw his eyes glittering beneath the lined, wrinkled lids.

Adelma closed the door behind her.

"Oh, she's utterly perfect in every way!"

"Except in her manners toward you, it would appear."

"Exactly."

"She was overtly and unreasonably rude, Hendryk."

"I know, I know. Wasn't she wonderful?"

Dr Freud shook his grizzled head slowly.

"I take it you are sexually attracted to Adelma?"

"Of course! I'm overwhelmed – overpowered! – by her. Can you blame me?"

"Without undue immodesty I think I can claim to be a leading authority on the psychology of human sexuality, but desire which is fuelled by opprobrium and insult seems to me a very peculiar kind of psychology indeed. Probably a sub-variety of the sado-masochistic impulse, in which the Id forms an alliance with the Superego in attacking the Ego: the former for the purposes of arousal, the latter for the substantiation of its own authority, with the result –"

"With the result," I interrupted, "that I *want* her! I must have her!"

89

Dr Freud rose unsteadily to his feet.

"Calm yourself, Hendryk! It is clear that the girl despises you."

"And it's equally clear that she isn't a girl, especially not a thirteen-year-old girl. She's a young woman. Twenty at least, I'd say."

"Almost certainly."

"What was all that nonsense about it always being the first of the month?"

"I'm afraid I don't know. I would have been inclined to put it down to mental instability in the girl – the young woman – herself, had it not been for the fact that it was her father who told us she was only thirteen. Perhaps it is effect of a mass psychosis of some kind. It is certainly most fascinating."

"Not to me it isn't."

"Oh?"

"Another effect of this mass psychosis is that everyone thinks I'm an expert on yodelling."

"Ah, that."

"Yes, that. What on earth am I going to do about it, Dr Freud?"

The old man lowered himself into the armchair again. He sighed.

"You will simply have to get them to do your job for you," he said.

"Meaning?"

"It's a technique that I and several of my fellow students devised when we were faced with a *viva voce* with old Professor Gabriel. By God, his oral examinations were real stinkers!"

Dr Freud rubbed his liver-spotted hands together gleefully and chuckled.

"I remember on one occasion –"

"Look, what exactly is this technique?"

"It is based on the principle of answering one question with another when you do not know the answer that is expected."

"So?"

"So, begin the address with the practical demonstration

that everyone appears to be anticipating with such relish. Except instead of providing it yourself, get your audience to provide it without arousing in them the slightest suspicion that they are doing so."

"How, may I ask?"

"Tell them that before you demonstrate the *perfect* style and the most accomplished method of delivery, you wish them to see for themselves how *imperfect* the commonly accepted style and delivery is. Allow them to yodel first. I am quite sure that, since no one present will have the slightest inkling of how it should be done, your subsequent effort can only be seen as an improvement. After that, well, you will simply have to improvise."

I took Dr Freud's hand in mine and shook it vigorously.

"Your advice is sound!" I cried. "Indeed, I think you may have saved me from a catastrophic humiliation! I shall do exactly as you say, Dr Freud. Thank you, thank you!"

Dr Freud looked pleased with himself.

"Perhaps, after all, you will make a great impression."

He was right, I did. But not in a way that either of us could have anticipated.

★ ★ ★

−5−

The pinstripe suit that the count lent me fitted less than perfectly, but it had clearly been made for him in younger, slimmer days and the overall effect was not entirely unacceptable. There were one or two unsavoury-looking stains on the tie that I managed to sponge off with cold water. I was sorry finally to abandon the skirt that I had not only grown used to but actually *liked* wearing; however, I did not feel that it was appropriate for an evening which, everyone assured me, was to be positively glittering, attended by many high civic and religious dignitaries. The dull, sickening dread of having no idea who or where I was, had begun to give way to a sort of numbed resignation; besides, I was not entirely alone in my chronic bewilderment: Dr Freud and the odious Malkowitz didn't know where *they* were either. Or was it − could it actually be? − that I was slowly beginning to convince myself that my name truly *was* Hendryk and that I was indeed a leading authority on the art of yodelling? This is perhaps not as mad as it sounds, since to be at least partially convinced of being *someone* is infinitely less painful than the absolute certainty of being *no one*.

This is not to imply of course, that as seven o'clock, then half-past seven approached, I was in any other state than one of deep apprehension. I had insisted, much to the count's chagrin, on being served something in my room, claiming that I always needed to be by myself for at least two hours before any professional engagement. As for the "engagement" itself, well, Dr Freud's advice had certainly struck me as sound and I had every intention of taking it.

There was a sudden knock at the door and Count Wilhelm walked in.

"Well, we're ready for you! Did you eat your sandwich? A pity you had to miss Mrs Kudl's dinner. There was *Salad Alice, Pigeonneaux en Papillote, Sole Bercy, Coeur de Filet Schloss Flüchstein, Sorbet aux Poires −*"

"Thanks for letting me know."

"Actually, the sandwich was my idea. When you said you needed to be alone, I guessed you were prone to pre-performance nerves and that it would be better not to have anything too digestively stimulating. Wouldn't want you throwing up all over the city worthies, would we now? Ha ha."

I was unable to decide whether this had been genuine solicitude on the count's part, or merely malice. In view of the annoyed disappointment he had shown when I told him I would not be at dinner, I suspected it was the latter.

He clapped a meaty, manicured hand on my shoulder.

"Well then, my boy. Are we ready?"

And he led me away.

The ballroom was fairly large. This surprised me, because despite the pretension of its title, Schloss Flüchstein was in reality no more than an extended villa. The tall, mullioned windows leading onto the grounds were hung with gold-tasselled drapes in crimson and peach pink; there was a large central chandelier fitted for electric light and innumerable candles in ornate silver candlesticks; a kind of raised platform had been set up at one end of the room, banked on either side by fresh flowers, and there was a small mahogany table nearby on which had been placed a goblet of water. The place was full – indeed, every chair appeared to be taken – and as I entered with Count Wilhelm, his arm still on my shoulder in an avuncular manner, I heard the loud buzz of animated conversation.

"Listen to them! They're in a fever of expectation," the count murmured to me.

As we walked slowly toward the platform, the audience rose to its feet and began to applaud. I sensed a myriad of eyes on me: curious eyes casting inquisitive glances, eyes shining with avaricious expectation, looks that were cold and cruel, stares that were incredulous, envious, hard and judgmental, or merely vacuous. I felt a little warmth here and there, and tried to see where Adelma was. There – there she was! – in the very front row, beside Dr Freud. Malkowitz was on the other side of Dr Freud, and as he watched me approach the platform, I felt the most unkind eyes of all appraising me.

93

We turned to face the audience. The count motioned for everyone to be seated. A few places away from Adelma was the large, blowsy woman – the archbishop's wife – who had made me autograph her breast. Next to her was a grossly corpulent, bald-headed man with a slightly debauched look, whom I assumed to be the archbishop himself, although he was not wearing anything that remotely resembled clerical dress.

"Ladies and gentlemen!" the count shouted. "Distinguished guests, friends, lovers of culture! It is my singular honour this evening to present to you a young man whose academic qualifications and professional reputation renders any intro-ductory words of mine completely superfluous."

There was another burst of applause. The count waited for it to die away before continuing. Superfluous or not, he was obviously intent on delivering a few words more. I did not doubt that he was a man fond of the sound of his own voice.

"That he has consented – condescended, rather! – to speak to us on this truly auspicious occasion, is not only a tribute to the gigantic proportions of his modesty, his humility – yes, his very humanity! – but is also a mark of unprecedented favour for our fair city. Indeed, in view of the staggering breadth and complexity of his achievements, his presence here tonight reveals him as the perfect *model* of condescension – of self-effacement, I can truly say! – and of gracious goodwill."

Just as I thought the count's speech could not become more ridiculous, he paused for breath; then he turned his head to one side, apparently looking at someone in the front row, and I quite clearly heard him whisper:

"He thinks he's God Almighty and the rest of us are turds."

Before the shock of this had really had time to register, the count went on:

"Indeed, where else would one expect to find such infinite accessibility of the sublime except in the realm of the divine? His empyrean loftiness, his grave and remote stature, the incomprehensible distance of his genius from all things commonplace – these he has willingly abandoned –"

I felt myself beginning to doze off. I could not resist the cloud of narcotic somnolence, the warm colour of candle-light, that crept over me as the count's ludicrous paean droned on. I entered that strange hinterland between waking and sleeping – between consciousness and coma – where the distinctions are blurred, boundaries dissolved, and anything becomes not only possible but, according to the dictates of fantasy and desire, probable. It was here that I encountered Adelma: lithe, lovely, lascivious . . . and completely naked. She kissed me, her mouth on mine, and I felt the questing of her delicate pink tongue. My trembling hands covered her magnificent breasts, the nipples now elongated and taut.

"How dare you!" she cried, immediately drawing back. *"What gives you the right to touch me? You filthy animal! How I hate you, how I despise you!"*

Suddenly, confusion and bewilderment gave way to the sweet light of perfect comprehension.

"Does my contempt arouse you still?" she whispered. Then, glancing down at my aching tumescence, she whispered: *"I thought it would."*

As I eased myself into her, she threw back her head and wailed:

"You unspeakable bastard . . . no, stop before it's too late . . . ah, stop this! You know it repulses me, you know I'm sickened by the feel of you pulsating inside me!"

Then she dissolved into giggles and as we held each other close, the giggling became louder, spreading out across whatever psychic landscape I wandered through, gathering momentum until it came not from the pale and slender throat of Adelma but five hundred others, less intimate and more raucous. It was a tidal wave of laughter – brittle, unconvincing, orchestrated with neither subtlety nor grace – and with a jerk of my head I seemed to come to myself. Count Wilhelm had obviously made some kind of joke. At my expense perhaps? Well, I would never know now. The laughter faded and my moment had come. The count was beaming at me expectantly. As I rose to my feet, I glanced at Dr Freud sitting next to Adelma in the front row of the

ballroom-cum-auditorium; he was nodding at me in an encouraging manner.

I cleared my throat.

"Ladies and gentlemen," I began. "I wish to preface my address tonight with an experiment. Or, shall we say, a *comparison?* The art of yodelling, or ululation, to furnish it with one of its technical titles, has alas fallen into a sad decline since it was first brought into being, through tentative experimentation and timid physiological curiosity, by the –"

I heard Dr Freud hiss something at me under his breath, but I could not catch it.

"– by the embryo of human civilisation itself," I said, quite pleased with this improvisation, until I saw him shake his head slowly. "The purposes of ululation have been many and various: to express joy, to give warning, to share grief and, in comparatively recent times of course, to make music. Music and melody and modal meanderings . . . mellifluous murmuring . . ."

I was aware of Dr Freud hissing at me again.

"The comparison, you fool! The technique!"

I glanced over at him. He nodded.

"Ladies and gentlemen, it is precisely as music that this art has been overtaken by the decline of which I spoke. In order to demonstrate my point, I am now going to ask you to attempt a little ululation of your own."

There was an animated buzz of interest.

"In your own time, and by whatever technique comes naturally to you, for despite current controversy on this point I believe there is no one method which may be classified as *de rigeur,* I want you to yodel for yourselves. Be patient with one another, as I shall be patient with you. After you have demonstrated in this practical manner the sorry effects of its decline, I shall present you with an example of the art in its perfection."

For a moment or two there was complete silence. I began for the first time to feel the tremors of nervousness beginning to tickle the lower reaches of my stomach. Then, from somewhere at the back of the auditorium, there came a tiny, high-pitched, tentative wobbling sound.

"Excellent!" I declared, *pour encourager les autres*. "A brave attempt!"

A woman several rows back wearing a glittering evening gown that was far too tight to accommodate her voluptuous bosom with decency, pushed her head forward on her neck – like an aggressive plumed bird, I thought – and raised her eyes. Then she emitted a rather splendid noise with a marked vibrato and sustained it for several moments before slumping back in her chair, crimson-cheeked and breathless.

"Amazing!" I cried. "Was it your first time?"

She nodded vigorously, clearly taken aback by her own accomplishment, then sniggered at the sexual innuendo of my question.

One by one, the rest of the audience, emboldened by my praise of those who had been brave enough to go first, followed suit. It began cautiously enough: a sort of tremulous, collective vocal bobbing, like innumerable ping-pong balls of sound on jets of water. I smiled and nodded approvingly, pointing to one or two of the more enthusiastic yodellers in a gesture of encouragement. Before long however, they needed no encouragement: eager for approbation or determined not to be out-performed – or perhaps both – every member of the audience was soon at it. The intensity of their efforts began to alarm me, but I did not see how it was possible to stop them quite yet. The sound rose up like the surge of some approaching tidal wave, the various pitches at first clashing dissonantly then somehow melding into a single chord of fantastical harmonic texture, thick as primeval mud, yet piercing like a honed blade. It gathered both volume and vibration and I glanced up to see one of the chandeliers beginning to tremble. People were standing up now – indeed, I involuntarily jumped to my feet myself – their mouths stretched wide, teeth protuberant, uvulae flapping, veins straining, heads shaking, eyes staring. By now the noise was quite appalling. Wave after wave of it crashed over me. Someone's yodel degenerated into an attenuated scream. I put my hands over my ears in desperation. It was like an orgasm. Indeed, looking over at Adelma, it seemed to me that this was precisely what she was

experiencing now: her head was thrown back, her eyes closed, her cheeks flushed; her hands were clutching her breasts; her legs were spread wide, her skirt halfway up her thighs. Her mouth, even locked in an open rictus, was incredibly beautiful . . .

"Ladies and gentlemen!" I yelled, but my voice could not be heard above the din. What the devil was I to do? I raised my hands and waved them in the air, to no avail.

"Enough, enough!"

The very floor beneath my feet seemed to tremble and move. Was it an earthquake? Or was there – yes, surely there was! – some deeper, darker rumble of sound growing closer, heavy with menace?

"Please, ladies and gent –"

At that moment, with an electrifying smash, one of the mullioned windows shattered – exploded, almost – and a cloudburst of razor-edged glass *scintillae* flew across one side of the hall, descending like a deadly snow on the nearest rows of manic yodellers. I saw the vile face of some demonic beast, its eyes crimson and glaring, its black lips drawn back in a horrifying grimace as it bellowed in fury, steam shooting from its quivering nostrils, and then I thought, but no, I couldn't think! I was petrified –

The count was shouting. People were screaming, pushing and shoving to get near the doors.

"The cows, the cows!" Count Wilhelm cried above the hideous cacophony. "It's a stampede, I tell you! Get the women out first!"

Then he turned to me and hissed:

"Look what your idiotic experiment has done!"

"What, what?"

"The noise has maddened the vile creatures!"

"The *cows*?"

"I told you they were savage beasts, didn't I? Outside, men! For God's sake, get your weapons –"

And he was swallowed up in the heaving, yelling mob.

I could scarcely believe that behind the modest Schloss

Flüchstein there was what appeared to be a vast private estate, but there was. It lay spread out under the blue-black velvet of the night sky; in the distance I saw the darker outline of some great forest, the finger-like tips of densely-packed trees reaching up toward a pale citron moon. It was bitterly cold. I was momentarily lost in a kind of reverie, absorbed in contemplation of the melancholy romance of this midnight landscape, then somewhere behind me I heard a shout:

"Run, man, run!"

And other voices: harsh, strident, fearful, thickened with the awe of death or victory, and all at once I realised I was in the middle of some great, bloody battle between man and beast. There were screams of agony, yells of triumph, the ugly clash of steel, the frantic bellowing of the crazed cows and even what seemed to be the wild stamp of horses' hooves on the ice-hard ground. Horses, for God's sake? I looked around me – yes, horses! – and I saw Count Wilhelm astride a great black steed, his face twisted in fury; he was brandishing some sort of broadsword – the blade glittered with thick red blood – and behind him were half-a-dozen similarly armed riders.

"Hack them to pieces!" he screamed. "But bring me the heads intact!"

They thundered past me, trampling people on either side. There were, I suppose, about twenty cows on the rampage; they lumbered around madly, blindly, one or two of them already badly wounded and further infuriated by the pain; I saw a sword hanging from a muscular rump like a useless appendage. A couple of women ran across the fields carrying burning torches, their gowns ripped, breasts exposed, their faces distorted by the sinister copper light of the flames, their eyes wide with terror. I turned and stumbled after them, trying to keep clear of the cows which charged and charged again aimlessly; I knocked people over without meaning to, I trod on someone's arm and immediately there came a shriek of outrage and agony. A young man, almost naked, lay spread-eagled on the ground, his chest gaping bloodily open.

"Strike, sir! Bring it down, I tell you!"

"– it's coming straight at you –"

"In the name of God, there are women here!"

I swung around one way – the crimson-smeared face of a charging cow loomed up at me from out of a dense silver-grey cloud of its own breath – then the other; in the chaos I had lost sight of the women with the torches. I fell to one knee and a sharp pain shot through my ankle. I flung myself onto my back, rolling over as swiftly as I could to avoid being beaten to a pulp beneath the hooves of a passing horse. Then I managed to pick myself up again. It was madness! It was a nightmare. My only hope of escape, I knew, was to head back to the house. I could still see the lights of the abandoned ballroom some distance away to my left. I threw myself toward them, loping like a maimed creature out of some cheap gothic novella of mutants and maledictions, my heart thumping desperately in my chest.

"Heed me, there! Did I not say I want the heads intact?"

A huge cow thundered past and with an exquisite spasm of horror I saw that it had what appeared to be a human arm in its mouth. I could clearly see the short, gingery hairs on the pale skin. I broke into a sweating run. Cows simply did not behave in this monstrous fashion, not in my experience anyway; cows were placid, sloe-eyed creatures who minded their own business, grazed amiably on upland pastures and stood stock-still for hours doing nothing in particular: certainly not ripping the limbs from people and stampeding over private estates in a murderous frenzy. Were they some kind of genetic hybrids, the result of hideous clandestine experimentation, perhaps? Or had they been separated from the count's herd years before and somehow survived in the forest, becoming feral in the process?

At that moment I heard a dull thud and felt a diffused ache in my right side, as if someone had punched me fairly hard but without any intention of seriously hurting me; I lurched forward and downward, putting my hands out to break the fall, and immediately my face was in a chill, acrid puddle of cow's piss. I spat and wiped my lips on the back of my sleeve. For a fleeting moment I was tempted to surrender to the wave of exhaustion that swept over me and to go to sleep there and

then, where I was, but the danger of being trodden into the ground by cows or horses – or possibly both – prevented me. So I heaved myself to my feet again and staggered on toward the lights of the house. Behind me I heard the screams and the bellows and the *zwiiiccchhh!* of steel slicing into bovine muscle.

There were one or two bodies – women I think, but I did not stop to look – still in the ballroom. The chairs were over-turned and scattered; the floor was strewn with shattered glass; pearls, diamonds and rubies glistened among crushed blooms like a valedictory carpet laid out beneath the chariot wheels of some ancient conquering hero. I ran across the deserted entrance hall and out through the front doors into the street. The sickly yellow glow of the sodium lamps cast unnerving shadows. Without once glancing back I hurried on, trying to put as much distance as possible between me and Schloss Flüchstein. Indeed, I do not know exactly how far I went – my awkward lope gradually becoming a quick then a casual walk, since my ankle was still paining me – but soon I found myself on the outskirts of the city, in a labyrinth of narrow, winding side-streets consisting mainly of dark, old-fashioned apartment buildings and the occasional shuttered shop. I was still wearing only the count's hand-me-down pinstripe suit and I began to shiver with the cold. I glanced up from time to time in order to see the street names, but of course they meant nothing to me:

Rötensbergstrasse . . .

Weberstrasse . . .

Tannenbaumweg . . .

And, somewhat incongruously:

Dorothy Parker Allée.

I was beginning to tire by now and, since I had only been given a single sandwich for lunch, I was growing increasingly hungry. The count's suit was torn at one elbow and stained with mud. I reeked of cow's piss. Whoever I was, I was def-initely in a mess.

"Here! Here, you, this way!"

I looked across the street and saw a middle-aged woman standing in front of an open door. She was silhouetted against

a rectangle of golden light so that I was unable to see her properly, but her voice, despite the distinct tone of casual indifference, held a certain warmth. I hobbled over toward her.

"Well, are you lost? It's very late, you've missed the supper."

"I think it's a fate I'm doomed to," I murmured.

"Where's your invitation?"

"Invitation?"

"Oh, don't tell me . . . you forgot to bring it. You men, you're all alike! You'd forget where your cocks were if we women didn't remind you from time to time."

I was rather taken aback by this unexpected vulgarity.

"It doesn't matter, anyway. There's still plenty to drink, and people are beginning to dance."

Close up, I saw that she was quite attractive in an overblown sort of way. She reminded me a little of the archbishop's wife – and she was wearing a splendid evening gown. He hair was swept back and piled high, burnished a coppery-red and studded with tiny white stones attached to a thin net of gold wire.

"Well don't stand here all night, silly! We'll freeze to death."

I climbed the short flight of stone steps up to the door and stepped into the bright light of the interior. Immediately I heard the jolly strains of an old-time waltz and the animated buzz of conversation.

"Go on in. I'll have one of the servants take your coat – oh! – you haven't got one. I suppose this is the modern fashion, now."

"What is?"

"Walking about half-naked and looking like a starving refugee."

"I *am* starving."

"Well, I don't pretend to understand it, but there we are. Go on, go through, for heaven's sake!"

The great room – certainly as big as the ballroom-cum-auditorium at Schloss Flüchstein – was crowded with people, all of them elegantly dressed and most of them lavishly

jewelled; some were sipping champagne, others standing around in little groups. A string quartet, discreetly surrounded by potted ferns, was playing the waltz I had heard. Several couples were attempting to dance but kept bumping into each other. Waiters mingled, bearing salvers of champagne glasses and tiny cold snacks. I tried to snatch one as a young, super-cilious-looking fellow squeezed by.

"I wouldn't take that if I were you, sir."

"But I'm hungry."

"Wasn't the supper to your liking? I thought the roast guinea fowl tender to perfection. To say nothing of the glazed wild salmon and –"

"I missed the supper. I've only just arrived."

"Ah. Well I still wouldn't touch it, sir."

"Why?"

He leaned forward conspiratorially and put his plump, moist lips to my ear. For a brief moment I thought he was about to kiss me. Then he whispered:

"I'm afraid Madam Petrowska has already had it, among other things, in her mouth. Then she realised it was garlic sausage, which of course, owing to her condition her doctor has strictly forbidden. So she took it out again and put it back. Look closely, sir, you will see the little mark of her dentures."

"What about the rest? Surely –"

"She tried every single one, I'm afraid. They're all garlic sausage. They do say that the *condition* isn't catching, but I wouldn't like to risk it."

"It's just that I'm so hungry."

"Look, I *could* go down into the kitchen . . . for a consider-ation you understand, sir . . . and find you something. I believe there's plenty of hot, fresh bread still left."

"No!" I cried, a little louder than I had intended; I saw one or two people glance across at me curiously. "Not bread, please!"

The waiter drew away from me and squared his shoulders in a slightly insolent manner.

"Well then sir," he said, "I suggest you have a glass of champagne instead."

As he moved off, I heard him hiss to someone:

"Our bread isn't good enough for him, the stuck-up little prick."

Naturally, my stomach being empty, the champagne began to go to my head almost immediately. I made my way tentatively around the room as naturally and as casually as I could, but wearing a stained and tattered pinstripe suit in such a place, among such people, I could not help feeling extremely awkward. More than once I sensed myself to be the cynosure of narrow-eyed, judgemental stares. I heard whispers, saw nudges, caught glimpses of furtively appraising gestures. Where the devil was I?

"Are you enjoying yourself?"

I turned to see who had addressed me. To my utter astonishment, it was – but how could it possibly be? – Adelma!

"You!" I managed to gasp. "How – I mean – how on earth did you get here?"

She smiled at me and I felt my legs begin to wobble.

"The same way that you did, of course."

"But I don't understand . . ."

Then she slipped her arm through mine and led me slowly across the room. She looked absolutely stunning: she was wearing a peach-coloured spangled dress of some stretch material that clung to – kissed! – the contours of her perfect body. I could see the little round points of the nipples, the indentation of her navel, the rounded curve of – ah! – she might as well be naked. At her pale throat was a black velvet choker with a single pearl.

"I'll explain everything," she said, smiling again, then pouting at me, and finally making an "o" shape with her gorgeous red lips.

"Where are we going?"

"Somewhere a little more quiet, Hendryk. The bedroom, I think."

I was scarcely aware of the carpeted stairs, the walls hung with paintings in gilded frames and the antique tapestries; nor did I count how many doors we passed along the length of a hushed, candlelit corridor; I only know that as we entered a spacious bedroom with gilded shutters, hung with silk and

damask, containing little more than a vast, canopied bed piled high with embroidered cushions, my whole body was trembling uncontrollably.

Adelma shut the door behind us.

"Well," she murmured. "Does it meet with your approval?"

"Yes . . . oh, yes."

"Sit on the bed, Hendryk."

I did as she commanded; but then, she could have told me to jump out of the window and I would have obeyed her.

"Now take your clothes off. All of them, mind! You must be quite, quite nude. I want to see *everything*."

"The wish is mutual," I said, beginning to undress, fumbling impatiently with buttons and cufflinks, yanking at the impossibly difficult little knot of my tie, tugging at my socks, then, with a certain apprehension, I admit, drawing my underpants down over my thighs. I let them fall and kicked them off altogether.

Adelma, naked now herself, stood to face me. She was indeed a goddess! A numen worthy of all devotion, a ravishingly flawless deity presiding over some exotic cult dedicated to the love and pursuit of beauty. Oh, I burned to be her initiate! I could hardly take my eyes from that cloud-like bush of fiery golden hair that crowned the luscious cleft between her white, slim thighs. To say nothing of the enchanting curve of her belly, the tender swell of her breasts – her mouth, eyes –

"It's a dream, Hendryk," she said softly.

"A dream of paradise . . ."

"No. Just a dream."

I was momentarily disconcerted.

"What do you mean?"

She came and sat by me on the bed. I felt the heat of her body against mine. How could it be a dream? She was here, with me . . . she was real, flesh and blood . . .

"I mean that you're dreaming. Or shall I sulk and insult you and call you names, since that seems to arouse you so swiftly?"

"No. I want you to be nice to me for a change," I answered in a whisper.

"I'll be whatever you want me to be. It's your dream, after all."

"But this is absurd! If I'm dreaming, then I'm not really here . . ."

"No."

"And if I'm not really here . . . where am I?"

"Are you sure you want to know?"

"Of course! Oh – no, wait – I'm not on a train, am I? Without a ticket?"

Adelma shook her head.

"A train? No. Why should you think so, my darling?"

"Let's not go into that right now. Where am I?"

"You're lying in the grounds of Schloss Flüchstein."

"What?"

"You were knocked down by a horse – or was it a cow? – but not badly injured thank heavens. Just a few nasty bruises. You're unconscious and you're soaked in cow's urine. Someone will come and carry you back into the house before very long."

"Oh my God . . . yes . . . I remember something hitting me . . ."

"Exactly. But there's nothing to worry about now. The cows have been driven off and father has another couple of trophies to stuff and mount."

I looked at Adelma shyly with, I confess it, perhaps a touch of cunning.

"Talking of mounting . . ."

"Yes, Hendryk?"

A thought suddenly struck me. I asked her:

"Where are *you* by the way?"

"In my room, of course. I'm reading *The Development of Stockbinder's Equation in Quantum Mechanics*. I stole it from father's library at the same time as *An Annotated History of the Cyrillic Alphabet*. I'm strictly forbidden to go there, but I don't care."

"Why are you forbidden?"

"Everybody is. Father says it's all nothing but millions of words. Words that aren't part of our world, that belong –"

106

"Out there," I said. "Beyond you."

"Yes. Anyway, I left your silly lecture just before the cows stampeded. Quite honestly Hendryk, I don't believe you *are* a leading authority in the art of yodelling; as a matter of fact, I don't think you know the first thing about it."

"No, I don't. The truth is, I don't even know who I am. Hendryk is certainly not my name. At least I don't think it is, although since I don't actually know *what* it is, I suppose it could be. I might still be asleep on a train, dreaming all this."

"But I told you, you *are* dreaming."

"Everything, I mean: Schloss Flüchstein, Mrs Kudl, the archbishop and his wife, the cows, your father . . . *you*."

"Oh, I'm real enough to a certain extent," Adelma said slowly.

"Only to a certain extent?"

"Yes. But this isn't. Sitting naked, side-by-side, on a sumptuous bed: all *this* is the dream."

"I think we'd be more comfortable if we stretched out, don't you?"

She looked into my eyes and smiled.

"Whatever you want, Hendryk."

Then she giggled.

She was everything – everything and more – that I could ever have dreamed of. But then, according to Adelma, I *was* dreaming. I kissed that incredible mouth and inserted my tongue so that it encountered hers and contrived an appointment with delectation; I sucked on her stiff little nipples, cupping her breasts in my hands and glancing up into her eyes as they narrowed in desire, astonishment, further hunger; I moved down toward the nimbus-crowned lotus-bud of her moist and delicate cleft, using my tongue again, then my fingers, then – finally unable to bear the all-consuming ache any longer – brought myself up and pushed myself in. Her legs folded around my back, her heels drumming rhythmically into my buttocks as the *ne plus ultra* of her passion was breached and gradually disintegrated.

She brought her mouth close to my ear and gently bit the lobe.

107

"Shall I abuse you and be contemptuous to you?" she whispered.

I continued to thrust steadily, knowing that very soon I would lose all control and pour myself copiously, helplessly, repeatedly, into her sweet body. It was therefore the perfect moment for her contempt . . .

"How dare you!" she murmured, the tenderness in her voice giving lie to the violence of her words. "How dare you do this to me? First you ogle my exposed body, then you fondle it shamelessly with your filthy hands – now – now you force me to submit to this vile, shocking act of penetration!"

"Yes, oh yes, I do . . ."

"You're a monster, an evil-minded brute! What do you think you're doing? Stop it, do you hear? I despise you, I loathe you –"

Then, as my climax took me and I fell shuddering against her sweat-filmed breasts, I whispered:

"Adelma . . . I love you."

At that moment, I truly did.

Later, holding her in my arms as we lay propped up on cushions beneath the silken sheets, I said:

"I wonder when I'll wake up? I'd like never to wake up. Then we could stay here forever."

"There's no such thing as forever, Hendryk. You can't stay lying out in the grounds of Schloss Flüchstein all night. You'd freeze to death. Then you'd never see me again."

"But the you I'll see when I wake up isn't the same you I'm with now, is it?"

"Unfortunately not. The waking me won't have made love to you like the dreaming me has just done. Or perhaps I should say the me that's *being dreamed*. I suppose it comes to the same thing in the end."

"What is this place, Adelma? Who is the baroness and who is Madam Petrowska?"

"I've no idea. I suppose they don't actually exist, except in the dream, that is. Is it important to know?"

"Perhaps not, but I'm curious all the same. Why did I

dream of *them* in particular? I don't know anyone called Petrowska. Or –"

A faint light dawned tenuous but definite somewhere in the subfusc cellar of my otherwise darkened mind.

"Or what?" Adelma asked. She began to toy with one of her nipples in an indifferent sort of way, but I saw it stiffen.

"Or perhaps I *do* know someone called Petrowska but I've forgotten. Maybe in my unconscious I haven't forgotten and she's still there somewhere, waiting to be remembered. That would certainly explain why she's a part of the dream I'm having now."

"Who could she possibly be?"

"I'm not sure . . . but her doctor has forbidden her to eat garlic sausage on account of her condition, whatever that is. Would I dream of such a very particular detail as that, if no one called Madame Petrowska actually exists? On the other hand, if in my real life – the life I can't for the life of me remember! – if I really *do* know such a person, who has been forbidden garlic sausage, wouldn't it be logical for her to pop up in a dream?"

I turned to look at Adelma, becoming quite excited now by the possible implications of my speculation, but her hand had slipped beneath the sheets and was moving down there in a sly, slow manner. Her eyes had assumed a faraway look.

"Is this boring you so much that you have to fiddle with yourself while I'm talking?" I said with a trace of irritation.

"Not at all," she answered in a purring voice. "I'm listening, truly I am."

"Don't you see? The first possibility is that I'm still on a train somewhere, fast asleep, dreaming everything . . ."

"Why do you keep going on about trains, Hendryk?"

"Never mind. That would be the best thing of course, because when I wake up I'll know exactly who I am. The second possibility is that everything that happened after I left the train is real enough . . . except the dream I'm having now."

"And you dream of the baroness and Madame Petrowska because they're people you really do know," Adelma said

sleepily, yawning. She wasn't stimulating herself now. In fact, she had almost drifted off.

"Precisely. Which means as soon as I find out who *they* are, it's almost certain that I'll begin to remember who *I* am. I'm being given a clue, my own unconscious mind is trying to help me. I'm sure of it."

"None of it makes any sense to me. Waking or dreaming, real or unreal, who cares? Besides, if you're still on a train somewhere, asleep and dreaming, that means I'm only part of the dream and not real. I don't care for that idea at all."

"Someone said exactly the same thing to me on the train."

"Who?"

"Dr Freud. He didn't care for it either."

Only half-awake though she was, Adelma took my manhood in her hand, gave it an affectionate squeeze, and laid her head on my shoulder.

"I must admit," I said, "I'm rather tired myself."

"Have a little sleep," she advised in a slurred, barely audible voice.

"But I'm already sleeping! Sleeping and dreaming, remember?"

"Can't you have a sleep within the sleep?"

"I don't think I should."

I closed my eyes, nevertheless.

"Why on earth not?"

"You never know . . . I might have a dream within the dream."

"That's impossible, you foolish boy," Adelma said.

"Are you certain of that?" I asked.

"Of course."

"You can't be certain of anything in –"

"A dream within a dream? How silly!"

But she was wrong.

★ ★ ★

110

At length I became aware of other voices – different voices, less strident but no more kindly – whispering like the rustle of dead leaves in a windswept alley. There was something sinister about them, but that might have been because they sounded so far away. Yet I could hear quite clearly what they were saying:

– *Oh, indeed, if he ever wakes at all, that is.*

– *It would be a miracle. Yes, a miracle.*

– *Ought we to yodel to him again? You know what they say: a familiar and well-loved sound, repeated often enough, might eventually penetrate the deep, dark place into which he has fallen.*

– *I think not, count.*

– *Perhaps we should give him another bed-bath? I'll do that. He won't thank us if he comes round and finds himself stinking.*

– *No, Malkowitz.*

– *What would you suggest, Dr Freud? Those damned cows, the murderous beasts!*

– *If I believed in God, I would suggest that we pray. As it is, I think watching and waiting is the only choice we have. There is always hope.*

– *By heaven, you're a man of compassion Dr Freud! Everyone says so, sir, and they aren't wrong.*

– *Thank you, Malkowitz.*

– *Are you quite sure about that bed-bath? I wouldn't mind just giving his wedding tackle a quick rub round . . . for his own sake, I mean.*

– *Very well, Malkowitz. You may proceed.*

It was this which dragged me up from the clinging, subfusc depths. The thought of Malkowitz giving my "wedding tackle a quick rub round" pulled me out of unconsciousness, like a fish thrashing on the end of a line, as perhaps nothing else could have done. In the darkness a light began to glimmer, tenuously at first then waxing with every passing moment. The veils of enforced slumber trembled and dissolved; the

denizens of my dreamworld fled into the farthest shadows before the advent of wakefulness; and when I finally opened my eyes – gummed and sticky – the first thing I saw was the meaty hands of Malkowitz clutching a silver bowl of water. Droplets fell, glittering onto the sheets.

"No!" I cried, shocked by the sound of my own voice. "I do not want a bed-bath!"

Startled, Malkowitz let the bowl fall with a harsh clatter. He stared at me incredulously.

"Why, he's awake!" he said.

I looked around the room: besides Malkowitz there was Dr Freud, Count Wilhelm and a portly man I recognised as Archbishop Styler: he was wearing a kind of black cassock with a little shoulder-cape edged in silver. His face loomed down at me. There were beads of sweat on the sides of his thickly veined nose.

"So," he muttered. "You're the young man who stripped and sodomized my wife in front of a crowd of applauding onlookers, eh?"

I had neither the energy nor the inclination to correct this gross distortion of the facts.

"How are you feeling?" the count asked in a much more sympathetic tone of voice.

"Poorly," I managed to whisper.

"I'm not surprised in the least! By God, it's a wonder you weren't killed outright!"

"What – I mean – what happened, exactly?"

"I can't say exactly, only roughly. They told me you were knocked down by a horse and almost trampled by a cow. We got to you just in time: much longer out there and you'd have frozen to death. However, Dr Freud has already given you a thorough physical examination and there are no broken bones, I'm glad to say."

"Dr Freud is a psychiatrist," I said.

"He's a doctor, isn't he? We considered that good enough under the circumstances. And Malkowitz gave you a couple of warm bed-baths."

"Oh, God . . ."

"Well!" Malkowitz cried. "There's ingratitude for you! Why, I should have left you in your own filth!"

"Come now Malkowitz," Dr Freud interjected. "There is no need to be bitter. Remember, Hendryk has undergone a deeply traumatic experience, sustaining physical *and* mental damage. He probably doesn't realise what he's saying."

"I *do* realise!" I said, "and I'm *not* mentally damaged!"

"Then you're just an ungrateful bastard," Malkowitz muttered.

"Are you feeling hungry?" the count said quickly.

"Ravenous."

"I'll have Mrs Kudl bring you up some toast."

"Bread?"

"What else do you think you can make toast from?" Malkowitz snorted with contemptuous hilarity. "Slices of smoked ham? Breast of duck? Rare roast beef, slick with its own juices, chicken grilled with butter and garlic, bacon and asparagus flan, savoury jellied pies, risotto – *spaghetti* – ha, ha!"

I began to weep.

"Dr Freud has decided that it would be best to restrict your diet at present," Count Wilhelm said, trying to sound concerned and consoling but failing miserably. "He wants to be sure that you haven't twisted any tubes or flattened your diaphragm or anything of that sort."

"Flattened my diaphragm? That's rubbish!"

"Are you still accusing Dr Freud of talking rubbish?" Malkowitz demanded threateningly.

"Yes."

"Look," the count went on, "we're only thinking of *you*, you know. We want to see you up and about again as soon as possible. After all, you'll have to give your lecture again."

"What?"

"Well, you'd barely started before those savage beasts broke loose. Everyone was so much looking forward to it. They're penned in now, on the edge of the forest, so they can't do any more harm, not for a while, anyway. Just try to do without the practical demonstration, next time."

"There won't *be* a next time," I said, wiping my eyes with the back of my hand. I was beginning to feel foolish for giving in to such a display of emotion.

Count Wilhelm said in a distinctly odd tone of voice:

"Oh, but I insist, dear boy. You shan't leave here until you give that lecture."

I looked slowly around the room, then at their faces.

"I must get back," I said.

"What, to that field out there? To the maddened cows?" Archbishop Styler cried.

"Of course not! To the room, I mean."

"What room? This room? You *are* in this room dear boy!"

"I dreamt I was in a bedroom . . ."

"Aha!" Dr Freud said loudly, waving one gnarled finger in the air. "It is undoubtedly a symbol of the womb. He wishes to return to the maternal uterus."

"Rubbish," I countered as decisively as I could.

"Can a womb be anything *other* than maternal, doctor?" the archbishop asked in an almost professionally interested tone of voice.

"Certainly, Your Grace. If, for example, it belongs to your sister, who is barren."

"How do you know my sister is barren?" Archbishop Styler said, his face reddening.

"I don't. I merely use it as an illustrative hypothesis."

"But she *is* barren!"

"After all, we do not assume that every penis is *paternal*," Dr Freud went on. "Even though Harkbender in his *Psychology of the Male Anatomy* virtually proved that in certain cases –"

"I dreamt I was in a shuttered bedroom –"

"Shuttered, eh?" Dr Freud murmured. "That would indicate difficulties in the sexual act. The womb is barred to you, that's what the shutters mean. Are you impotent? Do you have trouble sustaining an erection?

"You should ask Adelma that," I said with a brief little smile.

"You insatiable blackguard!" – that was Malkowitz, of course.

114

"Besides, your interpretation is incorrect, doctor. I wasn't trying to get inside the room, I was already there."

"In which case," Dr Freud declared. "It means you do not wish to *leave* the womb and are therefore suffering from a psychotic infantile dementia. Pure regression in its most untreatable form."

"Adelma was in the room with me," I continued, ignoring this absurd and insulting diagnosis. "We were both naked."

"You dirty beast!" – Malkowitz again.

"And I have to get back."

"What for?"

"Because after Adelma and I had made love – vigorously so – there was a dream within the dream. Something happened. There was another room –"

"He's raving," Malkowitz muttered.

"Will you shut up!" I shouted at him.

"Now then," said the count, "there's no need for violent language. You're sick in both body *and* mind. You need rest, sleep, plenty of hot buttered toast –"

I pulled myself up onto my elbows.

"If you say another word about toast," I said, "I'll knock your fucking brains out. I can't put it any plainer than that."

"Quick, quick! You'd better inject him with something, doctor," Malkowitz hissed to Dr Freud. "He's becoming obscene and abusive. He can't control himself, if you ask me."

"No one *is* asking you, you fat, meddlesome, disgusting moron!"

"He's calling me fat again, doctor –"

"I think this calls for a public ritual," Archbishop Styler put in. "In spite of the fact that he almost tore my poor wife's insides to shreds with his vile act of repeated rape, I pity the boy. He needs a Rite of Healing. A public ritual. I'll arrange it."

"I don't want one of your absurd rituals!" I cried.

"The sooner the better in my opinion," Dr Freud said in his querulous old voice.

They began to move away from the bed and Archbishop Styler had the door open. Malkowitz was close behind,

pushing him out with his shoulder. Dr Freud glanced back at me pityingly.

"I'll have Dean Kurmer in for a meeting straight away," the archbishop called from the hallway. "Dr Freud, you can sedate him if necessary."

"Or put the maniac in chains," Malkowitz added fearfully.

Dr Freud closed the door noiselessly behind them.

I lay there for some time, staring up at the ceiling and thought tenderly of Adelma. I dreamt I had made love to her, but it seemed so gloriously real. Did she remember that dream too? As vividly as I did? Or perhaps her slumbering psyche knew nothing of it? I had to find her and ask her.

Getting out of bed was easy enough, but keeping myself steady on my legs was a more difficult task. At first I held onto things for support: the iron bed-head, the nightstand, the side of the wardrobe . . . then I managed to move slowly into the centre of the room, holding my arms out to balance myself . . . and by degrees I reached the door. After this I forced myself to walk back to the bed again, then to the door once more. I did this several times before I began to feel sure of my footing. I experienced a slight dizziness, nausea almost, but I attributed this to the fact that I had been lying down for – for how long, exactly? – for some time, anyway. My stomach was rumbling, I was so hungry. My right side ached a little and when I moved too quickly a pain shot through my lower back. Apart from this, however, I seemed to be in reasonably good repair. Dr Freud's nonsense about a flattened diaphragm was precisely that: nonsense. I opened the door and walked out into the hallway.

Where would she be, my beautiful Adelma? She could be anywhere. I made my way along the corridor toward the stairwell at the end of it, keeping one hand pressed against the wall to steady myself. Progress was not swift, but it was sure. When I finally reached the stairwell I looked down over the balustrade to the floor below, which seemed to be the entrance hall of Schloss Flüchstein, for I recognised the pretentious black-and-white marble flooring. I turned away and began to climb up to the floor above. There, I came to another corridor which was hung with peculiar diagrams in gilt

frames. They looked incomprehensible to me, all scribbles and numbers and esoteric algebraic formulae. At the end of it was a single black door. Was there no other room on this floor? Apparently not. However, if there was somebody in there, perhaps they could tell me where to find Adelma. It was a possibility, anyway.

When I came to the door I put my ear to it for a few moments, but could hear nothing save a faint rustling or scratching sound. I knocked softly on the hard, lacquered surface. No reply. I knocked again. Then a third time, a little more forcefully.

"I heard you, I heard you!" a voice cried out from within.

I put my hand on the brass doorknob and turned it slowly. Then I pushed the door open about six inches. There was a dim light showing.

"May I come in?" I said.

"Are you a mathematician?"

"No."

"A philosopher?"

"No, I'm not."

"You reject as invalid the search for universal wisdom?"

"I think it's a lot of baloney."

"That makes you a philosopher."

"Does it? In which case –"

"Are you a physicist, biologist, theologian, astronomer, astrologer, phrenologist or cartographer?"

"None of those, I'm afraid."

"Don't be afraid, it's a good thing."

"Why?"

"Because I'm *all* of them, and if you were too, both of us in the same room would cause the inter-dimensional atomic sub-structure to implode. I'm certain of it."

"In my experience," I said with a note of sadness, "you can't actually be certain of anything."

"Are you certain of that?" the voice answered.

I knew I had already been through this exchange several times, at least once on a train, but before I had time to think of something to say in reply, he added:

117

"In which case, you may enter."

The room, which was large, looked as though the inter-dimensional atomic sub-structure had *already* imploded; either that, or Count Wilhelm's blood-crazed cows had trampled through it. It was in complete and utter chaos: books, manu-scripts, sheets of paper, journals and notepads were scattered everywhere; a couple of chairs lay overturned and abandoned; half-burned candles in makeshift holders stood on every avail-able surface; there were unwashed, crumpled clothes – socks, underpants, vests, shirts – bundled in murky corners; here and there I saw the remnants of long-discarded meals, including a chop with a single bite taken out of it, covered in dust and turning green. The thick curtains were drawn against the light and at a desk in front of the window, totally covered in detrius, sat a tall, angular man with long, straight silver hair that reached down to his shoulders and a white goatee. He was wearing thick-lensed spectacles and dressed in a shabby, stained dressing-gown. He blinked several times as he stared at me.

"Who are you?" he demanded. His voice was slightly shrill and even more slightly mad.

"I don't know."

"Good. That's a perfectly acceptable beginning. One of the best, indeed. Why are you wearing only a nightshirt?"

"I've been in bed."

"That is not the answer I require."

"Why?"

"Because it merely indicates that, as might be expected, you wear a nightshirt in bed. It does not explain why you are wearing one now. It's like walking naked in the street and, when asked why, saying that you were in the shower."

"I forgot to get dressed."

"That's better."

He nodded and extended a long, thin arm. The hand was skeletal, like a claw. Then immediately he withdrew it.

"I am Professor Bangs," he said.

"I've heard of you."

"How?"

"The count mentioned you once or twice. He said we would be unlikely to meet you because you were so busy with your magnum opus."

"I'm *always* busy with my magnum opus. Not just some of the time, but always."

"May I sit down?" I asked.

"Can you find anywhere to sit?"

I glanced around the room helplessly.

"I don't think so."

"Then you'll just have to stand. I do that a great deal. The mess doesn't bother me, Herr – well – what shall I call you?"

"Hendryk will do."

"Hendryk, then. Oh, dear me no. I've become accustomed to it, you see. Twenty years ago this room was spotless, clean as a new pin, perfectly neat and tidy. I couldn't possibly go back to that, my nerves wouldn't stand it. I know where everything is, even though to you it might appear a total shambles. With familiarity, one finds order in disorder. It is known as the Infinite Variability Factor."

"Who called it that?"

"I did. Do you like it?"

"I don't know what it means," I said.

"It isn't necessary to know what a thing means in order to like it. Do you like roast chicken?"

"I'd rather we didn't talk about food, if you don't mind. But yes, I like it."

"Do you know what it means?"

"Roast chicken? It doesn't mean anything, does it?"

"Aha!" cried Professor Bangs, leaping out of his chair and pointing toward the ceiling with one skinny, trembling finger. I was quite startled. "There you have it!"

"Have what?"

"The essential question posed in my magnum opus, of course! Do things have meaning? Does *anything* have *any* meaning at all?"

He began to pace the room nervously, his shoulders hunched. He looked like a tall, emaciated bird. I lowered myself gingerly onto a little pile of leather-bound books.

"That," Professor Bangs went on, "is the question which has consumed me for so many years. I convinced myself, and I stand by this conviction, that in order to arrive at any answer, I would first have to construct a theoretical map, or a map of theory, whichever you prefer, of every philosophical, psychological, mathematical and otherwise scientific scheme ever devised to explain the meaning of things, then collate them into one inevitably vast and complex whole, fitting them together like the pieces of a great jigsaw. The picture that would emerge, so I deduced, would be the answer to my question: the question of *all* questions. However, it had to be absolutely complete, without any internal contradictions or lacunae. Theology and God I decided to leave out of it, since apart from certain strands of philosophical thought which contradict each other anyway, psychological, mathematical and otherwise scientific schema reject both as untenable and certainly unnecessary. It also made my task, already mind-bogglingly mammoth, a little easier. Although 'easy' is not a word I would willingly use about any aspect of it whatsoever.

"I decided to create my theoretical map using the cube as a basic methodological tool: each discipline would have a cube of its own, would *be* a cube, and every statement of explanation as to the *meaning* of a thing or things would be placed in the appropriate facet of the cube to which it properly belonged. When the cubes finally held all that has ever been spoken, written, discovered and demonstrated – from within whatever discipline – about meaning and explanation, I would fit them together into an entirely and absolutely coherent whole. I called it *Unus Mundus Cubicus*. For example: if mathematics tells us that $C3 = XX2 \, xC = ß$, this would be placed on the second facet of the advanced mathematical theory cube, related to quantum formulation. You see how simple it is? Or again, if psychology states that the capacity for initiating and sustaining relationships in adulthood depends upon the infant's experience of fundamental affirmation on the part of the primary caregiver, that particular little nugget (which I can tell you from personal experience is indubitably valid) would go on the fourth facet of the

theory of human behaviour cube, related to ego-development. Naturally, I had to leave that ghastly old charlatan Jung off the cube altogether: all those serpents and circles and psychic squiggles. The man was as mad as a hatter! Freud on the other hand was quite acceptable: no-nonsense, straightforward filth. He was nothing more than a pornographer. Not that there's anything wrong with that, you understand. Pornography, indeed, has its own facet on the psychology of human sexual behaviour cube.

"The trouble was, after spending years and years collating the material to put on the cubes, I began to find that they didn't actually fit together as I had anticipated they would. There were awkward angles of contradiction, clumsy corners of mutual exclusion jutting out here and there, lines of implication and development that did not run quite parallel. So I was obliged to begin *removing* data from the cubes: pulling away bits and bobs, snipping edges, re-shaping the pieces of the jigsaw to *make* them fit. What else could I do? I started to lose too much material, in the end. My wonderful, perfect, glorious *Unus Mundus Cubicus* gradually became denuded; I found myself being too selective in my sources; by slow but inevitable degrees the fabric of my nexus of meaning and explanation for everything that exists was unravelled. My heart was unravelled with it.

"I've started to reweave and rebuild it but I'm running out of time, and I am afraid that the *Unus Mundus Cubicus* will never be completed now. The very thought fills me with panic and terror! Who is there to carry on my work? No one! In which case it will all be lost, abandoned and left to rot. Oh, help me! I can't let it happen! Nobody here gives a sausage about my work, nobody even begins to understand the importance of it. They're all preoccupied with their own trivial, idiotic concerns! Count Wilhelm only cares about hunting down and mounting his ridiculous cows. I do not say this in a sexual sense of course, although I believe that *has* occurred once or twice in unseasonably warm weather; Archbishop Styler is a complete fool; Dimkins is starving his wife to death in a particularly shocking manner; Adelma —"

121

"I wanted to ask you about Adelma," I said quickly, before Professor Bangs had a chance to go on. "Do you know where I might find her?"

I saw his black, beady eyes narrow behind the thick lenses of his spectacles.

"Why do you want to know?" he muttered. "Aha! I understand now! You are the latest in her endless series of paramours, are you not?"

"I love Adelma, Professor Bangs."

"Rubbish! Cube 7b, facet 3 referring to the nature and function of human instinct: lust is a personalised refraction of the instinct to mate and propagate the species. You do not love her Hendryk, you *lust* after her, which is quite a different matter. Neither should you deceive yourself: Adelma herself is incapable of love."

I rose unsteadily to my feet and drew up my shoulders, causing a sharp pain to shoot through them. I must have been quite badly bruised.

"I shall *make* her love me!" I declared.

"You're mad."

"No, Professor Bangs, it is *you* who are mad. You and your ridiculous *Unus Mundus Cubicus*. You have spent your life in pointless calculations and futile equations. You have been unable to arrive at an answer to what you call the 'question of all questions', and I can guess why."

Professor Bangs now rose. He was trembling, blinking at me behind those distorting lenses, his mouth opening and closing like a fish. Then he hissed:

"You *know*?"

"I told you, I can guess."

"How? Never mind! Tell me, tell me this instant! What have I missed? What was lacking in my labour of research and collation? Did I go wrong? Did I follow a false trail somewhere? Speak! Answer me!"

He reached out with bony hands and gripped me by the shoulders. Then he sank slowly to his knees. I heard the crunch of withered cartilage.

"Don't torment me!" he cried. "Don't do this to me!"

I said calmly:

"Perhaps the answer is: *there is no answer.*"

Professor Bangs dragged himself to his feet again by the folds of my nightshirt. He almost yanked it off altogether. He brought his crinkled, despairing face close to mine.

"Are you absolutely certain of that?" he whispered.

"I had thought that one can't be certain of anything, but you proved me wrong, didn't you? It would have been easier on you if you hadn't."

He screamed. It was a long, attenuated, piercing scream of horror and revulsion, the scream of a soul lost in some dreadful agony that it knows will never come to an end. However, the scream itself *did* come to an end in a sort of lingering, sibilant burble.

He said:

"There *is* no answer. But surely if that is the answer – that there is none – there *is* an answer! Therefore the statement 'There is no answer' is self-contradictory. Which makes my *Unus Mundus Cubicus* utterly and entirely irrelevant, because as soon as one admits that the answer it is designed to discover does not exist, one has the answer already, without any need for either source material or its collation. It is a circle and I cannot find my way into it or out of it! Am I in or out? I don't know. I can't think –"

Professor Bangs turned slowly away and walked toward the high, curtained window. He drew the curtains aside with a swift, snatching movement of one talon-like hand. Daylight flooded the room and a million motes of dust suddenly swam around us, like minuscule fish in an undulating, enveloping school.

He pulled open the windows. A sweet-smelling breeze penetrated the ancient fustiness.

"What are you doing?" I asked.

Without replying – in complete silence, in fact – Professor Bangs climbed up onto the windowsill and jumped out. A split second later, somewhere outside, two floors below, I heard a sickening thud.

At that moment the door opened and Count Wilhelm entered with Dr Freud and Malkowitz.

"So there you are," he said. "Where is Professor Bangs?"

"He jumped out of the window."

The count snorted impatiently.

"Not again!"

"You mean," I cried, "he's done this before?"

"Of course. Several times. It happens when he gets agitated about his magnum opus. Some rubbish about cubes not fitting together . . . I don't pretend to understand it, no one does. Do you?"

"Not in the slightest. But what about the professor?"

"Oh, he'll be all right."

"How can you be sure?"

"After the first time he did it, we had the terrace paving stones below covered with a sort of thick latex material. He'll have a bad headache and a severe nosebleed, but that's all. Maybe a fracture or two."

"What about *you*?" Dr Freud asked cautiously.

"I'd say he was still crazy, by the look of him," Malkowitz murmured.

"I am greatly recovered," I went on. "Just a little pain in the back and shoulders, nothing more."

"I'm relieved to hear it."

"We'll have to go ahead with the Rite of Healing I'm afraid," Count Wilhelm pointed out. "A lot of old stuff and nonsense I know, but the archbishop has gone to a great deal of trouble to arrange it all. Martin Martinson has composed a new piece especially for the occasion. We can't let everyone down, not now."

"Will Adelma be there? I'd like to talk to her."

The count suddenly winked at me in a distinctly lewd way.

"Talk? Oh, yes, that'll be right! Talk, my eye. I know what you want to do with Adelma, you filthy young dog! Give her a thorough seeing to, eh? That's more like it! Well, good luck to you. It's perfectly obvious to me that you've made a marvellous recovery."

"Thank you, excellency," I muttered.

"Certainly Adelma will be there."

"Then so will I."

The Rite of Healing was scheduled for three o'clock that afternoon.

I was taken to the Cathedral of the Keys-in-Triplicate in a sort of open carriage. To my amazement, crowds lined the streets, cheering and applauding enthusiastically. Although they stood in perfect rank and file, they were occasionally whipped in a savage manner by uniformed guards. I managed to catch snatches of conversation as we passed:

"There he is! Oh, look, it's him!"

". . . so Franz and I will definitely be at the second lecture . . ."

"Turned into a raving lunatic, they say. As mad as the count's cows. But so strong, so brave! Hurrah!"

"It's a miracle!"

Then, somewhat incongruously:

"I thought he looked much nicer in the skirt."

Beside me in the carriage sat Count Wilhelm, covered in medals and official decorations, wearing a ridiculous pseudo-military hat with copious white plumes that nodded and bobbed in the faint breeze. Opposite me were Dr Freud and Malkowitz, both in black suits and cravats; Malkowitz's suit, like his uniform, barely accommodated his greasy bulk. He reached down and scratched his testicles.

"Must you do that?" I said. "It isn't dignified."

"What would you know about dignity?" he muttered peevishly.

Dr Freud said:

"Now, Malkowitz, you must try to enter into the spirit of the occasion."

"Yes, sir. For your sake, Dr Freud."

His continual sycophancy was revolting.

Then Dr Freud tapped me on the knee, leaned forward and whispered:

"We may find the Public Records Office here."

"I don't think it matters much now, do you?"

"Why?"

I shrugged.

"But surely you wish to discover who you really are?"

"No time now, Dr Freud. Look, we're here!"

As we approached the steps of the cathedral the crowds grew thicker and more exuberant. One or two hats were tossed into the air. The bells began to ring. I saw Archbishop Styler, accompanied by an entourage of deacons, acolytes, candle-bearers, clavifers and thurifers, emerge from the gloom beyond the great bronze doors. He was sumptuously vested in a lace alb threaded with tiny pearls, a golden cincture, maniple, richly embroidered stole and a voluminous cope worked in gold and silver thread. On the front of his magnificent mitre, picked out in rose damask and red velvet, were the interleaved Keys-in-Triplicate. Clouds of white incense billowed from the jewel-encrusted thuribles, swung with an almost geometrical elegance by flaxen-haired youths. I could hear the choir singing inside the cathedral: a slow, plangent, progression of bitter-sweet harmonies, rising higher and higher by degrees, touching some ethereal plateau where all was languor and light. It was rather moving.

As we were descending from the carriage, Count Wilhelm nudged me with his elbow and whispered:

"Don't forget, it's a Rite of Healing, which means you're meant to be unwell. Try to *look* unwell. At the end of the service you can leap up entirely recovered, and the archbishop will declare another Public Holiday in perpetual remembrance of the occasion."

"I'll do my best," I said.

Inside the packed cathedral all was sweet odours, cool shadows, the glint and glimmer of gold, the shy presence of the numinous amid the interplay of darkness and light; polychrome saints looked down from their lofty niches: St Parthexus with his gilded phallus, St Romo and the blind lion, St Averina carrying her lacerated breasts on a silver platter; votive candles winked before gaudy shrines; above the High Altar was suspended a huge icon of the Keys-in-Triplicate, wreathed in the smoke of ambergris, rosemary, cedarwood and myrtle. Great shafts of air bisected the tene-

brous interior, their passage and dispersal echoing the whispered supplications of a thousand worshippers. Ranks of gorgeously-robed acolytes were already assembled on the marble sanctuary, which was inlaid with lozenges of onyx and porphyry. The choir sang "*Behold the Beginning of the End*" and "*Thrice-Blessed Three, in Triplicate Key*", both texts set by Martin Martinson I later learned, who was Director of Music. This latter was particularly affecting: a strictly mathematical construction in (so I guessed) the post-Cilean mode, each voice postulating a thesis, antithesis and harmonic synthesis before becoming part of a never-ending canon that ascended from the base note of the mode, taking in all the accidentals, rising to a poignant climax on the dominant, then descending again to come to rest on a sustained collective susurration in the minor. Something like that, anyway.

In the sacristy, a gathering of deans, deacons and sub-deacons, all fabulously robed in cloth-of-gold, was waiting for me.

A red-faced, portly man stepped forward.

"Ah!" he cried effusively. "I am Dean Kurmer. You must be Hendryk, our sacrificial lamb."

"Not literally, I hope."

"Well, not quite. Ha, ha! But you *are* the centrepiece of our Rite of Healing, are you not?"

"Apparently so," I said non-commitally.

"Oh, don't worry, there won't be any of that charismatic, pneumatic, catatonic stuff-and-nonsense here."

"I'm glad to hear it."

"You see," Dean Kurmer went on, "we broke away from the One Antique, Gnostic and Apostolic Church some time ago, and Archbishop Styler declared himself Supreme Primate of the Church in this part of the world. Count Wilhelm is Defender of the Faith of course, but that doesn't mean anything because there isn't really anything to defend. There was far too much dogma, you see – fixed and immutable and necessary for salvation and all that nonsense – but we prefer a more subtle approach, open-ended and only vaguely defined. Leaves a lot more room for manoeuvre. Then there were far

too many rules and regulations. For one thing, the clergy was celibate; this was rather a problem, since His Grace wished to marry Anya Ognarovitch, the lady who now has the honour to be his wife –"

"So clerical celibacy was abolished?"

"Good Lord, no! We're not extremists, that's the whole point. We constitute a *via media*. Celibacy was abolished *only* for the holder of the office of Supreme Primate."

"Which happens to be Archbishop Styler."

"Exactly. Not only that, we have more than fifty public holidays – religious festivals established by the archbishop – each one of them on every *fifth* first day of the month."

"But surely – I mean – that's not mathematically possible."

"We are speaking of *spiritual* matters, young man, not mathematical. Besides, it's perfectly possible if it's always the first day of the month. The *fifth* first day is also when His Grace plays quoits with the count."

"How convenient."

"Yes, we think so," Dean Kurmer said without a trace of sarcasm. "Our guiding tenets have remained constant since the breakaway: nothing too hard-and-fast as far as belief goes, lots of time off for everybody and splendid public rituals. What more could you want?"

"How about moral guidance?"

Dean Kurmer shook his head vigorously.

"Messy business," he huffed. "Moral guidance has caused no end of trouble for the One, Antique Gnostic and Apostolic Church; we're glad to be out of it. Besides, what a man does in private is his own affair. Or a woman. Or even what a man and a woman do *together* in private – ha, ha! It isn't our job to go poking around in the bedroom. There's enough poking done in bedrooms without our help. Now, I suggest you strip down to the buff and get the sacred robe on. There's a rack of them over there. Size fifteen will fit you perfectly, I should think."

We processed out onto the sanctuary in splendid formation: thurifer, clavifer, candle-bearers, sub-deacons, deacons, deans – then myself – and, walking beneath a crimson damask canopy held by four Guardian Knights of the Keys-in-Triplicate,

Archbishop Styler. The congregation rose and together with the choir sang *As Above, So Below* in a key which was not familiar to me.

"Bow to the people," Dean Kurmner whispered.

I did so.

"Now lay upon the Altar of Secondary Ineffability."

"Where's that?"

"Right in front of you."

Indeed, there was a kind of portable marble slab with multi-coloured porphyry supports before the High Altar. I climbed up onto it slowly and lay stretched out on my back. I had glanced into the congregation at the first opportunity, but had not noticed Adelma. I shivered. I was wearing only my off-white sacred robe – whether off-white by design or negligence I could not tell – and was feeling distinctly chilly. I looked up into the far-off cerulean blue of paradise, populated by *putti* bearing garlands of roses and dotted with gilded stars that required neither night nor darkness to glimmer and gleam.

"Our brother Hendryk is sick unto death!" the archbishop declared with brazen exaggeration. "Therefore we invoke the infinite and everlasting power of the Keys-in-Triplicate! We offer our praise and supplication for his restoration to health, we bless his body with the chrism of recovery, we call upon the benevolent grace of thrice-blessed keys to effect the healing that we, in our miserable weakness, cannot."

His mitred head leaned down toward me.

"Now I will perform the anointing," he said in a soft voice.

"Thank you."

"You must remove your sacred robe."

"But I'm not wearing anything underneath."

In a sudden and distinctly malicious tone, he hissed:

"That's right, let them all get a good eyeful! Just like they did with my poor wife."

"I've already explained about that –"

The sacred robe was pulled down over my body and whipped away by two smirking young acolytes. I quite clearly heard one of them whisper to the other:

"Not much to be modest about, is there?"

Then the anointing itself began.

Archbishop Styler dipped his forefinger in a small silver dish carried by his personal attendant and traced the sign of the Keys-in-Triplicate on my forehead; then my lips; then my throat, nipples, belly-button and – mercifully passing over my genitals – knees, shins, the soles of my feet.

I felt myself beginning to doze off. I couldn't help it! I tried, at first, to steady and hold my fluttering eyelids – to will away the dense cloud of ambergris-fragrant narcosis that began to enshroud me – but it was to no avail. I felt slumber creep over me and steal away consciousness like the advent of dawn stealing away a pale silver moon. The last thing I heard was the plagal cadences of the choir:

"Isax punquit dy tixana dex – pqarnix deta suluuit pyx."

"What's that?" I managed to murmur.

"The ancient, mysterious language of the primeval sacred texts," Archbishop Styler said, smearing more oil on the soles of my feet and making me shiver. I *think* I had remembered to wash them that morning.

"What does it mean?"

"Nobody knows. If we knew what it meant, it wouldn't be mysterious, would it? Idiot."

Then I succumbed.

★

She awoke me with her kisses . . .

. . . on those very places the archbishop had anointed: forehead, lips, throat, nipples, belly-button and – ah, this time not leaving out my stirring manhood! – before pressing her mouth to the soles of my feet. She moved beneath the sheet.

"Adelma . . ." I murmured.

Then she wriggled upward, her head emerging beside mine on the warm, damp pillow.

"You're awake, then," she said.

"Am I?"

"Well, technically, no. You're still dreaming."

I felt my stomach heave with anxiety as well as desire.

"You mean, have I just awoken from the dream within the dream? That second room where a man was waiting for me, expecting me?"

"You never told me about that . . ."

"I haven't told anybody yet. Oh, God, don't say it! Professor Bangs and his *Unus Mundus Cubicus* . . . the Cathedral of the Keys-in-Triplicate . . . was that all a dream too?"

"Of course not, silly. You're still lying on the Altar of Secondary Ineffability. Being in bed with me is the dream, just like it was before. When I say you're awake, I mean you've fallen asleep and awoken into the dream again."

"Is that possible? To *wake* into a dream?"

"Certainly."

I drew her toward me and put my tongue into her lovely mouth. I cupped one ripe, impertinent breast in my hand and squeezed gently.

"Be careful," she said gently.

"Why?"

"Because if you don't, you'll get an erection in front of the whole congregation. That isn't supposed to be part of the Rite of Healing."

"Archbishop Styler could institute another public holiday —"

"He will, anyway."

" 'The Feast of the Holy Upright.' "I said, feeling the need to giggle.

Adelma sighed prettily.

"It can't go on forever, Hendryk."

"Can't — can't *this* bit of it — go on forever?"

"I'm afraid not."

"I'd like it to," I murmured.

"So would I. But I'm afraid liking something almost always ensures that you won't actually get it."

That was a thought I did not care for.

"In my experience, anyway," she added.

She drew the sheet over our heads and in the warm, skin-smelling darkness our faces came close. I felt the gentle

flutter of her eyelids, the slight brush of her lips against mine . . .

. . . and she began to hum some strange, undulating melody, wordlessly at first, then in low, sibilant syllables, her voice increasing in volume, gaining momentum . . .

. . . *isax punquit dy tixana dex – pquarnix deta suluuit pyx* . . .

★

"Thrice-blessed be the all-hallowed Keys-in-Triplicate!" Archbishop Styler cried.

"Amen!" the congregation responded enthusiastically.

"Ever glorious, ever infinite, ever always and always forever!"

"Amen, Amen, Amen!"

The great organ of the cathedral rolled forth a mighty torrent, a tidal wave of crashing, thundering, overwhelming sound. The bells rang, thuribles were swung, banners were hoisted high, the congregation applauded and I peeked down at myself to see with understandable relief that this exultation was not in honour of my erection but the conclusion of the Rite of Healing. I climbed off the Altar of Secondary Ineffability and was attired once again in my sacred robe.

Behind me I heard an acolyte whisper:

"You can have me, if you want."

"Thank you," I hissed back without turning round, "but I don't."

"What's wrong with me?"

"Nothing. I just don't want you, that's all."

"All the clergy have had me." There was a snigger. "Sometimes on the High Altar itself."

"I'm not a member of the clergy," I said, becoming rather irritated now.

"Pedantic bastard."

I whipped round to face my importuner, but instead of the blond acolyte I had expected, I saw a wizened, swarthy, cruel-eyed dwarf. His cassock trailed on the marble floor of

the sanctuary. He looked grotesque. He grinned at me like some lewd monkey and I quickly turned aside.

"Are you ready to proceed, my son?" Archbishop Styler said, casually kicking the dwarf away with his right foot.

"Only too ready," I replied.

And we made our way, wreathed in sweet-smelling incense, down the nave of the great cathedral.

Outside, on top of the steps, Archbishop Styler raised his arms and the roar of the huge crowd subsided.

"Our brother Hendryk has been restored to us!" he cried. "Praise be the all-holy Keys-in-Triplicate! In perpetual memory of this felicitous event, I hereby declare a public holiday, now and hereafter to be called 'The Feast of the Glorious Recovery'!"

"Superfluous too, in my opinion," I muttered. "I was never ill in the first place."

The archbishop smiled slyly.

"The faithful will never know that, will they? Listen to them!"

To renewed acclaim, we descended the steps and I climbed into the waiting carriage with Dr Freud, Malkowitz and the count. I was still wearing my sacred robe. I suddenly hoped it would not become as permanent an accoutrement as my rhinestone skirt. Even so, I could not help smiling.

"You seem in good spirits," Count Wilhelm remarked, squeezing my knee as we took our seats in the carriage.

"Yes, I suppose I am."

"Is he still insane?" Malkowitz asked half-fearfully. "Has the Rite of Healing worked?"

"It must have done," I said. "It's given me an idea. A wonderful idea."

"What, exactly?"

"Never you mind. All I can say is that I'm feeling distinctly cheerful about it."

Had I known what was soon to happen, I would not have indulged myself in this buoyant mood. That's for sure.

★ ★ ★

I asked the count to provide me with pen and paper and told him that I wished to write a letter of gratitude to the archbishop.

"That's jolly sporting of you," he said. "His Grace is always grateful for appreciation and thanks, especially when he's taken particular trouble with a public ritual."

"It's the least I can do."

"Oh, while you're at it, perhaps you ought to try and convince him that you haven't laid a finger on his wife since the . . . incident."

"But I haven't!"

"Well, it shouldn't be too hard to convince him then, should it? I admire and respect a man who can control his baser sexual urges. I realize it can't be easy for you. Well, I'll leave you to it! As soon as you've finished let me know, and I'll have Dimkins take it round to the cathedral. By the way, shall I tell Mrs Kudl to fix you up with some toast?"

"Actually, count, I'd prefer something a little more substantial. The fact is, I've had nothing but bread ever since I arrived."

Count Wilhelm punched me hard but playfully on my arm. I winced.

"And whose fault is that, eh? Truth is, the supplies haven't arrived yet, and the kitchens are quite bare. Apparently old Erik Schlägermann has had a heart attack, and they're still looking for another driver. Erik is Gustav's father. You remember I told you about Gustav? He's the one who had his cock and balls ripped off by one of my cows. Do you want that toast or not?"

"Thank you, no. I've asked Dr Freud to let me know when the gong for dinner has sounded."

"Please yourself!" the count said in a jolly manner. He left the room, shutting the door noisily behind him.

I walked slowly over to the desk in front of the window and

looked down at the stack of gleaming white paper the count had provided. There were two pens, a small glass bottle of black ink, and a large virgin blotter. Very shortly I would take up one of the pens and would begin to write. I sat down. For a moment or two I stared out of the window, thinking of nothing in particular.

All at once there was a knock on the door.

"Yes?" I snapped, irritated that my reverie had been so soon disturbed.

"Can I come in?"

"Who is it?"

"It's me, Malkowitz."

"Then no, you can't."

"Hendryk – *please!* – I want to talk to you."

I hesitated for a moment or two, then I said:

"All right, you can come in, but make it quick."

The door opened and Malkowitz slowly edged into the room. I think he was still a little afraid that in a sudden fit of madness I would take a knife to him. The truth is, I was really rather amused by this absurd notion. Or, rather, by its effect on him.

"Am I disturbing you?" he asked.

"You always disturb me, Malkowitz.'

"The feeling's mutual, I can tell you that much!"

"Is this all you came here for, to insult me? Because if so –"

"No – no – it isn't that," he replied, his voice suddenly lower, less aggressive.

"Well, what *do* you want?" I said.

Without being invited, Malkowitz plonked himself down heavily on the edge of my bed.

"It's a bit awkward," he began. "I mean, I'm not sure how to, well –"

"How to what?"

"I thought what with you being the way you are and all that . . ."

"All what?"

"Look, don't think it's been easy for me to come to you like this, because it hasn't! I had to nip down to the kitchen

and persuade Mrs Kudl to let me have a good swig of apricot brandy. Just to get my courage up, I mean."

I swivelled round in my chair to face him.

"Why Malkowitz," I said in a teasing manner, "this doesn't sound like you at all. Where's the man of authority? Where's the guard invested with special emergency powers by the Department of Internal Security?"

Then, to my astonishment, Malkowitz began quietly to sob.

"I just don't know what to do," he mumbled, pulling out his filthy handkerchief and blowing his nose noisily, copiously.

I was beginning to feel embarrassed.

"You see, Hendryk . . ."

Neither did his addressing me by name instead of the more usual "you young ruffian" or "you filthy swine" bode well, I thought.

". . . I'm not the man I appear to be: strong, confident, smart, self-possessed and attractive –"

"Don't worry, you've never appeared to be any of those."

Malkowitz looked slightly confused. He knew he had been insulted but obviously could not quite work out whether it was with affection or malice.

He went on:

"The truth is, I'm weak, lost and helpless. Despite my special emergency powers. Yes, me! Can you believe it? I can hardly believe it myself, Hendryk! It's even got so I'm afraid to go to sleep at night. I stay awake for as long as I can, then when I can't keep my eyelids open for a minute more, I knock back half a bottle of something or other and hope that it won't happen again. But it always does."

"Hope that *what* won't happen again?" I asked, expecting some gruesomely intimate revelation involving bodily fluids of one kind or another.

"Why, the dream of course!"

"What dream?"

"Of – of *her*. The woman in the magazine. Well, that's how it began, anyway. You see, it was on one of the long night runs to P—, when Hubert Dankers was the driver. Well, it was pretty quiet for most of the time, except for Madame Polinski

who rang for me to come and massage her legs at about two o'clock in the morning, so I kept myself amused by flicking through some of the old magazines that people tend to leave behind. My personal favourite is *Society Talk* but that particular night I'd only found a copy of *Dental Hygiene* and *Fashion for Fuller Figures*. It was in that one I saw the photo of the woman. By God, she was a looker! I saw that straight away. It was an advert of course and she was only wearing a bra and panties designed for the fuller figure. Oozing out everywhere she was, if you'll pardon my expression, Hendryk. I've got a thing about the more mature woman with the fuller figure, I don't mind admitting: a woman with curves where they ought to be, not all skin and bone like some of the youngsters you see flashing themselves around. Mind you, I'm no skeleton myself, so it's only natural, I suppose. I couldn't take my eyes off her: off the photo, I mean. I stared and stared at it, then I started to get peculiar feelings so I nipped into one of the toilets and took myself in hand but the feelings didn't go away and I couldn't stop looking at the woman in the bra and panties. Her eyes looked at me back, right through me you might say, and I began to think that she could read my mind. Oh, I know how ridiculous it sounds! Stupid, even, but that's not how it was, believe me. I wanted her to step out of the photo, whip her underwear off and make love to me on the floor of the carriage. I started to think how the jigging and jogging of the train would excite us, make our pleasure last longer, add to the thrill of it. Well, you must know how it is, Hendryk. By the time the train pulled into P— about nine o'clock in the morning, I was still staring at her like a lovesick puppy and still stiff as a flagpole. Poor old Hubert Dankers was quite concerned about me. He thought I'd taken a queer turn, but I didn't tell him what was really up. No fear! It would have been all over Central Bureau by mid-afternoon and I'd have looked a proper idiot. Even so, I tore the photo out of the magazine, folded it up, then slipped it down the front of my underpants.

"That night I had a dream about her. I dreamt that I met her in the bedroom of a big, modern house in the suburbs

137

where she lived. She was on the bed, stark naked, smiling at me with a kind of pleading, expectant look in her eyes. Without the bra and panties designed for the fuller figure, she was even more gorgeous than in the photo. 'Do you like my house?' she said. I told her that I did. 'Do you like my bedroom?' I said yes. 'And do you like me?' I could only nod. Then she murmured: 'Make love to me. Do it now, for I am on fire with longing! Ravish me repeatedly!' Well, naturally, I didn't wait to be asked twice. I practically tore my clothes off and leapt on top of her. Then, oh God, I wish I'd never – then! – just as I grabbed hold of her and positioned myself for penetration – just as I pressed my mouth onto hers – oh! – right in front of my very eyes she turned into the most repulsive, wrinkled hag you could possibly imagine! She must have been at least eighty. It was disgusting! Well, I pulled myself off her pretty damn quick, I can tell you. 'What's the matter?' she asked, but now her voice was cracked and quivering and full of outrage. 'You said you liked me!' I told her that I *did* like her, but the way she was before, not the way she was now. 'The way I was before is only a photograph,' she answered. 'It isn't real. It's an illusion created to persuade women with fuller figures to purchase the bra and panties. *This* is the real me. Besides, the photograph is twenty years old.' When I tried as gently as I could to explain that I wasn't in a position to make love to someone as old and ugly as her, she said: 'Oh, but you must! If you don't, the dream will never end. You'll never wake up again.' I was frightened out of my wits, Hendryk! Who wouldn't be? I couldn't be certain that she was telling the truth of course, but I didn't dare risk it. So I made love to her and it was every bit as ghastly as I'd imagined. She was all sagging, crinkled folds of flesh, all dry and papery and difficult to negotiate – like parchment her skin was and not a drop of natural juice in sight – and the smell of her was rank. The worst thing about it was the way she cried out, almost screaming when I finally managed to take her, flailing her scrawny arms and wrapping her wizened shanks over my arse. She screeched, she cursed, she yelled obscenities, she foamed at the mouth like an uncontrollable

beast – some vile animal! – in squalid ecstasy. When it was all over she slumped back on to the pillows, panting and exhausted. 'Well,' she said. 'Same time tomorrow night, then?' And that, my friend, is *exactly* what has happened from then till now. Every night, regular as clockwork, I'm back in that house, in that very same bedroom, making love to an ancient hag. I can't escape it! It's hell, you've got to believe me! This is why I asked to be put on the night runs whenever possible: at least I can fall asleep in the carriage and have the dream on the train, rather than frightening my poor wife. Things are bad enough as it is, with her defective tubes. Like I said, I try to stay awake for as long as I can, then at the last minute I knock myself out with apricot brandy or schnapps or caraway-seed vodka. But she's always there, naked and sickening and waiting for me. Oh God, oh Lord, I think it'll drive me crazy! Why won't she get out of my head, stay out of my dreams and leave me in peace? It's always the same: 'If you don't make love to me you'll never wake up,' she says. Well, I believe her now. I think I believed her the first time she said it.

"I don't mind telling you, Hendryk, it's beginning to put me off women altogether. Sometimes, rather than make love one more time to that blasted old bitch, I think I'd prefer a clean-limbed, muscular young man with good equipment and no questions asked. Much like yourself, if I may say so. All right, I admit it, I *have* looked at you with interest once or twice –"

"What?"

"But it isn't me, don't you see that? It's *her*. It's that god-damned fat, ugly old cow who makes me poke her every bloody night – night after night – and I wish to heaven I'd never set eyes on that photo!"

"Couldn't you call her bluff?" I asked, anxious to steer the conversation right away from Malkowitz's sexual interest in me.

"What do you mean, exactly?"

"I mean, couldn't you refuse to make love to her, then just wait and see whether you wake up or not?"

Malkowitz stared at me with something approaching contempt.

"Oh yes, that'll be right," he snorted. "And what would happen if she's telling the truth and I never wake up again? In a coma for the rest of my life. Worse, stuck in an endless dream with her! No, no, it's too much of a risk."

"It's what *I* would do," I said.

Malkowitz dragged himself to his feet.

"Well you're not me, thank God. Is that the best you can do? Tell me to put my waking life in mortal danger? I was a fool ever to think you might be able to help."

"Frankly, Malkowitz, this sort of thing is not my speciality."

"Not like yodelling, I suppose?" he remarked with malicious cynicism. Then, staring at me with pleading eyes again, he said:

"I daren't look at magazines anymore. Well, at least not at pictures of big women in their underwear."

"Why?"

"I tried it once – just to see what would happen, I mean – and it was exactly the same. A gorgeous, mature, full-figured woman turned into an old hag just as we'd started to make love. She was advertising a banana and pecan cake-mix in *Home and Kitchen*, although why anyone would be baking a cake in their underwear beats me. Oh, the women might change but the dream never does, don't you see? It's driving me mad, I swear it! Sometimes I catch myself glancing at my wife as though I expected *her* to change into a repulsive old woman too. Well, come to think of it, she's pretty much a repulsive old woman anyway, what with the strain of her defective tubes . . . but worse than that, *she* saw *me* looking at her in that odd kind of way – surprised and fearful and angry all at the same time, see? – and lately she's started to avoid any – well – *intimate contact*. I'm a normal, red-blooded man, Hendryk, with all the desires and needs and urges of a normal, red-blooded man! I can't go on worrying myself sick when it comes to bedtime, going through that awful, disgusting sex-act with a revolting crone night after night, then finding my own wife is turning away from me when I reach out to her for comfort. I've tried looking at other photographs – pictures of

140

ordinary, unremarkable things like washing-machines, cock-tail cabinets, vacuum cleaners, handbags, lavatory brushes – but it's no good. Mind you, it's surprising what you can get up to with a vacuum cleaner. No . . . *she* just keeps coming back and forcing me to make love to her. I'm too scared to go to bed and I'm too exhausted to get up. It's got to stop. I can't take it anymore!"

Couldn't you consult Dr Freud about it?"

Malkowitz's lumpy features reddened.

"Never!" he cried. "Why, I'd lose every scrap of his respect!"

"Does he respect you, then?"

"Of course he does! I'm not only an important employee of the State railway, I've also got special emergency powers invested in me by the Department of Internal Security. Don't forget that."

"But Dr Freud is a psychiatrist. Surely he's just the person to help you?"

"Are you saying I'm mad?"

"No, I'm just saying that he might be able to stop you having these horrible dreams."

"I'd rather have the dreams than tell Dr Freud anything of this. And if *you* tell him so much as a single word, why, I'll thrash you so soundly, I'll –"

Like all bullies, Malkowitz made only empty threats. He knew it, and he knew that I knew it too.

"Don't worry," I said casually. "I won't breathe a word to anyone about your nightly trysts with the fat old woman."

Malkowitz hesitated for a moment, then he said:

"What's a tryst?"

"It's a close encounter."

"Well your balls will be having a tryst with my boot if you don't keep your mouth shut. Got it?"

"Yes."

"Besides . . ."

He suddenly lowered his voice and adopted an unpleasantly confidential manner.

". . . there *is* a way . . . to stop the dreams, that is."

"Oh?"

"It's like this, see. One night I took a knife to bed with me and put it under the pillow before I went to sleep. I thought maybe if I could somehow *use* it in the dream, on the old woman, I mean, I could make an end of her. Understand what I'm getting at?"

"No, not really," I said.

"Well, it worked right enough. There she was, all luscious and smiling bare-arse-naked as usual, ready to change into a ghastly old hag as soon as we started our business; only this time, before we'd got very far, I reached under the pillow and, sure enough, I found the knife. I threatened her with it and she started to panic. I held it under her throat and told her that if she didn't get out of my dreams for good, I'd open her up like a stuck pig."

"My God!" I cried. "What happened?"

"She started to whimper and beg, pleading with me not to hurt her. I pressed the point of the knife to various parts of her body, just to see which one frightened her the most. When I held it against her stomach, a little bit above the belly-button, she almost screamed. I don't mind admitting, this excited me! It aroused me, if you see what I mean."

"You unspeakable monster!"

Malkowitz shook his head and sneered.

"Not a bit of it!" he hissed. "But how would you know what it makes a *real* man feel like to have power over a woman?"

"What the devil are you implying?"

"I'm not implying anything, I'm just saying this: I *liked* it when she grovelled and wept and almost pissed herself. By God, she'd been tormenting me for long enough! So I pushed the point of the knife into her flesh – oh, not much, I swear it, just a fraction! – and I saw a round, bright little bead of blood ooze out. The feelings that tiny drop of blood gave me – *her* blood! – were fantastic . . . sort of sexy and masterful and godlike all at the same time. I started to lose control of myself. Anyway, a few seconds later she shrieked and disappeared. Gone! I'd beaten her!"

Malkowitz paused for breath. He stared at me with a peculiar expression in his piggy eyes. His skin was damp with sweat.

"The only thing was, the next morning my wife came out of the bathroom and she said: '*I must have scratched myself in my sleep. There's dried blood on my stomach.*' Well, I almost threw up! Can you imagine how I felt? I'd cut my own poor, dear wife as well as the bitch in the dream! That was it! I've never taken the knife to bed with me since. I just daren't. So now she's back, knowing that there's nothing hidden under the pillow, mocking me and calling me all sorts of obscene names to my face, flaunting herself and daring me to prove I'm a man. It still goes on, night after night and there's nothing I can do about it, nothing. Oh, of course I'm *tempted* to take the knife to bed with me again and use it on her in the dream – finish her off proper I mean, once and for all. But . . . oh, God in heaven! I'm too scared of what I'll find beside me when I wake up in the morning."

Malkowitz sniffed noisily and wiped his red cheeks on the back of one hand.

"One night, though –"

"What?" I murmured fearfully.

"– she's going to drive me over the edge and I'll have the knife ready and waiting. I'll use it to get rid of her forever."

"And what about your wife?" I cried.

Malkowitz shrugged.

"With her defective tubes," he said, "some might consider it a kindness."

"No!"

"Well, what do *you* suggest?"

"Apart from talking to Dr Freud about it –"

"*Never!*"

"– I'm afraid I really can't think of anything. I'm sorry, Malkowitz."

"I should have known you'd be useless."

As he walked from the room, I asked:

"By the way, what became of the photograph?"

"It's still down the front of my underpants. Want to see it?"

"Shut the door behind you, will you?"

I wrote for a while. Then I looked out of the window and saw that the cows were grazing peacefully in the meadow adjoining the woods on the edge of the grounds of Schloss Flüchstein. They ambled slowly, chewing the cud, their big brown eyes blinking occasionally in the strong light of the new day's sun. They were contented, placid creatures, as all cows by nature are. Two pretty young milkmaids came out with stools and metal buckets.

"There, there, Blossom! Time for emptying those aching udders!" the first milkmaid called sonorously in her high, musical voice.

"Come, Peach! Here, Daffodil!" cried the other.

The cows made their docile way toward where the milkmaids sat on their little wooden stools, their supple fingers ready to begin their ministrations on the fat, brown teats . . .

The door opened again.

"Have you been using all the bread for toast, young Hendryk?" asked the count, popping his head into the room.

"No. I told you, I don't want any toast."

"I'm not offering to make you any. I can't. There isn't any bread. Mrs Kudl is driving herself into a frenzy. She can't bake any fresh either, because there's no flour."

"Well, as I said, I don't want any toast. So it doesn't much matter, does it?"

A moment's pause. Then:

"Do you only ever think of *yourself*, you little prick?"

"At the moment, yes. It's vital that I do."

The door slammed noisily shut. Then it opened yet again.

"I say, I'm sorry about the 'little prick' bit," the count murmured. "I don't know what came over me."

I smiled to myself.

"No harm done."

"Ah. Good. You're busy I take it?"

"Yes."

"Don't forget to tell His Grace that you haven't touched his wife's private parts since, eh?"

As the door closed for the third time, I began to imagine

in my mind's eye how lovely it would be now for Adelma and I to be taking tea in the drawing-room of Schloss Flüchstein . . .

"How is Frau Dimkins?" Adelma asks, her gentle heart solicitous even for the wellbeing of servants.

"In very good health I am glad to say," Dimkins answers. "If her appetite is anything to go by, at any rate. Why, that dear woman eats as much as she likes, whenever she likes, and never puts on an ounce of weight! She's as slim and as pert as the day we met. There's many who think she's still a schoolgirl, God bless her. And God bless you for asking, Miss Adelma."

"You may put the iced fancies on the plate and then you may leave us, Dimkins."

"Yes, miss."

"Such a cheerful, good-natured soul," Adelma remarks to me. "I don't know where we'd be without him."

"And where would I be without you?" I reply, gazing directly into her lovely blue eyes as I pop an iced fancy – strawberry with cream piping – whole and entire, into my mouth. "Adelma, my body burns for you! It's a consuming fever –"

"And mine for you. You must know that, Hendryk. It will not be long now until we are united in the joys of fleshly love."

She glances at me coyly, with unaffected modesty, then looks down at the iced fancy – chocolate-cherry fudge – that is still untouched on her plate.

"Would you say that you are a – large – man?"

"I certainly think that I must be larger than average," I reply proudly.

Adelma brings one hand slowly up to her mouth, which has become a little "o" of surprise and apprehension.

"Then you must be very tender with me," she says quietly. "Tender and patient and careful."

"Can you doubt it?" I cry, both moved and aroused by the delicate, vulnerable way she expresses herself.

"You must be my teacher in love's art and technique," Adelma goes on. "For I am innocent and unlearned. You must show me how to position myself – the way in which I must move my parts to accommodate you – tell me what sensations to expect and how to

145

*surrender to their sweetness, explain the placement of my extremities
in relation to yours and how to apply —"*

*"Adelma, please!" I interrupt urgently, dropping a half-consumed
iced fancy onto the luxuriously woven silk carpet. "If you continue in
this vein, you will arouse me to a point beyond my control —"*

*"Then I shall stop at once. Our love will be consummated tonight,
Hendryk, not a moment before. Once we are both naked and in bed,
Archbishop Styler will perform the Rite of Carnal Bliss over us. It has
all been arranged. That man is practically a saint, everybody says so.
He never spends less than three hours every day on his knees, absorbed
in contemplative prayer. And his wife lives like a nun, so I under-
stand. His blessing will ensure that our conjoining is everything that it
should be."*

*"It will be perfect in every way!" I cry, suddenly feeling very
emotional . . .*

All at once my delightful reverie was suddenly interrupted.

"Hendryk? Hendryk!"

I threw down my pen.

"For God's sake, what is it this time?" I almost screamed.

Adelma practically threw herself into the room and ran
toward me.

"Adelma!"

"Oh, my darling, my darling!"

She fell to her knees and flung her hands around my waist.
Her face was wet with tears. I bent to touch her cheeks.

"Whatever is it?" I said, already knowing what her reply, or
at least the essence of it, would be.

"I — I love you —" she said brokenly. "I realize that now. I
didn't before, you see. I just thought, oh God, I don't know
what I thought! — but I *do* love you, heart and soul, Hendryk,
my sweet Hendryk —"

"I have always loved you, Adelma," I said. "From the first
moment I saw you, topless, reading *An Annotated History of the
Cyrillic Alphabet*. Do you remember?"

"That silly book," she sniffed. "There were no murders in
it at all. Not one."

I was slightly confused.

"Murders?" I echoed.

146

"Aren't there always meant to be murders in books?"

"Probably not in *An Annotated History of the Cyrillic Alphabet*, no."

"That's what Dimkins told me."

"Forget what Dimkins told you. Go back to where you were before."

"Where was that?"

"Well, you were saying that you love me, weren't you?"

"Was I?"

She suddenly got to her feet. She wiped away what was left of her tears on the back of her hand.

"Why on earth should I say that?" she demanded, her voice at once sharp and imperious.

Desperately, I said:

"If you'd like us to sleep together, we can get Archbishop Styler to bless us when we're naked in bed."

"Don't be disgusting! You must be mad. They're all saying that you're mad."

"Who are?"

"Papa, Dr Freud, Dimkins, the archbishop, the archbishop's wife, that ghastly fat man who stinks –"

"Malkowitz?"

"Yes, him. He said you're mad, too."

"You don't love me, then?"

Adelma threw back her head and laughed, almost braying like a donkey. Then, as her head came down, her eyes assumed a glassy, faraway look and she murmured:

"I've longed for you, my dearest! I've yearned and ached for us to be together! Of course the archbishop will bless the bed! It would be quite wonderful!"

She flung her face against my neck and began nuzzling me, sighing and crooning something gentle and soft into my ear.

"Hendryk, take me away from here," she said breathily.

"What?"

"Oh yes, yes! After we have given ourselves in love for the first time, with Archbishop Styler's blessing, of course, take me far away from Schloss Flüchstein. Please."

"Adelma . . ."

"Will you, my darling? Will you?" she pleaded.

I brushed her lips with mine, then planted a chaste kiss on her forehead.

"Of course," I said. "We'll go away together and never come back. We'll have a life all of our own."

"Oh, Hendryk!"

At that moment Dr Freud tapped on the door.

"What the devil do you want?" I snapped.

"You asked me to tell you," he answered slowly, studying the pair of us intently.

"Tell me what?"

"When the dinner gong has sounded. It has."

He was shaking his head as he left the room.

Dinner was what I can only describe as *sumptuous*. Well, perhaps several other adjectives also come to mind: rich, extravagant, profligate and for the first time quite breadless. First there came coconut and lime-leaf soup, made with ginger, garlic, chilli, creamy coconut meat and fresh limes; then sautéed chicken livers with fennel and a Shiraz vinaigrette, all slick and dark from the pan; next we had chargrilled turbot steaks with wild mushrooms, roast halibut, rosemary and lavender glazed lamb shanks in a port gravy and pork cutlets with lentils; for dessert there was roasted plums with blueberries in a balsamic liquor, tarte tatin with marscapone ice-cream and lemon syllabub. I stuffed myself until I was almost comatose.

"Well!" cried the count, releasing a wet-sounding little fart and wiping his plump red lips, glittering with manifold juices, on his napkin. "Mrs Kudl has achieved the apotheosis of her art! Superb! Magnificent! Shamelessly sinful!"

Then, glancing toward the door, his face took on a look of astonishment.

"What's this?" he said, as Mrs Kudl came in bearing a tray of more steaming dishes.

"*Antipasti assortiti*," she announced with a triumphant shriek. "*Pasta e ceci, tonno e fagioli, funghi trifolati* and no bread, neither a crust nor a crumb, no bread!"

She put the tray down on the table and dashed off again toward the kitchen.

"I don't think I could eat any more," Malkowitz murmured, belching loudly. "I'd be poorly."

"If dear Mrs Kudl has gone to all this trouble –"

And then in she came again, accompanied this time by two rough-looking youths in stained aprons. They carried great piles of trays, bowls and platters.

"*Petits légumes à la grecque!*" she screamed. "*Salade Messidor, mouclade, daurade crue à l'aneth, foie de veau au vinaigre et aux deux pommes! Pêches, poires et pruneaux au vin rouge . . .*"

As yet further quantities of food were fetched out of the kitchen, I noticed that Mrs Kudl had foam bubbling around her lips. Her face was very red. She began swaying.

"Stop!" the count yelled, getting unsteadily to his feet. "What in the name of heaven has come over you?"

"Roasted quails served in a liquor of the marinated livers of their young, lamb's testicles with minced tongue – oh, giblets and offal! – blood-rich, penis-sized sausages perfumed with clove, cardamom and passion-fruit zest! Two-day-old baby piglets suffocated with bay and thyme, caressed with whole black peppercorns and stuffed up their own arses – ah! – help me –!"

As she fell to the floor, urine spurting erratically down between her legs, I heard Dr Freud saying:

"Allow me to examine her. I am an important figure in the world of medicine. Here, hand me a spoon. I shall use it as a probe."

I hurried from the room.

Later, I sat and pictured in my mind's eye how it could be. I had every detail of the scenario perfectly in place in my head. The consummation of our love . . .

The bed in which Adelma and I lie naked is vast, canopied with velvet and damask hangings, strewn with roses plucked from the arbour of Schloss Flüchstein. The air is heady with their fragrance. Innumerable candles wink and glitter in the copper-golden twilight of the room. Beneath the silken sheets she takes my hand

in hers and places it over her left breast. It is firm and warm beneath my palm and I feel the nipple hardening. I am already erect.

Archbishop Styler, in mitre and cope, swings his thurible gracefully over us in a figure-of-eight flourish. Behind him, a small group of acolytes in white and scarlet chant softly, sonorously, from their leather-bound liturgical missals. In his light, attractive tenor voice the archbishop sings above them:

> "May their union be sweet and true,
> Their passion be made ever new,
> Replenishing its carnal art
> From each full and loving heart.
> Bless this young felicitous pair,
> Exorcising every care:
> Undistracted, may they bend
> All labour to love's lovely end."

Then, leaning forward in a slightly conspiratorial manner, he whispers:

"I wrote that myself. What do you think?"

Embarrassing drivel, is what I actually think.

"Very nice, Your Grace," I say.

"I did think of submitting it to Twilight Musings. Dean Kurmer is the editor, you know."

He hands the thurible to one of the acolytes and is given a branch of myrtle by another. This he dips into a silver bowl of consecrated water.

"I sanctify the bed in which, naked as on the first day of creation, you now lie side-by-side, soon to consecrate your desire for one another by the holy act of sexual intercourse. It is a noble and dignified deed which, undertaken with spiritual as well as physical understanding, expresses that which the beasts of the field can know nothing of but which man and woman alone may experience: conscious self-surrender to another. Therefore surrender, consciously and willingly, that this night of love may be truly blessed. Amen."

"Amen," the acolytes respond in unison.

Slowly they begin to back out of the room, bowing and effecting elegant liturgical gestures, the archbishop waving his sacred napkin,

until at last Adelma and I are left alone. We turn to look into each other's eyes.

"Are you ready my love?" I whisper.

Adelma nods, smiling modestly.

"I am ready, Hendryk. Do you have the cream?"

"Yes."

"And the implement?"

"Yes."

"And the illustrated manual?"

"Oh yes, yes, yes!"

"In which case, my love, I think we may proceed with intercourse."

I lean toward her and place my mouth with an almost mathematical care upon hers, my fingers moving across her taut breasts. I pull myself slowly onto my side, positioning myself between . . .

Oh, the consolation of imagination! Then my mind was pulled, sickeningly, back to the mundane present.

"What's happened to Adelma?"

"Adelma? Why, is she ill? Is she –"

I rose from my desk and I turned to face Dr Freud. He seemed to be looking older than I remembered seeing him last, which was absurd because that was at dinner half-an-hour before.

"What about Adelma?" I said with urgency in my voice. My stomach was fluttering.

"She came to me in tears after dinner," Dr Freud murmured. "She begged me to find some way to release her, but I – I am sorry to say – that I was unequal to the task."

"Release her from what, in the name of God?"

"Never bring God into a psychological analysis," Dr Freud replied, a touch of severity creeping into his voice. "It only complicates matters. God is a neurosis."

"Didn't Freud say that?"

"Yes, I did."

"No, I mean the other – oh, never mind! *Is* this a psychological analysis?"

"It soon will be, my young friend. Adelma is disturbed in her mind. She suddenly finds herself prey to absurd, loathsome fantasies –"

"What absurd, loathsome fantasies?"

"She imagines that she is in love with you, for one."

"How dare you!" I cried, shaking my fist at the old man. "What's so absurd or loathsome about being in love with me?"

"She hates you," Dr Freud said. "I have seen for myself how she treats you, how she insults you at every opportunity. You are repulsive to her. Now – I ask you! – is not absurd to find yourself irresistibly attracted to something which repulses and disgusts you?"

"I am *not* a thing," I said firmly. "And I don't repulse or disgust her. Adelma *is* in love with me."

"How can you possibly know that?" demanded Dr Freud, banging his stick on the floor impatiently.

"Of course she is!"

"She's refusing to eat, she cries and moans and calls ceaselessly for you. Why, your very name is like a prayer on her lips! When you aren't with her she pines, unsleeping, uncaring –"

"That's just how it *should* be."

"You monster!"

"I'm no more a monster than you, Dr Freud."

"What do you mean by that?"

"The heartless and cruel 'experiment' you performed upon your poor daughter, convincing her that a snake is living in her intestines –"

"She persuaded herself . . ."

"Yes, with a great deal of help from you."

"Listen to me, Hendryk! –"

"Where is Adelma now?"

"In her room, making love with Malkowitz."

I stared at Dr Freud, hardly able to believe what I'd heard. *"What?"*

"This is what I have been trying to explain, *Dummkopf*! Adelma is telling everyone that she is hopelessly, desperately, insanely in love with you, that without you, she wishes only to die –"

"Then why in the name of heaven is she fucking Malkowitz?" I cried in angry confusion.

Dr Freud tut-tutted in disapproval of my expletive.

"She came looking for you but was unable to find you. Someone told her that you had gone to make arrangements for your elopement and that you might not be back for several days. Oh, she fell into a frenzy of weeping and wailing, tearing at her breasts, pulling her hair out in handfuls, screaming, protesting that she could not endure life more than an hour without you by her side. Her suffering, if it was genuine, was truly pitiful."

"Of course it was genuine!"

Dr Freud went on:

"Then she was told that Malkowitz would be pleased to solace her until your return – warming her bed, relieving her urgent bodily longings – and she seemed to calm down considerably."

"Who told her that?"

"Malkowitz, of course."

"I'll kill him!" I shouted, making for the door. "I'll rip him to pieces with my bare hands!"

"Wait – Hendryk – wait!"

But I was already out of the room and on the stairs.

"No fisticuffs!" Dr Freud called after me in an old voice.

I burst into Adelma's room just as Malkowitz was lowering his naked, sweat-slick, hairy body onto hers. The pitted and stained buttocks wobbled and shook.

"No!" I cried. "Adelma, no!"

Her eyes, peering over Malkowitz's meaty shoulder, met mine and widened in surprised delight.

"Hendryk!" she cried, pushing Malkowitz off with unexpected strength. He tumbled from the bed and fell onto his back on the floor. His thighs gaped open and his erection bobbed obsoletely.

"You unspeakable bastard!" I hissed at him.

"I was only trying to help," he whimpered. "Please, don't hurt me –"

"Hurt you? I'm going to kill you!"

I threw myself onto him, kneeling on the great expanse of his stomach and pummelling my fists into his shoulder. He began to scream and flail beneath me.

153

"No, no, please don't!" he screeched in horror.

At that moment Count Wilhelm came hurrying into the room, closely followed by a wheezing Dr Freud. I glanced up momentarily and saw that the count was in a very dishevelled state: his jacket and shirt were torn, his trousers were caked in mud and one shoe was missing. There were streaks of blood on his flabby cheeks. He looked down at me and his mouth fell open.

"What do you think you're doing?" he muttered.

"Malkowitz –"

"Oh, don't tell me, I can see perfectly well what you're doing."

"Look –"

"Buggering Malkowitz in front of my daughter, eh? Why, I've a good mind to –"

"I wasn't buggering Malkowitz! I wouldn't dream of it."

"Why not?" Malkowitz asked with sudden petulance.

"Then why is he naked?"

"I was just about to beat him senseless, as a matter of fact."

"And does he have to be naked for that?" the count demanded.

"Help me!" Malkowitz wailed. "I don't want to be beaten senseless . . ."

"Shut up!" I said, involuntarily spitting in his face. "You don't have a choice!"

"I warned him," Dr Freud put in, apparently getting his breath back at last. "I told him there ought to be no fisticuffs. Personally, I deplore violence."

"As every sane person does, Dr Freud. As we all do. Well, you vile cur, what has poor Malkowitz ever done to you that you wish to beat him senseless?"

"The list would be endless," I answered. "However, on this occasion it is for attempting to rape your daughter."

The count's mouth, which had only recently closed, now fell open again. He looked across at Adelma, who was still lying naked on the bed.

"Is this true, Adelma?"

"Of course not, papa."

"Adelma!"

"I *wanted* him to do it to me. I *asked* him to."

I pulled myself off Malkowitz and got to my feet.

"Look," I said. "I was trying to protect her. It's me she wants, not Malkowitz."

"Not according to Adelma," the count replied. "However, this disgusting matter will have to be sorted out later. At the moment I need to get the military onto the streets."

"Why?" Dr Freud asked. "Is there some trouble?"

"Trouble?" the count echoed. "My dear Dr Freud, there's a full-scale *riot* going on out there! How do you think I got into this state?"

"But why are they rioting?"

"Because," Count Wilhelm said slowly, looking at each of us in turn but in an especially suspicious manner at me, "there's no bread."

"No bread?"

The count shook his head and wiped away some of the blood on his face with the back of his sleeve.

"Not a loaf, a roll, a bun, nothing. The shops are empty and the bakeries are not baking because there's no flour. People are convinced that they're going to starve. Naturally, as Defender of the Faith and Governor of the City, they blame me. I barely managed to escape with my life."

"What about me?" Malkowitz mumbled.

"You won't starve," the count snapped. "You could live off your body fat for months, I dare say."

"I meant *him!*" Malkowitz cried, pointing a sausage-like, accusing finger at me. "Is he still going to beat me senseless?"

"Certainly not," Count Wilhelm said self-importantly. "Not in my presence. Isn't that so, Hendryk?"

I nodded mutely, glancing across at Adelma. Her suddenly cool, indifferent gaze met and held mine steadily. Then, with deliberate, calculated lasciviousness, she winked at me. Winked!

"All right men, let's get the military out and we'll open the armoury."

"I'm ready for a fight!" Malkowitz cried, getting clumsily

to his feet. He placed one hand over his genitals. In view of his recent display of snivelling cowardliness, I thought this was a ridiculous remark to make.

"I'm staying here," I said. "With Adelma."

"Oh no you're not! If you think for one moment that I'm about to leave her in the company of a crazed sexual brute like you –"

"I can take care of myself, papa," Adelma put in.

"No you can't. Hendryk is insatiable. I won't risk it."

The count tried to grab me by the shoulders but I shook him off; Malkowitz came at me from behind; suddenly, Dr Freud began lashing out with his stick, catching me a glancing blow on one arm.

"That hurt!"

"And so it was meant to!"

"Break his damn bones!"

The tussle very quickly became rather violent.

"Keep him down! Use your fists as hard as you like!"

I struck Malkowitz in the stomach with my elbow and I heard him scream; Dr Freud whacked me several times on the neck with his stick; then Malkowitz and the count were both on me in a concerted effort to bring me down. I flailed and lashed out but I was pushed back against the wall. I noticed that Malkowitz had started to become erect again.

"Kick him in the testicles, get him where it hurts!"

"Ah, no," Adelma murmured thoughtfully, "not the testicles."

At that moment I lost my balance and slid halfway down the wall, vainly trying to steady myself with one hand. Malkowitz was biting my shin. As I fell, I struck my head against the windowsill and suddenly a harsh, extremely painful zig-zag of light shot through my brain somewhere behind my eyes. They closed. The shouts in the room became a muted buzz. Darkness.

* * *

−8−

When the light returned, it was somehow more kindly, suffused with a gentle warmth and tinged with the palest of cerulean blue. It was a welcoming light, a light that was natural and at peace with itself. Nothing had caused it − no blow to the head, no whack with a cane, no malicious fist − it simply *was*. I did not wish to open my eyes but I knew that eventually I would have to. When I did − slowly, tentatively − I saw that above me was the vast expanse of a summer's sky. A solitary bird, black against the sun-bathed blue, silently soared and dipped.

"I'd like to stay here forever," a voice said.

I turned my head, for it seemed that I was lying on my back, and looked into a pair of friendly eyes. I knew at once whose eyes they were. It was my childhood friend, Trudi Mennen!

"Trudi," I murmured, hardly able to believe it. I scarcely dared to move, afraid of shattering the loveliness of the moment.

"Hello, Hendryk."

"Is that really my name?"

"Yes, it is. Of course it is."

"And are you really Trudi?"

"Yes. Well, in the dream, anyway."

I felt a tingle all over and I realized that we were both naked.

"It's another dream then," I whispered.

"Within a dream within a dream within a dream, Hendryk. It's a box of dreams and you're in the innermost box."

"What's happening to me?"

"Nothing much. You're lying unconscious in Adelma's room, but of course that's a dream too. The rest of them have gone out to deal with the riot."

"So why am I dreaming that I'm with you?"

"Don't you know?"

I shook my head slowly.

"It's good to see you, Henrdryk. So good."

She smiled at me, placed one hand carefully around my neck and drew my face to hers. We kissed each other and I tasted fried chicken on her lips. Then she drew away.

"I think I'm going to cry," I said.

"Why?"

"Because I love you, and I'm here with you under a blue sky, naked in the warmth of the sun. I want to say that – to say –"

The words caught in my throat and my chest heaved with a sudden restrained sob.

"It's all right Hendryk, really it is."

I pulled myself up onto one elbow. The grass was hot and prickly beneath my nakedness. I saw our clothes lying in a heap some distance away.

"This moment is the moment seconds before it happened," Trudi said.

"Before what happened? – ah! –"

"You see, it *all began* here."

"Will it end here, too?"

Trudi rolled over onto her side and stared into my eyes.

"Good Lord, no!" she answered. "The dream is continuous. It *never* ends. It never finishes, never has a beginning, a middle or an end. It's like a river except that it doesn't have a source. It flows perpetually. When you sleep, all you do is *step into the dream* and when you wake, you step out of it again. It doesn't depend on you for its life, Hendryk. It goes on whether you're in it or not. It's *independent*."

"But how can that be?" I said, my eyes widening in wonder.

"It just is. Trust me, I know. What you have to do now is step out of *this* dream before it all happens again."

"Is that important?"

"My dearest Hendryk, it's absolutely essential."

"How do I step out of it?"

"You just close your eyes and go to sleep again. Of course when you come to, you'll have a nasty bump and an even nastier headache. You struck the windowsill as you went down, poor boy."

"Is there anything else we ought to say to each other?"

"Not really."

"Trudi," I murmured sleepily. "Is there a meaning, a purpose, to it all?"

"You sound like poor old Professor Bangs. He's in the dream that this dream is in. Yes, a whole big box of dreams."

"You didn't answer my question."

"The purpose of everything is to have a purpose. To be *given* a purpose."

"Now *you* sound like Professor Bangs!" I said with a soft laugh.

"Not at all. He wants to 'discover' the meaning and purpose of everything. It doesn't work that way. You have to *give* everything meaning and purpose. That's why everything is there."

"Trudi —"

"Life doesn't come with a built-in purpose any more than chicken comes with a built-in sauce. You have to make the purpose just as you have to make the sauce. But in both cases the end result can be delightful."

"But Trudi —"

She placed a forefinger on my lips and hushed me into silence.

"Look up at the sky, Hendryk. Isn't it beautiful?"

Yes, it was beautiful. It was like the first day of creation when everything was new, dropped whole and entire from the hand of the Creator, heavy with the fragrance of flowers and fruits and fresh earth. I could hear Trudi breathing smoothly and regularly like the ebb and flow of a distant tide and I could feel the nearness of her naked body, almost smell the sweat that filmed her skin.

I was so happy. I withdrew my hand from hers and passed it across her breasts.

I felt the full, firm nipples tickle my palm. I slid it down across her rising-and-falling belly and my fingertips brushed over the secret hair below, reaching out to caress and part the lips of her moist cleft . . .

" 'Mmmm . . . that's nice,' she murmured. "Now sleep."

I closed my eyes and sleep came immediately, unbidden, like a sudden, sweet evening breeze at the end of a stifling day.

★

Trudi was right: I did have a bump on the right side of my forehead and I did have a bad headache. I pulled myself unsteadily to my feet. The room was dark. I looked out of the window and saw that it was dark outside too. It must be evening. What time was it? Where was everybody? Oh, my head!

"Don't make the mistake of thinking that you've woken up," a kindly old voice said somewhere nearby.

"Who's that? Who's there?" I whispered.

"I am," the voice replied. "Well, technically speaking, only *you* are. But since you're still dreaming, we both are."

"Where?"

"Here."

"Where's here?"

"In the dream . . . or . . . ?"

"Where else is there," I said sadly, "except in the dream?"

"You've left Trudi Mennen and now you're with me. You're dreaming of course, but it isn't quite the same dream. After we've had a little chat about this and that, you'll wake up."

"Then where will I be?"

"In Adelma's room, where you're still lying unconscious. Your friend Trudi was quite correct. You knocked you head on the windowsill when you went down. But of course, you know by now that *that's* a dream too."

"Is everything that exists just a dream?" I asked.

"No, not quite. Allow me to introduce myself."

When he spoke his name, I groaned involuntarily.

"But you're dead! You've been dead for years . . ."

"Actually, yes. But remember, this is a dream within a dream within a dream, so anything can happen. *I* have happened. In dreams my friend, elephants can fly over the moon, chocolate cake can make you lose weight, film stars fall

160

helplessly in love with you and dead men come back to life for a little while to hold a conversation with you. This is what makes the very nature of dreams so unpredictable and elusive. Now, shall we have our chat?"

Suddenly the room seemed to grow lighter and I saw the man opposite me. He was sitting in a perfect lotus position, which rather surprised me, because he was by no means young. In his late seventies at least, I would have said. His hair was silver-white and he had a neat white moustache. His lined, friendly features were intelligent but down-to-earth; his eyes, blinking and glittering behind rimless spectacles were small and shrewd, but filled with a deep humour and understanding. There seemed to be something ancient about him yet he also exuded a kind of startling vibrancy. He was still, but he was bursting with energy. He was smoking a pipe. A small, self-contained cloud of fragrant tobacco smoke formed a pearly nimbus like a halo around his head, on which he wore a flat, round kind of fez in black velvet, embroidered with an intricate design in gold and silver. On the third finger of his liver-spotted right hand he wore a large, impressive ring with an engraved stone.

"It *is* you!" I cried with a gasp of recognition.

"Did I not say so?"

"Well yes, you did. However, I've been learning of late that one can't actually be certain of *anything*. Now of course you're going to ask me whether I'm certain of that. Everybody does."

The old man shook his head slowly.

"No, I'm not. I have always lived by the principal of 'both-and' rather than 'either-or'. But I take your point. Most of the time you do not know whether you are asleep or awake, moving in reality or a dream. You have become cautious. You accept nothing at face value."

"Can you blame me?"

"Not in the least," the old man said, smiling at me affectionately. "However, I think I ought to point out that you have not yet considered the full implications of what you have decided to do."

"Which is?"

"To escape with Adelma."

"I won't change my mind about that."

The venerable sage sighed gently but continued to hold his lotus position.

"Do you not think," he murmured, "that she might be perfectly happy where she is?"

"What?"

"They might all be happy where they are: Adelma, the count, the archbishop and his wife, Dimkins, Mrs Kudl, even the cows. They have everything they need. They have science, religion, sex . . . and now Dr Freud has brought them psychology."

"Yes," I cried, "and all of it useless! Professor Bangs and his *Unus Mundus Cubicus* is completely round the twist and can't find any answers to any questions, Archbishop Styler doesn't believe in anything except meaningless ritual and sex comes down to starving your wife or pornography. Moreover, Dr Freud is a ridiculous old charlatan."

"I can't help agreeing with you there."

"Besides, Dr Freud and Malkowitz don't belong with the others any more than I do because we arrived at Schloss Flüchstein together"

"That depends, my friend."

"On what?"

"On whether Schloss Flüchstein is part of the dream on the train, or vice-versa."

"You're complicating matters unnecessarily," I pointed out, trying not to sound unkind.

The old man nodded slowly.

"Quite a number of people said that to me on many occasions during my life. I was never able to see it myself. Oh, it's certainly true that I was obsessed with those squiggles and circles and snakes, that I adored ancient and abstruse texts, that I rejoiced in the meandering byways of myth and magic, fell passionately in love with the ambiguity of the symbolic and loathed the coldness of contemporary scientific clarity . . . but it was never a self-indulgent pursuit, you understand. My

voice, I like to believe – if hardly the *vox populorum* – was the voice of the age-old soul. It's just that I spoke a language which everyone else seemed to have forgotten. The purpose of my life as I see it was to remind them of it. To some extent that purpose was successfully accomplished."

"And what's my purpose?" I asked in almost a whisper.

"Probably," said the renowned old man, suddenly less pensive and more decisive, "to become a quaternity."

"What does that mean?"

"I'm not sure, but it's what I did."

"Even if I do manage to become a quaternity, Adelma will be with me. We'll be a quaternity together."

"My dear young fellow, Adelma will *always* be with you! She is, after all, a manifestation of your inner feminine self. I gave such manifestations the name –"

"Yes, I know," I interrupted quickly.

"Volume IX, Part 1. And scattered throughout The Collected Works, naturally. Adelma, you see, has been *differentiated* . . . the state of identification, and thus her inaccessibility to consciousness, has been broken. She is, so to speak, *objectified*. Now it is a matter of establishing a relationship with her . . ."

"I've already done that. Several times."

The old man tut-tutted.

"The sexual act is an expression of the *coniunctio* on one of the very lowest levels," he said decisively. "It is hardly important."

"Dr Freud would disagree with you there."

"Dr Freud has always disagreed with me. He made me so mad sometimes, I wanted to kick him in his fat posterior. He was such a stubborn swine."

"Especially in disagreeing with you . . ."

"Precisely. Calling him a swine however, is perhaps a little unjust, for swine have long been a symbol of good fortune in his home country – if Jews can be said ever to have a home country, which is a debatable point. *Schwein haben* means 'to be fortunate.' That, I should imagine, goes back well beyond the advent of Christianity, after which the poor pig became the carrier of every bestial passion: sloth, gluttony, lust, and so

on. In fact, in other cultures this lowly animal is the symbol of fertility, motherhood and happiness. Sows in particular, from the most ancient times, were worshipped as manifestations of the Great Mother. The pig is therefore an ambiguous symbol, bearing the best and the worst of human attributes, but the worst came long after the best. It is the monotheistic religions – Judaism, Christianity and Islam – which were responsible for the imposition of our more reprehensible characteristics, for they appeared long after the apotheosis of the mystery cults, to whom the pig was a sacred animal. This undoubtedly explains the Jewish and Muslim prohibition against eating pork, although some are of the opinion that a morbid fear of trichinosis was responsible for this – the trichina is a genus of nematode parasitic worm that lives in the small intestine of the adult animal, the larva encysted in muscle – but I myself would dispute it. After all, were not the ancient Sumerians, Mesopotamians, Babylonians and Greeks, who knew no such prohibition, equally vulnerable to the parasite? Rather, I believe the pig was despised by these patriarchal religions as an animal most commonly associated with the Great Mother and other lesser female fertility deities: a case, if you like, of Yahweh-Father-Allah defending His supremacy against the Great Mother. Remember, as far as She was concerned, He was a late interloper. When swine appear in dreams –"

"I've never dreamed of swine."

"Please, have the kindness not to interrupt. When one dreams of a pig, it can more often than not be a very positive symbol, for the Unconscious is far older than the mono-theistic culture. Indeed, it cannot be said to be monotheistic at all. Moreover, one of my colleagues has pointed out that pigs resemble humans anatomically more than other mammals; the frog does so *in potentia* of course, but the subject of psychic potentiality within the symbol is a vast and complex one and I cannot do more than merely allude to it here. The North American Indians believed that the appearance of pigs in dreams heralded the advent of great good fortune for the tribe, since they often portrayed the pig as a rain-bringer, irrigating the land and promising a fruitful harvest. In the

Bestarius of Ulrich Lammerdorf of Keitelbörn there is an oblique reference to the pig as a water-carrier, although the particular Baltic legend he chose to illustrate it, *'Little Anna and the Witch's Pig'* is not entirely felicitous in this respect. More significantly −"

The querulous voice became ever fainter and more distant. Then sleep came, or at least, the light faded and the old man gradually became less and less discernible in the gathering shadows until at last he disappeared altogether. Just as my mind began to sink down into a warm, welcoming oblivion, I heard his disembodied voice murmur:

"The dead came back from Jerusalem, where they did not find what they were seeking. Such a lot of ridiculous bunkum."

Then I distinctly caught the fading sound of a tiny, distant laugh.

★

When I awoke my headache was gone. I pulled myself up from the floor where I had been laying and stumbled out of Adelma's room. At that moment I heard a noise − something like a muffled explosion − coming from somewhere in the grounds outside. Then a cacophony of voices, shouting and cursing. I thought I glimpsed firelight in the darkness of the night.

There were screams now, agonised wails and harsh, stridently-uttered obscenities. The voices were coming nearer. A horse neighed in terror. A gunshot. The uniform tramp of military boots. I had to get out! There was no time for anything now except to flee, for I heard more gunshots ringing out then the anguished shout of a child. Good God, were they killing children too? I threw the pen down on the desk and hurried from the room. Outside in the corridor I saw a dark, dishevelled shape running toward me, the arms flailing, the spindly legs absurd in their exaggerated movements. The feet seemed very large.

"Stop, stop!"

It was Professor Bangs.

"Get out of my way!" I yelled.

His face was contorted in a rictus of terror, his eyes staring wildly, his silver-white hair like a crazy explosion of wire-wool on his head.

"My *Unus Mundus Cubicus* – it's completely disintegrated! – my whole life's work –"

"It was disintegrating anyway, you silly old fool."

"You must help me!"

I paused momentarily to look at him a little more closely: he suddenly seemed so *old*. He was stooped, burdened with the physical weariness and emotional satiety that too much experience can bring in advanced age. And yet . . .

"What day is it today?" I asked him.

"Friday," he hissed, almost spitting at me. "Friday the second! The second of the month – !"

"Move aside!" I cried, shoving Professor Bangs out of the way. He crashed against the side of the wall and slithered in a tangle of arms and legs to the floor. A yellowing engraving entitled *'Love Locked Out'* in a heavy gilded frame detached itself from its hook, fell, and struck him on the top of the head. He grunted once then his eyes closed. I ran on, down the narrow stairs to the second floor, then the first, practically hurling myself onto the grand staircase that led to the entrance hall of Schloss Flüchstein. I slipped and slithered across the black-and-white marble tiles of the hallway floor and shot out through the front doors. The street itself was quiet but all the lamps had been smashed and the ground was littered with fragments of frosted glass. A dog barked. In the distance somewhere I heard the sound of running feet.

"So there you are!"

I whirled around to see Adelma standing a few yards away. She was holding a burning torch and in the surreal gold-orange light of the flames her face seemed almost ghostly. She was breathing heavily.

"Oh Hendryk," she muttered. "I've been looking for you everywhere!"

"What is it? What's wrong?"

"Something terrible is happening to everybody. Do you know what it is?"

"No. We're getting out of this nightmare, Adelma. Together."

"Impossible, Hendryk! There *is* no way out."

"I love you."

She raised the flaming torch high in the air.

"Do you?" she asked, scrutinising my face, as if searching for evidence that might prove the contrary.

"You know I do."

"I don't know anything anymore. Hendryk, it's – it's my father –"

"Where is he?" I said.

"I'll take you to him. Please, we must hurry!"

"Adelma, wait –"

"Make sure you stay close behind me. Some of the military have got a little out of hand and there's been some casual raping as well as beatings."

"I'll protect you," I said, trying not to sound nervous.

"I was thinking of *you*."

"Me? Why should I be worried?"

"It wasn't so long ago that you were wearing a skirt, as I recall. For heaven's sake get a move on!"

She turned and staggered off into the night.

It was a small, tumbledown cottage on the edge of town, surrounded by a broken wooden fence. The front garden was overgrown with thick weeds and brambles. Obeying Adelma's instructions I had kept close behind her as we made our way through the darkened streets, stepping gingerly over bodies, sometimes slipping in a puddle of blood and losing our footing, deflecting the aggressive challenge of a lone guardsman with protestations of authority and finally making it unharmed to the spread of unkempt fields adjoining the municipal rubbish tip. A narrow, winding lane had led us here, to this lonely place where Adelma had told me Count Wilhelm would be waiting. We walked slowly up the path and she pushed open the old wooden door. It creaked noisily on

its hinges. Adelma tossed her burning torch into the shrubbery.

"Papa? Are you here?"

"Yes," I heard him reply in a soft, throaty voice.

We entered the cottage together. The door rattled shut behind us.

"Why is there no light?" I said. "I can't see a thing."

"He doesn't *want* you to see," Adelma whispered. "Isn't that right, papa?"

"Yes . . ."

Then there came a kind of muffled sob.

"What is it, count?" I asked.

"I have become old. Old!"

Suddenly the light in the front room of the cottage came on and I gasped involuntarily. Count Wilhelm was sitting in a chair on the far side of the room. His arms were wrapped around his knees, drawn up close to his chest. His face was lined and wrinkled and tufts of coarse grey hair sprouted from his ears and nostrils. There was a trail of saliva drooling from one corner of his mouth, snaking down across the sagging, crinkled flap of skin that was once his double chin.

"Look at me, Hendryk!" he hissed. "What has been happening?"

"He says he doesn't know," Adelma whispered. "Perhaps no one does."

She began to sob.

"It hasn't happened to me yet," she managed to say. "I'm sure it will. Then I shall become old too! Will you love me then, Hendryk? Will you feel desire for me when my ripe breasts have become shrivelled and empty? When my young cleft is nothing more than a slack, puckered mouth?"

"It won't happen, Adelma. I promise."

"I have reserved all my passion for you, Hendryk. Now I shall wither and rot away like everyone else and you will utterly reject me."

"Never!"

"How can it be otherwise?"

"Because I love you, Adelma."

"What has that to do with it?"

"Everything. I'll tell you soon enough."

"Oh Hendryk, what is to become of me?"

"I must be at least ninety," Count Wilhelm put in petulantly. "Professor Bangs is probably dead by now, if he hasn't been sent totally insane by the collapse of that *Unus Mundus* whatever-it-is. Mrs Kudl must certainly be dead, because she came to Schloss Flüchstein in my father's time. Who's going to cook our dinner? That's what I want to know. We might all be desiccated fossils, but we still have to eat."

"Shut up about Mrs Kudl!" I cried, stung by the count's words.

Then Adelma said:

"What are we to do?"

"I told you. We're getting out of this. We're leaving it all behind."

"What about papa?"

"Oh, you can forget me," Count Wilhelm murmured.

"We'll have to come back for you," I said.

He shook his wizened head sadly.

"No, it's too late. Take Adelma away from here, my boy. Save her."

I had expected Adelma, overcome with a commingling of shock and grief perhaps, to protest. Instead, in a rather brisk, businesslike tone she said:

"That's settled then. Hendryk, you heard papa. Let's leave at once."

"Are you sure?" I asked the count.

"Absolutely," he answered miserably.

Adelma said:

"You will forgive me if I do not kiss you goodbye, papa . . ."

Count Wilhelm nodded slowly.

"In my condition it would be repulsive, I understand that. For God's sake, Hendryk, go!"

With a last glance back at the count, we left the room and slipped into the night. I could still hear the rattle of sporadic gunfire and occasionally a terror-stricken scream rang out

somewhere far off, but there seemed to be no one about. I glanced apprehensively to the left and right as I came from the cottage garden into the street. We began to walk away as quickly and as calmly as we could.

"Where are Malkowitz and Dr Freud?" Adelma hissed, articulating a thought that had been at the back of my mind for some time. I couldn't even remember when I'd last seen them. Then I remembered. I'd last encountered the odious Malkowitz trying to mount Adelma, although I thought that this was not the time to remind her of that. Had Dr Freud been present? Yes he had, for he had struck me repeatedly with his walking-cane, the malicious brute. But when I had awoken from the dream of Trudi Mennen into the dream of the wise old man, and subsequently when I had awoken from *that* dream into this night of rioting and a fossilized count, both Malkowitz and Dr Freud were nowhere to be seen. I was fairly certain that when I left Schloss Flüchstein after being attacked by Professor Bangs, the place was otherwise empty. So where were they?

As these speculations ran through my mind, I found myself stopping – stopping, standing quite still and sniffing the chilly night air.

"Adelma – what's that – what is it?"

What could I smell apart from gunsmoke and fear? Something acrid and hot like molten metal? With an odd sort of odour of stale cooking to it . . . something that stung the eyes, too . . .

"Adelma!"

Had I heard that? Yes, I definitely had, but it was quite faint.

Then we both turned and in the distance we saw a ball of hungry yellow and red flames, flickering against the darkness of the night sky, shooting up as they gulped in oxygen, feeding on the air . . .

Fire! That's what it was I could smell. Burning. But what, exactly? Not metal as I had thought, but wood. The cottage! Then I remembered that Adelma had tossed her burning torch into the shrubbery just before entering, the thoughtless girl. She must have set the whole place alight. Then I saw the

mob, about fifty or sixty of them, shouting and yelling in fury. Arms, upraised, brandished makeshift weapons: sticks, garden hoes, pickaxes, broomsticks and, incongruously, a copper jelly-mould.

"There he is!"

"Run!" I cried to Adelma. "Get back to Schloss Flüchstein as quickly as you can!"

"But Hendryk –"

"It isn't you they want, it's me. Do as I say! I'll meet you there. Now go!"

I waited until she was out of sight, then I turned and staggered off down the nearest sidestreet. I fell awkwardly against a wall, slipping on the uneven paving stones and grazing the back of my hand. I felt the skin tear and wrinkle. The street itself was narrow, and when I looked up at the thin black ribbon of sky above me, I felt myself trapped, hemmed in between the sheer rise of the buildings on either side. Surely I could not be that far from the open scrubland by the municipal dump? It was as if the town and its hinterland had merged, one folding itself into the other, giving me an unpleasant sense of disorientation. My feet did not appear to want to move. I felt as if I was trying to run through waterlogged, clinging mud. My heart was beating very fast.

Just then I heard a clinking, whirring sound and when I turned I saw a small boy coming toward me on a bicycle that had obviously seen better days. It wobbled and shuddered as his thin, grime-smeared feet turned the pedals, but at least it actually worked.

"Stop!" I cried, holding up one hand in what I hoped was an authoritative manner.

"Can't!" the boy shrieked, but as he tried to pass me I grabbed the collar of his torn, stained jacket and jerked him to a halt. He slithered off the seat, nearly losing his balance.

"What do you want?" he demanded breathlessly. "I'm in a hurry."

"I want you to give me your bicycle."

"Well, you can't have it."

"Why?"

171

"Because this one isn't mine."

"Whose is it?"

"I don't know, I stole it."

"Perhaps I'll just steal it from you, then."

Suddenly the boy's frightened eyes widened. As he stared at me his mouth fell open. He pointed with a stick-like, trembling finger.

"You – you're – *him*! That madman, the one they're all looking for!"

"Never mind about that."

"Are you going to do something unspeakable to me?"

"Certainly not. What's your name?"

"Jüri."

"Well Jüri, will you give me your bicycle?"

"I told you, it's not mine."

"Will you?" I repeated.

The boy thought for a moment, then he said:

"Two hundred gold crowns and it's yours."

"I haven't got two hundred gold crowns."

"All right, a hundred. I can't say fairer than that, can I?"

"I haven't got a hundred either. I don't actually have a single crown on me."

"Piss off, then."

He tried to clamber back up onto the seat but I grabbed him by the shoulders and pulled him off again. He started pummelling my chest with small, ineffective fists.

"I *must* have that bicycle!" I yelled.

"Why?"

"Because there's an enraged mob after me. Can't you hear them? And if I don't get back to Schloss Flüchstein as soon as possible –"

Suddenly the boy stopped lashing out at me.

"Schloss Flüchstein?" he echoed.

"Yes."

"Why didn't you say so before? That's where Adelma lives, right? Any friend of Adelma's is a friend of mine. Here, take the bike – quick, quick – I *can* hear them! They're getting closer!"

172

"Do you *know* Adelma?" I asked, overcome with a spasm of curiosity.

The boy grinned cheekily.

"In every sense of the word," he replied. Then he winked at me and passed his tongue across his lips. "Get me?"

"Yes, I think I do. It's disgusting at your age."

"Do you want this bicycle or not? I can do without your moralising. Don't tell me you haven't had her yourself! We all have."

"What?"

"Look, just take the bike and get out of here."

"What about you?" I said.

"Ah, well, it's not my blood they're after, is it?"

I nodded, clambered onto the old machine and pedalled away as fast as I could. As I glanced behind me for a moment I saw the boy standing in the middle of the street, holding up one finger in an obscene gesture.

When I finally reached Schloss Flüchstein and dragged myself exhausted and depressed upstairs to my room, I opened the door to find Dr Freud, Malkowitz and Adelma already there. They were sitting in armchairs. Malkowitz had a dreamy, glazed look on his repulsive face and Dr Freud was saying in a monotonous, quavering voice:

"It is true that my sister Hannah was a moderately gifted musician and eventually ended up in the string section of the Stuttgart Philharmonic, but in later years she joined an eso-teric kabbalistic sect that encouraged its members to indulge in dangerous ascetic practices: in particular, frequent periods of fasting and severe self-inflicted penances. It was whilst undertaking such a penance – the precise nature of which I do not consider it proper to describe here – that poor Hannah damaged her womb and was therefore unable to position her instrument correctly without excruciating pain. She once passed out during a performance of Merkenberger's *Paren-thesis in F Minor* and, eventually, was obliged to resign from the Philharmonic. She never played the violoncello again –"

"Where the devil have you been?" I cried.

173

Dr Freud glanced up at me, clearly irritated at the interruption.

"I have been passing the time waiting for *you* Hendryk, by telling Malkowitz and Adelma a little something of the vicissitudes of my long life."

"I've heard it before," I said, equally irritated.

"I'm not telling it to you, but to them."

"Malkowitz has heard it before too."

"I haven't," Adelma said with a note of reproof in her voice.

"Besides," Malkowitz added aggressively. "I *like* hearing it, again and again and again. Where have *you* been, if it comes to that?"

"Running halfway across the town, being chased by a mob intent on murdering me, abused by a boy on a bicycle . . . oh, it's too long a story to go into in any detail."

Dr Freud shook his head slowly.

"Such boorish behaviour. There's no courtesy anymore, no good manners."

"I would say that being chased and attacked amounts to rather more than *bad* manners, wouldn't you?"

"Don't contradict Dr Freud, you young thug!" Malkowitz cried. Then, with an absurdly theatrical attempt at simmering menace, added: "I'll smack your bare buttocks next time you do . . ."

"Why not smack them now?" Dr Freud murmured contemplatively.

"Yes," I said to Malkowitz. "You'd like that, wouldn't you? Inflicting pain seems to be something of a hobby of yours. When you're not threatening to spank muscular young men, you're frightening overweight women with knives."

"You promised you wouldn't say anything! You promised!"

Dr Freud turned to Malkowitz and said in a low voice:

"Please do not concern yourself Malkowitz. Hendryk isn't telling me anything I don't already know."

"What!"

"I have been aware of your sadistic tendencies for years. So has everyone in B——, as a matter of fact. Why, there was even a

lecture about it two years ago at the Städler Institute. It was attended by over three hundred specialists in sexual psychopathology including Dr Hornbech of København and Professor Hildegard Krump. It was extremely well received, I might add."

"Who gave the lecture?" Malkowitz asked, his mouth open and his eyes staring at Dr Freud in disbelief.

"I did, of course. It was copiously illustrated by colour slides."

"Slides? What of?" I asked. I suddenly found myself quite curious.

"Malkowitz, mainly."

"Me?"

"Yes. In bed for the most part, but also in several other intimate situations and circumstances. Most of the bodily functions were photographed, including repeated acts of self-abuse."

"Who by?"

"You, of course. That's why it's called *self*-abuse."

"No, I mean who took the photos?"

"Your wife," Dr Freud answered. "She co-operated most willingly. For a fee, that is."

"How much?"

"I'm afraid that is confidential information."

"The sly bitch!" Malkowitz gasped. "I always did wonder how she was able to afford that new winter coat . . ."

"So you see, Malkowitz, I know all about your *penchant* for the darker aspects of sexual stimulation."

Then Dr Freud glanced up at me.

"Which reminds me," he said. "Where is Count Wilhelm?"

"Ah . . ." Adelma murmured.

"I'm afraid he's been turned into an antique."

"No . . ."

"Yes," I said, nodding.

Dr Freud's eyes narrowed suspiciously.

"Why are you so suddenly the object of everyone's anger and hatred?" he asked. "Why is the common mob intent on murdering you?"

I was silent. I hung my head.

175

"I think you owe us an explanation, Hendryk. Don't you?"

"Yes Hendryk," Adelma put in. "You promised me you'd explain everything."

Finally, I said slowly:

"You're right."

"Well?" Malkowitz demanded.

So I took a deep breath and began.

★ ★ ★

All three of them looked at me expectantly.

"While I was lying unconscious in the grounds of Schloss Flüchstein on the night the cows stampeded," I said, "I dreamt that I made love to Adelma –"

"You have told us this before," Dr Freud said.

"Maybe he *likes* describing how he mauled and pawed her," Malkowitz said in a sneering tone of voice. "Maybe it arouses him to go over every lurid detail of how he stimulated her aching body, how he played with her, teased her, brought her to a pitch of screaming passion –"

"I certainly hope it does," Adelma mused.

I gave Malkowitz a contemptuous glare and continued:

"What I *didn't* get round to telling you was that after we'd made love, I fell asleep in the bed. We both did. Then I dreamt I was in a small, dark room where there was a naked man –"

"Pervert!"

"– who related a very disconcerting story."

"A sex story, eh? Was it about sex?"

"No, it wasn't. *It was my own story*. The man in that room was myself. I saw his face and it was like looking into a mirror."

"You? It was you?" Adelma cried.

"Yes. When he had finished speaking, I knew everything there was to know. You see, after I regained consciousness, I *remembered*. I remembered the very first dream I ever had. I was six years old. I dreamt I was running across a field at the back of our house in Z—, being chased by a huge bird with great flapping wings and a cruel, snapping beak. It was shrieking and squawking and crying out in a cracked, inhuman voice: 'Run, run, but you'll never escape!' I woke up before the creature caught me, but I was full of fear and anxiety for the rest of that day. I never told my mother or father about it because I thought they wouldn't understand. I was convinced that they had never had dreams of being

chased by giant birds and would think me mad if I confided in them.

"As a matter of fact, there wasn't any field at the back of our house in Z—, but you know how dreams are. They say what they want to say in their own language and if you don't understand it, they aren't bothered in the slightest. I was never a strong child – not weak or sickly or perpetually in bed with colds or fevers or muscular pain you understand, just not very strong – and I think my mother mollycoddled me rather. At any rate, my father was always saying that she did. I suppose he was right. Instead of attending the school on the top of the hill for local boys – most of the girls were taught by the nuns at the Convent of the Most Agonising Heart – someone came every morning to our house to instruct me in the fundamentals of grammar, mathematics, history, geography and music; it was not considered worthwhile to teach me art, since it appeared I had no aptitude for it. Myself, I'm not exactly sure *what* I had an aptitude for. Stories I loved, and after an hour or so old Herr Franzli would leave me to bury myself in a book of fables or folktales or adventures while he sat by the fire sipping sliwowitz from his engraved silver flask, growing red in the face and eventually dozing off. My mother and father knew this habit of his, which is why they felt able to pay him so little for his services. Had he not been an inveterate imbiber, they could not have afforded him, or anyone else for that matter, since they were by no means well off.

"The years passed and I was still no surer of what I had an aptitude for, but it was assumed that as soon as I was old enough I would start work with my father on old Matthias Grünbackler's farm; it was heavy work but undemanding and my father had done it most of his life. My mother made apricot jam which she sold in the village to supplement his modest wages. They got by. However, working for Herr Grünbackler didn't in the least appeal to me and I persuaded my parents that I did not have the physical constitution for it.

" 'I was never a robust child,' I reminded them. 'You said so yourself.'

" 'But you're a man now,' my father countered. 'You're eighteen. Things have changed.'

" 'Not that much, father. I still have headaches, I still twist and turn in my sleep, I still need extra butter and milk to fatten me up. Look at me: I'm as thin as a stick! I'd never be any good with a scythe or a plough.'

" 'What are you talking about?' my father cried. 'Herr Grünbackler has a motorised tractor! What century do you think we're living in?'

"I had forgotten about the motorised tractor. However, I persisted, telling them over and over again that I had no intention of working on the farm, tractor or no tractor.

" 'Then what *will* you do?' my mother asked, a little more sympathetic than my father was proving to be.

" 'A writer,' I quite unexpectedly heard myself saying. 'I want to be a writer.'

"They found this extremely hard to accept, which did not surprise me. It was unheard of in our family. My mother's unmarried sister, Aunt Anne-Mone, once had a poem about ducks on a frozen pond published in the nuns' monthly magazine for ladies, but that was it.

" 'Writers are an idle bunch of swine!' my father objected, his rugged, creased face red with outrage, almost as red as Herr Franzli's when he had been at the sliwowitz. 'They wear silk dressing-gowns and scribble rubbish all day! They mock religion and describe things that shouldn't be described in the foulest, most sickening detail. They sit on their oh-so-delicate arses and think the world owes them a living. They're all twisted up inside, inverts, drunkards, drug addicts, addled with fancy wines and diseased women!'

"There were several inconsistencies in my father's frank description of writers, but I did not risk pointing them out to him. Instead, I simply insisted as firmly as I could:

" 'I want to be a writer, father. I'll be a good writer, I know I will. I love books and I want to produce books.'

" 'Then why don't you apprentice yourself to a publisher or a bookbinder?'

" 'That wouldn't be the same thing. I want to *write* books.'

" 'At your age the only thing you should be wanting to turn out is babies! And the only thing you should be writing is your name on a contract of marriage. I want sons from you, lad! Strong, healthy, lusty sons to carry on my name –'

" 'What, and go to work on Matthias Grünbackler's farm?'

"My father struck me hard across the face and – shrieking – my mother fell on him in a fury, sinking her teeth into his shoulder, pulling him away before he could hit me again. I pushed myself back against the kitchen wall, breathless, the side of my face stinging, a little frightened by the intensity of his anger. He had never struck me before.

" 'Do whatever you want,' he muttered, pushing my howling mother aside, 'I wash my hands of you, lad.'

"He did no such thing, of course. As a matter of fact, without actually relenting, he became quite helpful, saving a little from his wages each week to buy me a set of beautiful writing pens with gilt nibs and little rubber tubes inside that sucked up and held the ink; he purchased packs of good quality paper with the watermark *Russmann & fils* impressed on it; he managed to find a little cloth-bound volume, in translation, entitled *The Craft of the Man of Letters* by an eminent Englishman called Dimkins. These things I appreciated enormously, and loved him for his tender concern, his interest and, despite everything he had said, the silent pride that I knew he was feeling. That was my father all over: rough and hardworking and utterly practical, but also gentle-hearted and kind when he knew it was required of him. My mother would have supported me even if I had announced that I wanted to be a grave-robber, for such was her nature: she loved me with a fierce, possessive and consuming love, all the deeper for being expressed in deeds rather than words: an unexpected embrace when she folded me in her large warm arms, a kiss on the forehead as she put a steaming bowl of bacon dumplings on the table, a smile full of realisation and knowing, a brief squeeze of my hand before she said goodnight.

"All this – my father's quiet support and my mother's comforting demonstrativeness – made the great and terrible *Thought*, when it came upon me, the more acutely tragic. I

have often wondered – so many, many times that it has tormented me! – whether my life would have been quite different if the Thought had never entered my mind; or whether perhaps such a thing would have been impossible because it was somehow destined to come and I was doomed to receive it. Now, I suspect the latter. I am in the invidious position of not being able to believe in accidents, but also of failing to convince myself on purpose. That's what the Thought has done to me, and so much more. Indeed, when I tell you the things that I have been driven to because of it, you will scarcely believe me. Yet I speak the truth. Since its first advent it has overshadowed my life like an immense black cloud, blocking out the sun, chilling me, obscuring any clarity of vision, leaving me half-blind, stumbling along an unfamiliar path toward a destination I know I will never reach because it does not exist.

"I remember in every detail how it came. You see, I had a friend called Trudi Mennen, a girl I had known for many years who used to come to our house on Friday evenings for supper: she adored my mother's onion-and-noodle soup that was always served with home-baked bread and cheese curd. She was blonde, pretty and vivacious like her mother Emmy Mennen the butcher's wife, which is why I suppose I was drawn to her, for I was dark-haired, introspective and somewhat overly sensitive for a boy. Trudi didn't know the meaning of the word. I wouldn't want you to misunderstand me, she *was* kind: kind and thoughtful and, for someone of her extrovert nature, markedly gentle. Otherwise she would never have been my friend. Sometimes we skylarked around together as adolescents do and she would let me peep at – often even touch! – the mystery of her burgeoning body when we were alone. Unlike me however, there was nothing of the dreamer about her, nothing of the visionary or the mystic. Well, they say that opposites attract, don't they? I would look at a clump of cornflowers growing along the path bordering one of Herr Grünbackler's fields and say:

" 'Look at the colour of the sky! The colour of your eyes, Trudi. Perhaps if one of them were to open up, and keep

opening up, there *would* be a sky inside, full of birds and clouds just like the real sky. Maybe the sky inside the flower *is* real, only it's part of a different world. How many different kinds of blue are there?'

"Trudi would stoop down, grab a handful of flowers, and shove them under her nose.

" 'These are no good, they don't have any smell. You couldn't sell these. That's why old Grünbackler has left them wild. He'd sell a bicycle with only one pedal if he could find a man with a wooden leg.'

"It was that particular field on the edge of Matthias Grünbackler's farm where it happened, where the Thought first pushed itself into my mind. It was a hot summer's day, one of the hottest anyone could remember I think, and we had gone down to the field with bottles of cooled beer, some grilled chicken and fruit, just to stretch out in the sun and laze the morning away. We'd done it before, you see, when Trudi wasn't helping to wrap purchases in her father's shop and I couldn't think of anything to write. We ate and drank and talked nonsense together. It was all very pleasant.

"We had devoured the chicken and apples and were lying on our backs staring up into the shimmering sky, occasionally swigging our beer. Trudi belched uninhibitedly, as I remember.

" 'What's it like,' she asked, 'being a writer?'

" 'I'm not sure. Well, I haven't done much of it yet. It involves a great deal of thinking. I mean, you have to know *what* you want to write before you can actually write it. My mother and father understand that. They've told me I've got two years.'

" 'Two years for what?'

" 'To earn some money. If I don't sell something to a newspaper or publish a book – or something like that – in two years, I'm to work on old Grünbackler's farm with my father.'

" 'Everyone in the village says how peculiar it is.'

" 'Wanting to be a writer?'

" 'Yes. Frau Dörning says that all writers are revolutionaries. She says you'll end up getting shot by a firing squad. No one has ever heard anything like it before.'

" 'Getting shot by a firing-squad? I think it happens all the time in the army.'

" 'No, being a writer.'

"I turned my head toward hers and shaded my eyes with the palm of my hand.

" 'What do *you* think about it?' I asked slowly. My heart was beginning to beat faster. My stomach heaved. I was desperate for her approval!

" 'I think it's wonderful. I can't believe it. It's amazing and incredible and exciting all at the same time.'

She reached out and caressed my cheek with a fingertip.

" 'You're hot,' she murmured. 'You're burning up.'

" 'It's a hot day,' I answered.

" 'Why don't you take your clothes off, then? I'm going to take mine off.'

" 'Are you?'

" 'Yes.'

"We both stripped naked, tossing our clothes – including underwear – into a careless heap some distance away. Then we lay down again, holding hands and staring up at the sky. It was perfect! I can't think of anything that was more perfect than that moment: the vast expanse of blue, a solitary bird wheeling and dipping in an elegant parabola, the sweet coolness of the beer lingering in our bellies, the taste of garlic, herbs and grilled chicken still on our grease-moist lips, the soft and prickly grass beneath our nakedness. It was like the first day of creation when everything was new, dropped whole and entire from the hand of the Creator, heavy with the fragrance of flowers and fruits and fresh earth. I could hear Trudi breathing – smoothly and regularly like the ebb and flow of a distant tide – and I could feel the nearness of her naked body, almost smell the sweat that filmed her skin.

"I was so happy. I withdrew my hand from hers and passed it across her breasts. I felt the full, firm nipples tickle my palm. I slid it down across her rising-and-falling belly and my fingertips brushed over the secret hair below, reaching out to caress and part the lips of her moist cleft . . .

" 'Mmmm . . . that's nice,' she murmured.

183

"And then the Thought came.

"At first it was the merest glimmering of a faint shadow moving in the sunlight, the slightest of jarring sounds in the stillness of the summer day, and I thought I could flick it away with an almost imperceptible movement of my hand, as one would flick away a fly. Then – oh! – then it crashed into my brain with the terrifying power of thunder, breaking down the doors of my mind and hammering its way into the very depth of me!

It will come to an end.

"There, I've spoken it! I've uttered it in your presence. That was it. That was the Thought that came to me on the glorious morning of sunshine and beer and nakedness with my friend Trudi Mennen. Oh, I know it must sound trivial to you – absurd, even! – but it has never been that to me. For if happiness such as I knew on that day comes to an end, leaving only a poignant and painful memory, what's the point of knowing it in the first place? Why seek to experience something the passing of which can bring only the sadness of loss? And the passing is inevitable. The Thought made that horribly, undeniably clear. Everything which is good and pleasurable – every sight and taste and touch and smell and sound that brings delight – is fated also to bring the misery of emptiness and boredom, because *it will come to an end*. The more intensely the Thought seized me and held me in its dreadful iron grip, the more I knew it to be true. On the other hand, when awful things come to an end they bring – if not exactly happiness – relief and gratitude. Can you see what *I* saw that day? The pursuit of happiness is doomed to end in unhappiness, and good things are destined by their very nature to make you feel bad. The conclusion was, and remains, inescapable.

"Oh, I tried with all my might to escape it, believe me! I leapt up from where I was stretched out beside Trudi Mennen, frantically pulled my clothes back on and, ignoring her bewildered questions and puzzled concern, ran all the way back to our house. I tore up the stairs, threw myself onto the bed and buried my face in the pillows, twisting and turning in

a sweaty agony, repeatedly rejecting the Thought yet cease-lessly surrendering to it. For three days I could not eat and my anxious parents thought I was terribly ill, which in a way I was. Dr Wolf was called. He examined me, tut-tutted, pushed his finger up into my rectum and withdrew it again, advised my mother to give me a cold blanket-bath every four hours and left his bill on the bedside table in an obvious manner. My head ached, my throat was parched and burning, I perspired and shivered at the same time. I slept scarcely at all, and for the first time since my childhood the dream of the great flapping bird came back to haunt what little rest I managed to get. Even unconsciousness was not, for me, oblivion. My father was obliged to lift me onto the commode when I needed to relieve myself, but when he was out working on the farm and my mother did not hear my groans, I simply pissed myself where I lay, so that the sheets eventually became yel-low and stank.

"Finally, on the morning of the third day I fell into a fitful doze. It was about nine o'clock. When I opened my eyes I knew that my agony was over: it was over because the Thought had carved out a place for itself in the very centre of my soul and I realised that it was there to stay. It would never leave me now. In which case, there was no further need to fight it. I had accepted – or been obliged to accept because I was too weak to resist it – the granite block of despair it had pushed into my heart. Yes, the agony was over, but my quiet, enduring despair had only just begun.

"At all costs I must be practical, I knew that. I would have to draw up a list of tasks that must be accomplished according to the darkness in which I now lived and moved and had my being. Everything had to be done to minimise the misery that the ending of so-called 'happiness' would inevitably bring. Trudi would have to be the first to go. What was the point to days of grilled chicken and beer and intimacy in the warm sunlight if their ending would only leave me in emptiness and pain? I had to abandon them before they could abandon me. Inevitably, she did not understand. She was hurt and per-plexed and angry.

185

" 'Tell me what I've done wrong!' she cried, pulling me close to herself and shaking me hard.

" 'Nothing.'

" 'Then why, why?'

"I rebuffed her every attempt at affection, I refused all invitations to walk and talk with her, I avoided her company as if she were suffering from some infectious illness. Eventually she found me and cornered me and shoved me up against a wall. She was almost crying.

" 'I'm your friend,' she said. 'Why would you want to do this to me? Answer me!'

"I remained silent.

" 'Bastard, bastard, bastard!'

"She leaned forward and kissed me full on the lips. Then she smashed her fist into the side of my head and strode off, leaving me slumped and bleeding. We never spoke to each other again. I knew, however, that the Thought had been right: for her wretchedness filled me with anguish and it was almost unbearable to see her suffering, yet when she finally accepted the situation and made up her mind to do without me – when her wretchedness ended – I experienced a deep and profound sense of relief. And thankfulness. Of *course* the Thought was right! Its implications were working themselves out in my life exactly as I realised they would. Why had I never understood this before?

"It was more-or-less the same with my parents, and if the agony it caused me to see them suffer was more intense, so too was the relief when that agony subsided and they understood that I had changed, permanently; or, rather, that I had been changed by the truth of the Thought. My mother took it particularly hard when I refused to return her smile, when I drew back from her caress and turned my head aside from her outstretched, trembling hand. Conversation between us practically ceased except for formalities and trivialities. She moped and lost weight, becoming careless about her appearance and personal hygiene. My father displayed less obvious distress, but I knew deep down he felt it keenly. In the end, they too accepted the inevitable and my own misery at their suffering

was replaced by a dead, flat, iron-heavy sense of resigned gratitude when it was over. Once, passing the half-open kitchen door, I overheard them talking.

" 'It was that illness, whatever it was,' my mother whispered. 'He's never been the same since.'

" 'Doesn't look as if he'll ever be the same again,' my father replied.

" 'What do you think it was, some kind of brain fever?'

" 'I don't know. I only know he isn't our son anymore.'

"Then I heard my mother burst into sobs, so I crept slowly and quietly upstairs to bed.

"There was really no point in staying at home after that, so I told my parents I would be leaving to find somewhere to live in town, possibly even in the city. My mother had already shed all the tears she had to shed, so she remained dry-eyed and silent, merely nodding. My father offered to help me with my things but I said I could do it myself. He gave me a little packet of money instead, to start me off in my new life. As I glanced back for the last time at our house, I saw my mother standing at the door, looking so small and frail and vulnerable. Then my father came out and put his arm around her, scowling slightly. I turned and walked away.

"Of course, I began to understand now why it had entered my head to be a writer. Writing, you see, was the one way I could create a world in which chicken and beer, friendship, love, my mother's tender affection and my father's wordless pride would *never* come to an end. Why, I could fashion any kind of world I wanted *and* live in it! Most of the time, anyway. After all, there was no point in falling in love with some beautiful girl and getting married, because sooner or later that would finish, even if only in death, so I might just as well get married to a girl of my own devising who *couldn't* die. She would live as long as I lived; indeed, she would outlive me. You see how beautifully simple it was? Neither did it particularly matter if my fictional world was never published, because I would have it all in my head, permanently. Not only that, if I ever got bored with it I could change it, refresh and renew it, fill it with characters who would do exactly what I wanted

them to do. In this private world, nothing would ever go wrong: the sky would always be cornflower blue, it would always be summer, the bread would always be freshly baked, friendship would never fade and love would only ever deepen. I was prepared to live simply to serve these ends: a little room somewhere in the city I thought, with a bed and a table and a supply of pens and paper; a patisserie nearby where I could get cake and coffee when I was hungry; a washerwoman to whom I could take my laundry for a modest sum. What more would I need? The rest of the time I could devote myself to creating my own beautiful, pleasure-filled and permanent world. And I did."

"What on earth do you mean?"

"I mean that the world I created was *this* one. I am the author of it."

Dr Freud waved one trembling hand around in the air.

"All of this?"

"Yes."

"Schloss Flüchstein, Count Wilhelm, Adelma –"

I nodded.

"You *wrote* everything?"

"Exactly. And I've been *unwriting it* ever since."

"Ach, mein Gott!"

"I got pen and paper from the count on the pretext of wanting to thank the archbishop for that ridiculous Rite of Healing, and I started to rewrite everything. I made it the *second* of the month. I made the cows placid and docile as cows should be –"

"Schwachsinniger! How could you be so irresponsible?"

"I thought," I protested, "that I would be doing everyone a favour."

"Don't deceive yourself, my friend! You wanted only one thing: to make Adelma fall in love with you. This pretence at altruism is nauseating."

"And it worked. Well, at first, anyway, but the effect wasn't always stable. One moment she'd be slobbering all over me and saying that couldn't live without me –"

"The next," Dr Freud put in, "she would be allowing

Malkowitz to sexually penetrate her and telling everyone that she despises you."

"I'd begun to wonder why that was," Adelma murmured. "It was terribly confusing."

"Excuse me doctor," Malkowitz said in a small, apologetic voice. "It didn't actually get to the point of penetration . . ."

At this, she cried aloud:

"Don't you think it's for *me* to say who did and who didn't penetrate me?"

"The effect would have become stronger and more reliable with time," I said.

"But once you had ensured that it was no longer always the first of the month, time became your enemy, eh?"

I lowered my head sadly.

"Yes," I murmured, you're right. Now the count is a feeble fossil. I was so sick of bread, I wrote it out of existence and the city is torn by bloody riots . . . Professor Bangs has completely taken leave of his senses because his *Unus Mundus Cubicus* disintegrated . . . I made Mrs Kudl a *cordon bleu* chef and she is presently in a state of nervous collapse. Everyone is growing old and senile."

"Except me," Adelma pointed out. "Why haven't *I* grown older?"

I turned to her.

"Because," I answered slowly, "I love you."

"What?"

"You are the only person in this ghastly nightmare that I truly care about. You haven't aged like all the others because love has protected you."

"Sentimental balderdash!" Dr Freud cried angrily. "Look at the chaos and suffering you've caused! Poor Adelma's father —"

"It isn't really happening anyway, none of it is. This is all a dream, remember?"

"Kindly allow *me* to decide that!"

"Dr Freud is the expert in dreams," Malkowitz put in.

I looked at him scornfully.

"You sycophant," I muttered.

"What's a sycophant? Was that in the lecture too, Dr Freud?"

"No, Malkowitz. It has nothing to do with deviant sexuality. Not, that is, unless the sycophant or the recipient of sycophancy finds himself aroused by it. I remember a case once, some years ago it was –"

"There's no time for all that now," I interrupted him. "Adelma and I are getting out. Do you want to come with us?"

"Is that actually a matter for you to decide? If Schloss Flüchstein is a dream within a dream on the train, and remember, we have still not discovered which of us is the dreamer –"

"I don't give a damn who's dreaming and who's being dreamed!" I yelled.

"Are sycophants fat?" Malkowitz asked. "Couldn't you make me a *thin* sycophant if you rewrite it?"

Then, all at once, the three of us became absolutely still. From somewhere far, far away we heard the melancholy, attenuated sound of the whistle of a train. Slowly, as if afraid to shatter the tenuous magic of the moment, we glanced round at each other: I looked at Dr Freud, Malkowitz looked at me, Dr Freud looked at Malkowitz then at me.

"Did you hear that?" I said in a whisper.

They nodded.

"It's a train," Dr Freud murmured.

"Quite a distance away by the sound of it."

We were silent for a few moments, then I said:

"Do you remember how far we came after we got off Malkowitz's train in the snow?"

How long ago *that* seemed now!

Dr Freud shook his old head.

"We were picked up by the count's coach, if you recall. Perhaps fifteen minutes or so. But we had stopped in the middle of nowhere."

"The station can't be too far out of town, surely? It *should* be in the middle of town but I don't think it is."

"Well?" Malkowitz muttered.

"I say we make a run for it. I'm certain we'd reach the station before that train does."

"I'm afraid I wouldn't be able to run very fast or very far. I am an old man."

"Papa's horses are stabled in the coach-house. *And* the coach is there," Adelma said.

"Are you certain of that?"

"Yes."

"You can't be certain of –"

"Shut up!" I hissed at Malkowitz. "The last time I saw the count he was just about on his feet, not in his coach."

"What are we waiting for? It is perhaps our last chance!"

Malkowitz and I helped Dr Freud out of the armchair.

"If I find out that a sycophant is something not very nice, I'll thrash you within an inch of your life," Malkowitz muttered to me.

The coach *was* there and so were the horses, but we realized very quickly that none of us knew how to harness them and none of us had actually driven a coach before.

"That was the coachman's job," Adelma pointed out.

"I only know about trains," Malkowitz murmured self-defensively.

"And how to lose them," I put in.

"By God, I've a good mind to –"

"Tut, tut, gentlemen!" Dr Freud interrupted impatiently. "This bickering will get us nowhere. We must *think*. Malkowitz, are you capable of handling a coach and horses?"

"No, doctor, I'm not."

"Are you, Hendryk?"

"No."

"You needn't look at me,' said Adelma, pulling a face. "The only thing I know about horses is that they have astonishingly large sexual organs."

She glanced at me in a curious manner.

"Do they?" I murmured.

"Oh, yes. Many men would fall prey to envy, I'm sure."

Dr Freud sighed heavily.

"Well I'm certainly not capable of such a thing," he said.

"Of envying horses their sexual endowment?"

"No! I mean of handling the coach."

Malkowitz looked from one of us to the other.

"It can't be all that difficult, surely? All we have to do is get the coach out into the courtyard, then untie the horses –"

"How do you suggest we do that?" I asked. "That coach must weigh a ton or more. What should we do, just push it?"

"That's the trouble with you! Always carping and criticizing other people's ideas and never offering any yourself!"

"Look –"

"Why don't we untie the horses first and let them pull the coach out?" Malkowitz went on.

"There isn't enough space to harness them. The coach-house won't take the coach *and* the horses."

"Well how the hell does the count do it, then?"

"How should *I* know?" I cried.

Then he stood still for a moment or two, cocking his head as if listening for something.

"Did you hear that?"

"What?"

"A sort of murmuring. Like people shouting, only in the distance."

"Maybe it's thunder . . . I don't know. Who gives a damn what it is?"

"The coach," said Dr Freud slowly, "is a wheeled vehicle, is it not? One of us could be temporarily harnessed to it and *pull* it into the courtyard without too much difficulty. Then the horses can be untethered. Obviously I would be unequal to the task but you Hendryk, or you Malkowitz, one of you could do it I should imagine."

Malkowitz and I glanced at each other.

"Not me," he said in a surly manner.

"Why not? You're the biggest. You'd have more strength than me."

"I haven't forgotten how you jumped on me in Adelma's room and damn near killed me! I'd say we were about even when it comes to strength. Why can't you do it?"

I thought hard for a desperate moment or two then, suddenly inspired, I blurted out:

"Because I'm one of the world's leading authorities in the art of yodelling, remember?"

Malkowitz stared at me.

"What's that got to do with it?"

"Isn't it *obvious*?" I shouted.

His eyes bulged in his fat red face. He was clearly trying to work out the connection, but I had gambled on him being stupid enough not to see that there wasn't one. Finally, he looked at Dr Freud.

"Well, doctor?" he muttered.

"I have every confidence in you Malkowitz," the old man said.

"We all have," Adelma added.

"Well, if you say so – I mean – if you're sure."

"We're absolutely sure," I said quickly. "Now for God's sake get harnessed up, we haven't got much time!"

Now I distinctly heard something: like the noise of tide ebbing and flowing, like the rushing sound you hear when you hold a seashell to your ear. It seemed to be getting louder or coming nearer.

"What *is* it?"

"I do not care to know," Dr Freud whispered.

Malkowitz looked a bit like a horse himself: only less graceful, less noble and certainly less fleet of limb. The leather straps of the harness swathed across his bloated, flabby body, exaggerating the already prodigious swell of the breasts and belly.

"Shouldn't we use the bit?" Dr Freud said.

"My mouth isn't big enough!" Malkowitz cried in alarm.

"You could have fooled me," I muttered.

"What? I heard that!"

"Oh for God's sake, just pull!"

His face almost purple, the veins long obscured by rolls of oily fat now like ropes in his neck, he panted and gasped and shuddered as the coach slowly rolled into the courtyard.

"All right Malkowitz, that's it, that's enough. Now we can untether the horses and get *them* harnessed."

But we never did, for at that moment the sound of a mob screaming and cursing suddenly swelled and shattered the stillness of the night. For a moment or two none of us moved. I heard individual voices calling out:

"Burn the whole place down!"

"It's the maniac we want. He may be in there –"

"Then let him burn with it!"

"He'll kill us all if we don't kill him first . . ."

"He's a monster, a beast, a murdering bastard!"

"Burn him, burn him, burn him!"

"–and those lunatic friends of his –"

"The old one and the fat one . . . kill them all!"

I saw Dr Freud's rheumy old eyes glance first in my direction, then at Malkowitz, and they were filled with terror.

"Get in!" I hissed to him. "Get in the coach!"

"They're out for our blood, doctor – help me! – *us*, I mean –"

Dr Freud clambered up into the coach and slammed the door shut. I climbed up into the driver's seat and Adelma settled herself beside me. She squeezed my arm encouragingly. I took the reins in both hands.

"What are you doing? What's going on?" Malkowitz yelled.

"Get going, man!"

"But the horses –"

"We haven't got time for the horses! Pull, pull for your life!"

Malkowitz strained with all his might, puffing and blowing noisily like a pair of old bellows; he took two faltering paces forward then one back, then another forward, and another, and then one back again. The coach slowly and painfully, almost unendurably slow and painful, inched its way forward.

"I can't!" Malkowitz cried aloud. "It'll kill me!"

"That mob will kill you if you don't!" I yelled down at him. For good measure I kicked him in the back of his neck with the toe of my boot.

"Stop it, stop it!"

"Pull, pull, pull!"

The coach, gathering its own momentum now, rumbled over the cobbles of the courtyard and out through the gate. It was clearly becoming a little easier for Malkowitz. He brought it around the side of the house and into the street in front of Schloss Flüchstein. Actually, although I hated to admit it, he was doing quite well. It was good exercise for him, anyway. This gave me an idea.

"Malkowitz!"

"What?"

"Pulling the coach like this will make you lose weight. You'll be thin. Did you realize that?"

"No – *why!* – no, I didn't!"

"Then pull with a will, put your back into it!"

"Thin, thin!" he screeched ecstatically and the coach shot forward into the middle of the road.

Then the mob came around the corner some distance behind us. I glanced over my shoulder and saw a couple of hundred people at the very least, most of them brandishing weapons and burning torches. Most appeared to be quite elderly, thanks to me I suppose, and I saw a couple of walking-frames being shaken angrily in our direction.

"There they are!"

"Don't let them get away!"

"Stop them, stop them!"

All at once I realized that someone else, apart from Adelma, was sitting beside me in the driver's seat

"Hello Hendryk."

The voice was ancient, cracked, yet somehow childlike.

"Papa!" Adelma gasped.

Count Wilhelm was practically fossilized: the leathery skin hung loose, flapping in folds, pockmarked by spots and stains that looked disturbingly like lichen. Yet his eyes, rheumy though they were, glittered with a kind of naïve glee.

"Daddy has come back to say bye-bye," he quavered.

"What?"

"I'm ever so happy but I can't say why. I won't say, shan't say!"

Adelma and I quickly exchanged glances. The count began to sing:

> *"Before I met you dear,*
> *I'd been so blue dear,*
> *But fate has changed my luck.*
> *For now it seems dear,*
> *I've the girl of my dreams dear,*
> *The girl I was born to –"*

"Papa!" Adelma shrieked.

"Love!" cried the count. "To love!"

He put one skeletal, claw-like hand up to his papery lips and giggled.

"You thought I was going to say *fuck*, didn't you? Oh, is that a rude word?"

"Extremely rude."

"Don't tell mummy I've been a naughty boy."

"Is he drunk, do you think?" Adelma hissed. "I've seen him pickled before, of course. He once uncovered himself in front of Mrs Kudl."

"Where?"

"In the gazebo."

"No, I mean which bit of himself did he uncover?"

"Oh," Adelma answered somewhat casually, "the usual place."

"Usual?" I echoed.

"Yes."

"How do you know what the *usual* place is?"

"I'd really rather not say, Hendryk."

"Where are you taking my little Adelma?" the count demanded.

"Out of here."

"Does mummy know?"

"She won't if you don't tell her," I said with a conspiratorial wink.

"I won't tell her if you show me your willy."

"What?"

"Go on. Show me your willy. I'll show you mine if you like."

"I'd rather you didn't," I said. "Adelma, your father isn't drunk. He's senile. He's become so old he's lost his wits."

With the disarming *gravitas* of which only a child is truly capable, Count Wilhelm declared:

"Daddy needs the potty."

"Ah. That would be a little difficult at the moment . . ."

Then, in a shriek:

"Quick, quick, quick!"

At that moment he managed, somehow, to slither off the seat and reach the ground. He ran along beside the coach, then grabbed hold of the chassis and was partially dragged.

"Papa, what do you think you're doing? You'll kill yourself!"

"Daddy needs the potty!"

"He's not only lost his wits, he's also lost control of his bowels," I said.

Suddenly the count let go and reeled across the road, flailing and tumbling. He began to laugh, burbling in a combination of joy and panic. He clutched his backside with one hand.

"Fly away ladybird, fly away home!" he screeched as the coach clattered on and left him behind. The last glimpse I had of him, he was sitting in the gutter trying to pull his trousers down still singing. His old voice, richly fissured and plangent with emotion, floated on the chill evening air:

> *"I did it with a cow on Rudi's farm,*
> *she was big enough to take a baby's arm . . ."*

"What was all that?" Malkowitz demanded. "I can't see anything from down here . . ."

"Get going! Pull! Pull!" I screamed.

"What?"

"Or do you want to be fat for the rest of your miserable life?"

The coach shot forward just as a wild, beastly, bloodcurdling collective roar rose up from two hundred throats. The partially geriatric mob surged forward in outraged pursuit.

The vision I had given Malkowitz of a new, slim, attractive self undoubtedly spurred him on to an heroic effort, but eventually the strain of pulling the coach, Dr Freud – although he couldn't possibly have weighed very much – Adelma and myself, began to tell. He called up frequently for a brief respite, but I would not allow it. Even when the yelling, cursing mob had been left far behind us I urged and goaded him on. After all, we still had to get to the station before that train left. On the outskirts of town he began to stumble now and then and I heard the rasping, chesty wheeze of his laboured breathing. So I used the whip a couple of times, caressing the back of his fat neck and with the merest teasing flicks. Once or twice a spot of bright blood flew up and he yelped.

"It will help, I assure you," I shouted down to him.

"It won't, will it?"

"Of course!"

I did not wish him to waste precious breath on idle chit-chat, so I struck him with the whip again.

There, take that!" I cried.

I realized that the ground was covered in thick snow. It stretched out in front of us – almost to the horizon, except at that distance it was too dark to see – powdery and glittering and, to me at least, peculiarly affecting. How strange that it was only snowy *outside* the city! It was a night of snow and starlight and crisp winter air, just as it had been when we first arrived.

"Hendryk," Adelma whispered, snuggling close to me. "This is so terribly romantic."

I could feel the heat of her voluptuous body. Her breasts were pressing against my ribcage.

"My own thought exactly," I said.

It might, of course, have had something to do with the movement of the coach, but I was swiftly becoming erect. It was almost painful.

"How wonderful it would be," Adelma murmured, taking the lobe of my left ear between her little teeth and biting gently, "to make love under such stars."

"Yes, but –"

"It's funny, isn't it," she went on, "how everything we say about love doesn't actually make sense?"

"What do you mean?"

"Well, for instance, you can't *make* love, because it isn't a thing that's created; you can't *fall in* love, because it isn't a hole or a pit or anything like that; and another person can't *be* your love, because love is what you feel for each other. In any case, people say that they love chocolate or cherries or puppies, and you can't have intercourse with them, can you? Well, not with chocolate or cherries, anyway."

"Adelma —"

"Oh, Hendryk, shall we?"

"Shall we what?"

"Make love. Despite the impossibility of the phrase, I mean."

"I don't see how we can. I mean, it's rather awkward up here."

"Oh, but imagine it! The magic of the night, the enfolding stillness of the snow, the two of us joined in mutual desire under the vast canopy of the sky . . ."

"God, I really want to."

Then, with a sudden and slightly unnerving clinical frankness she said:

"Open your trousers. I'll sit on your lap and you can penetrate me that way,"

"What about your – well –"

"I'm not wearing any."

"Ah."

We managed it, even though I was still holding the reigns in one hand and the whip in the other. Adelma began to move herself lasciviously, sighing and moaning.

"I wonder what Dr Freud would say if he knew?"

"Knew what?" I gasped.

"That we're having carnal relations a foot or two above his head . . ."

"Write a monograph about it, probably. I can't bear it!"

"*You* can't bear it?" Malkowitz called up from below. "What about me?"

"Faster," I cried. "Oh please, faster!"

199

"I can't go any faster!" Malkowitz shrieked.

I brought the tip of the whip down across his neck.

"Not *you,* you fool!"

"Didn't I tell you it would be wonderful?" Adelma wailed, moving up and down on me with increasing vigour.

"That's not what I'd call it!"

"Shut up, Malkowitz!" I yelled, feeling a fire flickering somewhere in the small of my back, its flames beginning to spread and consume me.

"Stop, oh stop!" I groaned, hardly able to endure the sweetness of it.

"Stop?"

"You want me to stop?" Adelma murmured.

"No! Never, never —"

"I wish you'd make up your damned mind!"

I felt it coming, an inexorable flood, an unquenchable conflagration, when suddenly the whip flew out of my hand, the reigns slipped —

"God almighty!"

"In the name of heaven!" Dr Freud shrieked.

I glanced down at the side of the coach. The door had swung open and the old man was hanging out, his wrinkled face rigid with terror.

"Stop, stop!"

Then I heard Malkowitz utter a ghastly scream and the coach suddenly seemed to lift itself up into the air. It pirouetted and span as if on some invisible axis and my hands reached into nothingness, scrabbling in vain for something to catch hold of. Dr Freud was shouting something now but I could not hear it because my ears — my entire head! — was filled with a roaring, rushing sound like a great wind. There was a loud crack, a splintering of wood, and my whole body jolted, every bone of it, as if some giant fist had grasped me then thrown me against a stone wall where I was mercilessly dislocated.

For a brief moment before the blackness descended I felt a soft, soothing coolness against my skin . . .

★

. . . which I at once knew to be the air-conditioning in a spacious room whose tall windows were hung with crimson damask. I was standing on a podium, facing an audience of at least a hundred people. Cameras flashed. For one ghastly moment it occurred to me that this was when I was expected to begin my second attempt at a lecture on the art of yodelling and a *frisson* of dread shot up my spine; but no, it couldn't be that, for on the podium with me, sitting in ornately carved and gilded chairs, were Dr Freud, Malkowitz and Count Wilhelm. They had apparently just finished applauding. I was the cynosure of so many expectant, curious eyes.

A man's voice spoke from somewhere behind me, amplified by a microphone.

"And, therefore, it gives me great pleasure to present this year's Lilli Frankenheimer prize for original contemporary fiction to Herr Hendryk —"

Me?

So then, I *was* a writer after all! Not only that: I had written a novel, it had been judged worthy of merit, and now I had won the Lilli Frankenheimer prize! I had, as they say, 'made it'. I was a real author. It was a dream come true.

"— astonishing literary tour-de-force, *A Box of Dreams*, from which he has graciously consented to give us a reading."

A tiny voice in my head insisted: *Well, it's a dream at any rate. You're right about that* . . . but I managed to ignore it. It was a pity I'd not heard the speaker say my surname, as that would have been very useful. Still, what did names matter when I had been awarded the prestigious Lilli Frankenheimer prize? I assumed it was prestigious, but I don't think I'd ever actually heard of Lilli Frankenheimer, although I remembered that an Inge Frankenheimer had once stolen my mother's knitting pattern and won the "Best Winter Cardigan" competition organised by the nuns in our town. Funny how something like that should suddenly come back to me. Or was I merely confusing prizes?

"Furthermore, there is a special request that it should be the controversial and explicit scene of love-making between Malkowitz and the lovely Adelma."

There was a collective intake of breath and spontaneous clapping rippled through the great room.

"Who requested that?" I muttered.

"I did," I heard Malkowitz say.

He glanced up at me and poked me in the thigh with his elbow in a lascivious manner.

"No," I said decisively. "I shall read the controversial and explicit scene of love-making between the young hero and Adelma instead,"

I was almost certain I detected a low sigh of disappointment from the audience.

"He certainly isn't going to read that," someone declared.

Trudi Mennen! I turned and glanced around but I couldn't see her anywhere. Was she in the room or merely in my head?

"Why on earth not?"

I also recognised Adelma's voice immediately. So Trudi *and* Adelma were somehow both here together. I started to feel uncomfortable; it was like putting a cat and a dog in the same kennel . . . a recipe for disaster.

"It's so cheap. My Hendryk is worthy of better than that."

"Your *Hendryk?*" Adelma said snappishly. "*I think you'll find he belongs to me.*"

"But Adelma, I knew him long before you did. He loved me first."

"Since meeting me, he has clearly changed his mind."

"Besides, you don't even exist. Why, you're nothing but a dream!"

"I'd rather be the girl of his dreams," Adelma said with some dexterity of logic, I thought, "*than the girl he just happened to get lumbered with.*"

"Lumbered with? How dare you!"

"For heaven's sake, look at yourself. You're all skin and bone. You could never satisfy a man like Hendryk."

"And you could, I suppose?"

"I already have done, more than once."

"But only in a dream."

"You're just jealous," Adelma cried. "*Thank God my poor Hendryk —*"

"My poor Hendryk!"
"Mine!"

Their voices began to rise higher and higher as they shrieked and yelled at each other. I heard the sound of a protracted tussle. Then the shrieking became a kind of sharp, high-pitched buzzing that went through my head like a blade, making it spin, causing me to feel distinctly queasy . . .

★

. . . but no, it was not their voices at all. It was a ghastly ringing in my ears. I felt snow against my cheek. Snow! And it was very wet. I felt it creeping down across my neck in a discomforting curlicue, making me shiver and shake. Once I had opened my eyes and wiped away the icy, melting sludge, I dragged myself slowly to my feet. What in the name of God had happened? Obviously I had not won the Lilli Frankenheimer prize for original contemporary fiction. This realisation came as something of a disappointment to me, I admit.

Then I remembered: Malkowitz had been pulling the coach and it had crashed while Adelma and I had both been thoroughly enjoying ourselves. Indeed, as I recalled, I had been on the point of experiencing a rather copious sexual climax before the crash. But that was far from my mind now! I looked behind me. Some distance away was the twisted wreckage of the coach, but there was no sign of Malkowitz or Dr Freud, or of Adelma. I called their names, my voice echoing in the silent, starry night. And again. There was no response. Where were they?

Then I suddenly looked directly ahead of me and I saw it: *the train!*

There it stood, an elongated dark shadow against the darker sky, its solid blackness regularly punctuated by rectangles of soft yellow light, steam rising desultorily from the engine. It must surely have stopped some way from the station. Oh, thank God . . . the train! Malkowitz, Dr Freud and Adelma must surely be already aboard. I ran toward it, panting and

puffing, determined to clamber into one of the carriages before it pulled away into the night. Damn the count's coach! Damn Dr Freud and Malkowitz, damn them all! – only Adelma meant anything to me now. I wanted warmth, safety, food and to get to wherever it was the train was going. Anywhere. At that moment, feeling a sudden gust of wind snap around my legs, I glanced down to see that I wasn't wearing any trousers: they must have been ripped off in the accident. What did I care now? I had yanked open a door and was hauling myself aboard.

I found myself in the dining-car. The tables were laid with cutlery, glasses, napkins and all the accoutrements of an excellent dinner. The bead-fringed lamps glowed with a welcoming, friendly light. Then I noticed that on one of the tables, two plates of food had already been served and a bottle of wine had been opened. I caught the heady aroma of herb-rich baked meat. Adelma must already have ordered dinner for us! I found myself suddenly and strangely moved by this unexpected thoughtfulness, but recent events had doubtlessly left me in a vulnerable emotional state in any case. Where was Adelma herself? I plonked myself down in the seat with almost infinite exhaustion and the sigh of relief I gave at that moment came from depths which were positively primeval. I was shivering, wet, dispirited, exhausted, confused and shaken, yet there was a plateful of something hot and fragrant in front of me, just waiting to be eaten. I picked up the napkin, unfolded it, and tucked it into the front of my jacket. I suddenly realised how ravenous I was.

Then the train began to move!

It shuddered and shook and creaked, but it quite definitely began to move. I could have wept with joy! Within moments it had picked up speed and the whole of my aching body felt it hurtling onward into the blackness toward – well – toward where? – but who cared where it was going? Certainly not I. I glanced down at the food on the gold-edged china plate. It looked utterly delicious, but then in my condition, I suppose a pile of fried cow-pats would have seemed equally so. I made up my mind that I would go and

search for Adelma after I had eaten, for all that mattered at the present moment was getting something good into my stomach. I leaned forward, breathed in, savoured the aroma of the food and sighed with sweet satisfaction. I was still sighing . . .

Please turn back to page 7

Memoirs of a Gnostic Dwarf – *David Madsen*

"A pungent historical fiction on a par with Patrick Suskind's *Perfume*."

 The Independent on Sunday Summer Reading Selection

"David Madsen's first novel *Memoirs of a Gnostic Dwarf* opens with a stomach-turning description of the state of Pope Leo's backside. The narrator is a hunchbacked dwarf and it is his job to read aloud from St Augustine while salves and unguents are applied to the Papal posterior. Born of humble stock, and at one time the inmate of a freak show, the dwarf now moves in the highest circles of holy skulduggery and buggery. Madsen's book is essentially a romp, although an unusually erudite one, and his scatological and bloody look at the Renaissance is grotesque, fruity and filthy. The publisher has a special interest in decadence; they must be pleased with this glittering toad of a novel."

 Phil Baker in *The Sunday Times*

"Dedalus specialises in fiction that could roughly be classified as gothic or arcane – or indeed gnostic. First published in 1995, this one immediately caught readers' imaginations and has since become something of a contemporary classic. It has a cute frame opening ('It is not necessary for me to relate precisely how these memoirs fell into my hands . . .') and an ugly, if memorable opening proper, reminiscent of the start of *Earthly Powers*: 'This morning his Holiness summoned me to read from St Augustine, while the physician applied unguents and salves to his suppurating arse . . .' The rest is freakish couplings, religious sects, torture: a cracking read for all ages, then."

 Giles Foden in *The Guardian*

"Madsen's tale of how Peppe becomes the Pope's companion and is forced to choose between his master and his beliefs displays both erudition and a real storyteller's gift."

 Erica Wagner in *The Times*

"not your conventional art-historical view of the Renaissance Pope Leo X, usually perceived as supercultivated, if worldly, patron of Raphael and Michelangelo. Here, he's kin to Robert Nye's earthy, lusty personae of Falstaff and Faust, with Rabelasian verve, both scatological and venereal. Strangely shards of gnostic thought emerge from the dwarf's swampish mind. In any case, the narrative of this novel blisters along with a Blackadderish cunning."

The Observer

"Some books make their way by stealth; a buzz develops, a cult is formed. Take *Memoirs of a Gnostic Dwarf*, published by Dedalus in 1995. The opening paragraphs paint an unforgettable picture of poor portly Leo having unguents applied to his suppurating anus after one too many buggerings from his catamite. Then comes the killer pay off line: 'Leo is Pope, after all.' You can't not read on after that. I took it on holiday and was transported to the Vatican of the Renaissance; Peppe, the heretical dwarf of the title, became more real than the amiable pair of windsurfers I'd taken with me."

Suzi Feay in *New Statesman & Society*

"*Memoirs of a Gnostic Dwarf* was overwhelmingly the most popular choice of *Gay Times* reviewers in last year's Books of the Year. Reprinted now this outrageous tale of the Renaissance papacy, heretics, circus freaks and sex should be at the top of everyone's 'must read' list."

Jonathan Hales in *Gay Times*

£8.99 ISBN 1 873982 71 2 336p B. Format

Confessions of a Flesh-Eater – David Madsen

"Set in the present, the tale has all the grim foreboding of a genuine Gothic work. Its tone and emphasis owe much to James Hogg's *Confessions of a Justified Sinner* and Mary Shelley's *Frankenstein*, except that the touch is lighter. Fans of body horror will find more visceral lusciousness here than in most synthetic US nasties. One of Crispe's talents is the ability to call up synaesthesia: the mixture of sense impressions. I liked the comparison of beef to brass in music and to 'the sexual potency of young men before it had been squandered'. Orlando Crispe's gusto for copulating with carcasses retrieved from his restaurant's cold store, then serving them, is only rivalled by his heartfelt loathing for female flesh itself. Women are more fondly regarded by the chef as marinades for his masterpieces."

Chris Savage King in *The Independent*
– Book of the Week Choice

"Sin, sodomy and sirloin. Madsen's novels are driven by an overwhelming sense of decadence and corruption. His view of human nature in general and sex in particular is gloomy, relieved only by a strong line in humour. *Confessions of a Flesh-Eater*, set in the present day, follows the adventures of Orlando Crispe, who decides on a career in cookery. He opens two highly successful restaurants, one in London, then one in Rome, following his apprenticeship in the kitchens (and bed) of Master Egbert Swayne. Master Egbert, a monstrously fat old homosexual, is endowed with a lovely turn of phrase; this is his verdict on nouvelle cuisine: 'More fucking tomfoolery. Half a hamster's tit and two peas floating on a raspberry haemorrhage for thirty quid? God in Heaven! Do they take us for dizzards!' Orlando is sensually attracted to meat (he has carnal knowledge of sides of beef in between servicing Master Egbert) and develops his own philosophy which leads, logically, from cooking animals to cooking people."

Eugene Bryne in *Venue*

£7.99 ISBN 1 873982 47 X 223p B. Format

Orlando Crispe's Flesh-Eater's Cookbook –
David Madsen

"Without question David Madsen's *Orlando Crispe's Flesh-Eater's Cookbook* is the most bizarre tome to land on any food editor's desk this year. Conveniently categorised as Fiction/Cookbook/Decadence by his publisher, Madsen offers up something akin to Hannibal Lecter's kitchen through the eyes of film director John Waters. Amid the seemingly straight recipes are some quite queer ones, involving the use of precious bodily fluids and marinades. The least bizarre technique involves chef Crispe bathing in beef stock; "By rapidly clenching and unclenching my sphincter muscles, I could actually draw some . . .' Well, you get the picture. Homo-erotic gross-out is not a vein well dug in the culinary world, so should Madsen find his market, the words of his alter-ego are no doubt accurate; I think I can promise that you will not be disappointed."
The List

"More decadence from Dedalus, this being a work of philosophy as much as a book meat recipes. Some of the dishes require things like '2 teaspoons of the chef's sweat' or '1 tbsp freshly-ejaculated sperm'."
Venue Christmas Books

"The book is magnificently gothic and erudite meditation on the pleasures of the flesh, though the emphasis on bodily fluids may repel those more in tune with TV cooks. Nigella, eat your heart out. Or somebody else's."
Val Stevenson in *The Fortean Times*

£7.99 ISBN 1 873982 42 9 162p B. Format